VIEW FINDER

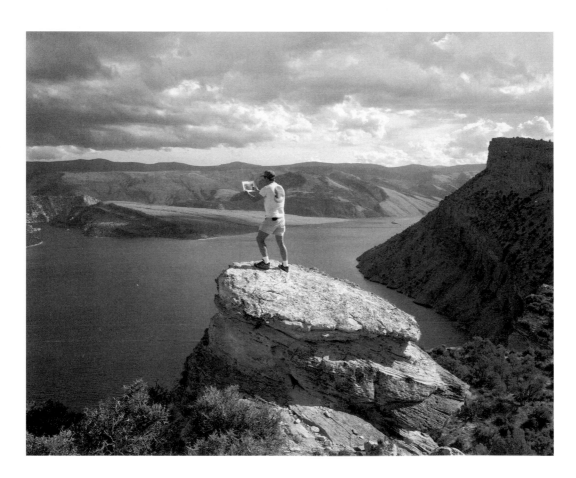

Mark Klett, *Standing where O'Sullivan stood, Flaming Gorge, Wyoming, 1997.*

VIEW FINDER

MARK KLETT, PHOTOGRAPHY, AND THE REINVENTION OF LANDSCAPE

WILLIAM L. FOX

UNIVERSITY OF NEW MEXICO PRESS ALBUQUERQUE

Library of Congress Cataloging-in-Publication Data

Fox, William L., 1949–

Viewfinder : Mark Klett, photography, and the reinvention of landscape /

William L. Fox. — 1st ed.

p. cm.

Includes bibliographical references (p.).

ISBN 0-8263-2219-0 (cloth : alk. paper) — ISBN 0-8263-2220-4 (paper : alk. paper)

1. Landscape photography—West (U.S.)—History.

2. Photography in geography.

3. West (U.S.)—Geography—Pictorial works.

4. Klett, Mark, 1952–

5. O'Sullivan, Timothy H., 1840–1882.

I. Title.

TR660 .F69 2001

778.9'3678'092—dc21

00-009521

Contents

Preface

Beth Hadas, the director of the University of New Mexico Press, and Dana Asbury, acquisitions editor, read an essay about photography that I wrote while living in Santa Fe in 1993. It was more about my personal dissatisfaction with the medium as a vehicle for investigating the world than anything else. I nonetheless admitted in it my admiration for certain contemporary photographers, Mark Klett among them. Although neither editor could figure out what to do with my essay, Dana urged me two years later to call Klett in order to find photographs for another project of mine that the press was publishing. Klett not only accommodated my requests, but the book's designer, Tina Kachele, who had worked earlier on his *Revealing Territory* book for the same press, chose one of his photographs for the cover.

In the course of talking over all this with the photographer, he mentioned that he would be going out into the Nevada desert the following summer to continue his rephotographic work. Following the path of Timothy O'Sullivan, the nineteenth-century photographer, the trip would involve multidisciplinary work by several of Klett's graduate students and colleagues. He asked if I might be interested in coming along. I was surprised by such a generous offer and gladly accepted. Beth and Dana, upon hearing of the invitation, suggested that I might consider writing a book about Klett and his remarkable role in documenting the landscape of the American West. This, too, was a unique invitation that I accepted without hesitation.

This book uses that trip as a narrative armature around which to investigate the history of landscape photography. It is, by the mutual desire of both Klett and myself, not primarily about Mark, but more about the evolution of a discipline. The stories that make up the

history of photography are complicated, overlapping, sometimes self-contradictory, and mostly beyond the scope of this book. There is no way, however, to understand the work of Mark Klett without considering how he fits into that history, and how those stories are, in turn, woven inextricably into the exploration of western America in the nineteenth century. I hope, therefore, that the curators and historians of both photography and the West will forgive what is an idiosyncratic summation of their works, but one done in admiration. I can only refer the reader to the bibliography where the titles of excellent books about those subjects are listed, and hope that they will read them.

It is unlikely that I would attempt to write anything about either the natural regions of Nevada or the nineteenth-century history of western exploration without consulting Alvin McLane. He is a widely acknowledged authority on both subjects, and a man who is believed by many to have walked, climbed, and skied over more of Nevada than anyone else in its history. Alvin was able to confirm everything from the location of specific O'Sullivan photographs to the length of time it took emigrants to cross the Forty Mile Desert. He willingly shared his extensive collection of nineteenth-century government survey publications and maps, including Clarence King's 1878 report, *Systematic Geology,* for which I am more than grateful.

Beth Hadas and Dana Asbury are wonderfully supportive friends and editors. They have overseen one of the most important photography publishing programs in the country for many years, and it is an honor to work with them. The University of New Mexico Press is one of the more congenial publishers at which a writer can find a home, due in no small

measure to the professional staff, including Peter Moulson, the director of marketing.

I would also like to thank Jennifer Watts, William Deverell, and Thomas Southall for their early reading of the manuscript and helpful suggestions.

VIEW FINDER

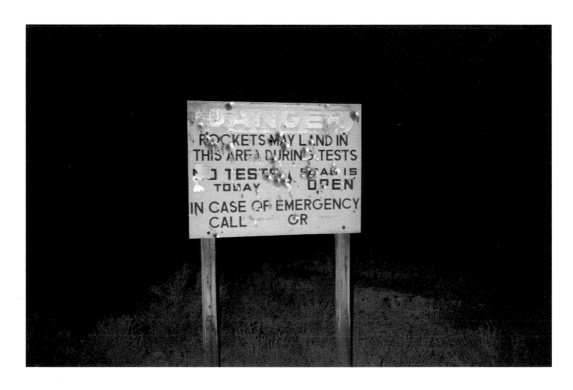

Mark Klett, *Warning sign, four-wheel drive road three and one-half hours north of Las Vegas, midnight, 7/4/98.*

Chapter One

THIRD VIEW: JULY 3ᴿᴰ: LOGAN CITY

It's five minutes to midnight, and our three vehicles are wandering up and down an obscure highway a hundred miles north of Las Vegas and just south of Hiko, Nevada, in what must be one of the darkest corners left in America. Mark Klett is hunched over the steering wheel of his 1984 Toyota pickup trying to pick out the dirt road that will take us west and up into the Mt. Irish Petroglyph District and toward the ghost town of Logan City, a site photographed by Timothy O'Sullivan more than a hundred years ago. I remember the road from a trip earlier in the year as being a perfectly well-defined track through the sagebrush, but it's so far been invisible in the dark. I'm balancing a map atlas, pad, pen, and flashlight, and am likewise peering out into the night. It's so black outside that we can't even see the reservoir which, according to the map, should be directly to the east of us.

We're making our third pass up and down this stretch of asphalt, and we've already tried two roads, one of which petered out into a cattle rut, the other ending at a local dump site. Mark is just about ready to give it up when we see a gate in the barbed wire fence that we haven't tried yet. I get out and unhook the fencepost, then hop in with Richard Stuart who's volunteered to scout ahead. The road curves up a hill and disappears into a direction that agrees with both my memory and the map, so we return to the highway and I clamber back into Klett's truck.

"You sure this is the right road?" he asks.

"Sure. Well, probably. It goes in the right direction. . . ." I've just met the man, a photographer whose work is legendary in the contemporary West, and I'd hate to disappoint him. Klett puts the truck in gear and I cross my fingers.

Five minutes up the road, I tell Mark to keep an eye out for a brown wooden Bureau of Land Management sign announcing the boundary of the national petroglyph area. Another five minutes go by before a sign comes into view. It's not the BLM one, but a shotgunned yellow aluminum plate that I'd forgotten about but nonetheless recognize. Its stenciled black letters warn us that "ROCKETS MAY LAND IN THIS AREA DURING TESTS." We stop so everyone can pile out and take pictures with a formidable array of still, digital, and video cameras. Then it's back to jouncing along what is an increasingly rough track. A few minutes later we pass the BLM sign marking our entry into the 640 acres set aside in 1970 as a protected area. Thousands of petroglyphs are scattered among rock outcrops here, and I'm looking for a large grouping called Shaman Hill, where there's a flat spot large enough to hold Mark's truck, Stu's Nissan Pathfinder, and Byron Wolfe's Toyota station wagon, which is crammed to the roof with computers packed carefully in cardboard boxes. There's no telling how their circuits are faring over the road, which has deteriorated into a fierce washboard. If the state of the vehicles is any indication, the news is not good; but, then, maybe it's just a matter of mileage. Mark's pickup has 121,000 miles on it, Byron's wagon is over 220,000, and Stu's Nissan is passing 95,000. Various and sundry pieces of sheetmetal, tail lights, and plastic underbody parts are flapping, blinking, and rattling at random.

Another fifteen minutes go by and we're on a part of the road I haven't seen before. At a fork we make the decision to follow the larger track, which by the light of the half-moon that has just risen, we can see leads us down into a canyon. Just as the road levels out, Mark

swivels in the seat and cranes his neck to look over his shoulder. Behind us a 150-foot-high cliff gleams dully in the moonlight.

"This is it! This is the goddamn site!" He's ecstatic and stops the truck, everyone else likewise halting in the middle of the road. We spread out and look for places to pitch a couple of tents, too tired to be properly astonished at driving directly up to the site when all we were looking for was a place to sleep. We end up doing the obvious: camping in the road, a logical choice given it's the only flat area of any size and there are no other tire tracks within miles. Before sleep I pull the altimeter out of my pack—5,950 feet. We're high enough that it shouldn't be too hot tomorrow.

July 4th

Everyone more or less gets up around seven. Mark is already down the road setting up on a tripod his 4x5 field camera with a Polaroid back, using a copy print of the original Timothy O'Sullivan photograph to estimate the vantage point from which it was taken. Byron, a photographer and Klett's assistant, walks down to join him and together they begin to assess more exactly where to position the camera. Klett's first major recognition as a photographer came when he co-founded a team in 1977 to undertake the task of rephotographing as exactly as possible the work of the nineteenth-century expedition photographers accompanying the Great Surveys of the West. The Rephotographic Survey Project ran through 1979 and made thousands of images. The resulting exhibition and book of 120 rephotographs, *Second View*, as it's called, was an astonishing feat of mathematical accuracy, cultural

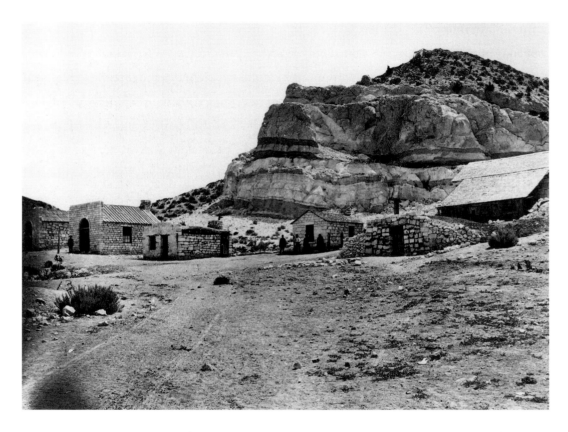

Timothy O'Sullivan, *Water rhyolites near Logan Springs, Nevada*, 1871. Collection of the United States Geological Survey.

Mark Klett and Byron Wolfe for Third View, *Abandoned house at Logan, Nevada*, 1998.

geography, history, and art. Now Klett's painstakingly working his way, twenty years later, through the Third View shots, sometimes adding new sites that he didn't have a chance to rephotograph himself, such as this one in Logan. It requires use of a compass, a calculator, a ruler, and a pen to triangulate reference points on a Polaroid test shot for comparison with the copy print—all this before coffee is made, a fact of which my fuzzy mind is numbly aware as I repack my sleeping bag, then leave my tent to wander down the road.

By daylight we can see the remains of a stone building nearby, as well as a newer wooden cabin with a camper propped up slightly off-kilter next to it. On the cliff, we see a deeply eroded pile of soft rock identified as water rhyolites; dark bands run horizontally under its prow, which is topped with a cross wired to the rock. We're in a classic piñon-juniper wood-land, a profusion of penstemon and lupine shooting up everywhere, along with a bumper crop of foxtails produced by this last winter's very wet El Niño storms. Scattered on the sur-face of the dirt road are both chert flakes from stone tools and shiny 30.06 brass casings from a deer rifle. The conjunction of neolithic and contemporary ammunition remnants creates an even deeper historical context for the work we're doing this morning.

Klett is sitting in a folding camp chair with his first test shot and tools, dressed in a white polo shirt, hiking shorts, and sandals. His lean and otherwise youthful-appearing six-foot frame has been somewhat smudged by a bicycle accident last week, huge scabs residing on his left knee and elbow, the palm of his hand likewise scraped. It seems he was trying to beat a traffic light in an intersection when the chain slipped off its sprocket and he invol-untarily vaulted over the handlebars. Byron stands nearby wearing a large floppy hat and

holding an aluminum document box *cum* clipboard, the kind building inspectors carry. A thirty-one-year-old graduate this spring from the Master's of Fine Arts photo program at Arizona State University, where Mark has been his mentor, he worked last summer in Colorado on the inaugural year of the Third View project. Like everyone here, he will be doing both rephotographic and his own original work. His primary job this morning is to pass film to Klett, keep track of the shots, and manage the profusion of gear in the immediate area around the photographer as he works.

Every few minutes Mark gets up, ducks under the dark cloth (actually just an old black T-shirt he favors), and stares into the ground glass, shifting the camera an inch or two forward or back and from left to right, then raising and lowering the height of the camera, tilting separately the tripod head, camera lens, and film back. The variables are infinite and minute, and I find it surprising that someone so energetic as to attempt sprints on a bike just to beat a traffic light can be so patient with a camera, spending an hour zeroing in on the same cubic inch of space occupied by O'Sullivan's shutter in the summer of 1871.

Another variable is the lens. First he takes a shot with a 90mm Nikon lens mounted on the Toyo camera body, then one with what is, for this 4x5 camera, a "normal" lens, 150mm. Deciding that the subsequent picture is a little too tightly framed, he borrows Byron's 135mm lens, which yields a slightly wider angle and satisfactory view. While he's sizing the lens to the picture he's rephotographing, Byron is taking a reading from a handheld GPS unit, receiving his triangulation from the various Global Positioning Satellites currently above the horizon and several miles overhead. When that's done they stretch a measuring tape downward

from the lens to log its height from the ground—sixty-three inches—and take a compass bearing from an ancient Brunton, the workhorse compass of the United States Geological Survey.

Recognizing that I'm more impressed by the legendary analog instrument than the GPS technology, Mark explains apologetically that it's one of two compasses he borrowed from the USGS over two decades ago and forgot to return. The second irony of the morning, following the rock flake-shell casing juxtaposition—is that the fix they take with the compass and maps may be more accurate than that provided by the GPS unit. It's not that the new technology isn't capable of pinpointing our position, but that the satellites are run by the Department of Defense, which in its post–Cold War paranoia deliberately programs them to send readings that can be as much as three hundred yards off in any direction.

Once he's satisfied that he's in position with the equipment properly set up, Klett leaves the camera and goes to make coffee and breakfast, a task all of us will take turns doing in the coming days. It's only eight o'clock and the sun won't be at the same angle as in the O'Sullivan shot for at least another two hours. The nineteenth-century photographers working in the field tended to shoot from roughly 10:30 in the morning until 2:30 in the afternoon, their emulsions requiring more light rather than less, and in order to even come close to duplicating the same angle of illumination Klett has to work in the same season, as close to the same date as feasible, and at a similar time of day.

While Byron and I strike our tents, Toshi Ueshima, another graduate student still in the program and the videographer for the trip, circles around documenting everything with a

tiny digital Sony that even from a distance looks expensive. Stu, who is the official "Web-meister" for the expedition, cranks up a laptop computer loaned to us by Apple and begins downloading digital camera images taken by Mark the day before while driving here from Las Vegas. A brand new computer with a G3 processor that's not available widely in the marketplace yet, it's a formidable addition to the Third View gear. Not being much of computer geek, I have Byron explain it to me.

"That little Macintosh Powerbook you have at home? It has four megabytes of memory, which is enough to hold several books, and it actually has more computing power than went up in the first space shuttle. This thing has four gigabytes of memory and is several thousand times faster."

"Oh," I say, suitably impressed.

"But it's not really enough," Byron continues. "Those stills take up quite a bit of memory, but it's nothing compared to what Toshi needs for editing video. We're carrying about ten gigs of memory with us on eight computers and various supplementary drives, but we could use twice that much in order to post this stuff from the field and on to the Web."

The primary difference between the Second and Third View projects is implicit in all the gear. Expanding the scope of documentation from simply rephotographing the work of O'Sullivan and others, Klett has put together a team that will capture the wider context of the duplicated view in this time and place. Not only will there be the inevitable changes from the original picture of Logan in the rephotograph—only one stone building instead of six, the advanced erosion of the cliff, and the cross on top, to name but a few—but we'll

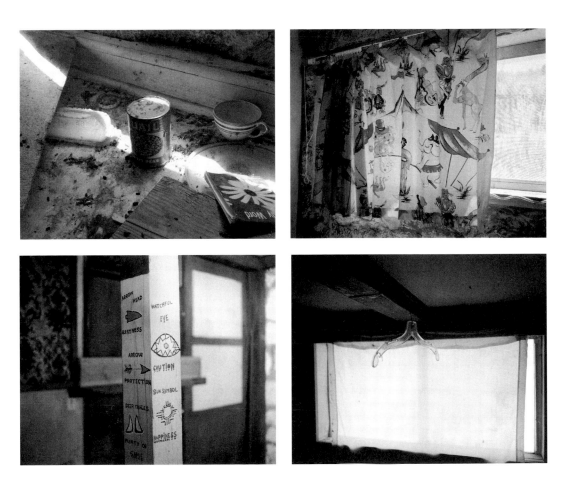

Mark Klett, *Can of peas from the abandoned kitchen at Logan, Nevada, 7/4/98, Kitchen curtains from the abandoned house at Logan, Nevada, 7/4/98, Painted column, living room of the abandoned house at Logan, Nevada, 7/4/98;* Toshi Ueshina, *Hanger, bedroom of the abandoned house at Logan, Nevada,* 1998.

also be sampling contemporary artifacts, making audio tapes, doing interviews with local residents and tourists when possible, and taking still, digital, and video images of everything. In essence, what Klett is doing is adapting a nineteenth-century expedition model to the turn of the millennium with late twentieth-century technology. He explains to Stu, who is attempting to organize a schedule for the input of images and some kind of linear flow to the look of the Web site, that this is nevertheless a process that is "less like journalism and more like poetry." Stu nods, but it's obvious he's unconvinced at this point.

While we're waiting for the sun to come over the crest of the hill and illuminate the cliff, we spread out over the area to investigate, coming together in various combinations as we stumble through the wildflowers and weeds. After clomping up the small rise behind the stone house to check out our surroundings, thus confirming my suspicion that we're far to the west of where I'd been among the petroglyphs two months previously, I head down to join Byron and Toshi who are poking around the stone house.

We have no idea why Logan is here, although we surmise mining as the logical reason. A small town with no pits, tunnels, quarries, or industrial machinery discernible in the immediate vicinity, it remains a mystery that the stone structure only compounds. Looking as if it sits in the same site as the building nearest to O'Sullivan in his photo, it also appears that the stones were taken apart and reconfigured. Inside, the ceiling is taking a slow entropic dive onto a floor of decaying shag carpet squares of mixed colors. The rooms are full of soggy Mormon tracts, political advertisements for a Nevada politician who, if I remember correctly, lost his race—and several women's stockings, not pantyhose, an interesting

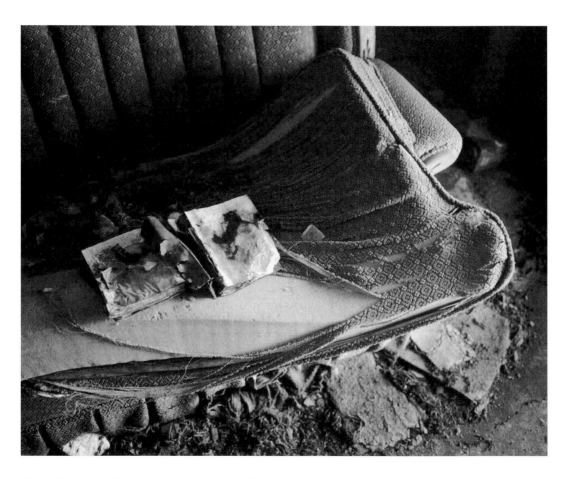

Toshi Ueshina, *Open book on decayed sofa, abandoned house at Logan, Nevada,* 1998.

contrast to the biblical materials. The walls and structural posts are decorated with neo-Hippie designs, while the aqua-painted shelves in the kitchen hold a miscellany of chipped mustard-yellow china. The chaos is dense, lovely, and difficult to decipher. While poking through it all, we startle a bat out of its sleep, who drops from a shadowy corner, circles us several times, then disappears up the chimney as if it were, literally, smoke.

By the time Byron and Toshi are finished shooting it's time to rejoin Mark and get ready for the rephotographing. In O'Sullivan's view the ground rises in front of the camera and up to the several buildings of the town; the cliff continues the upward thrust of the composition and dominates the background. Wagon tracks, presumably the photographer's, lead from the lower left-hand corner toward five dark figures who stand by the structures, too far away for their faces to be seen clearly. The horizon, an outline of the cliff and distant hills, was edited carefully by O'Sullivan. The wet-plate technique he used was very sensitive to blue, so he routinely masked out the sky in order to eliminate imperfections. Klett's work will be unedited. Another change in view today are our three vehicles and piles of equipment.

"Are you going to move our stuff?" I query.

"No, that's the view. We're in the picture." This is a hallmark not just of Third View, but of western exploration photography. In some of O'Sullivan's photographs, for instance, he left his wagon and mules, his version of the sport utility vehicle, in the picture for a sense of scale and presence. Second View work likewise accepted what fell into the frame. If Klett is violating the supposed purity of the rephotograph, he's doing so in a manner consistent with tradition.

Klett holds off shooting until he's satisfied the light is as close as it's going to get along the contours of the cliff to the original photo. "You usually don't see that much change in 120 years," says Klett, gesturing at the cliff bottom where huge boulders have crashed since O'Sullivan took his photo, then shading his eyes to check the progress of the sunlight. "It's like a game of brinkmanship, waiting for the light, but hoping it doesn't go too far."

Klett finally starts shooting at 10:37 A.M. with black-and-white Polaroid film, diving in and out of the black shirt draped over the camera. He switches to color, then to conventional black-and-white film to get negatives from which he will later make still more prints. Klett has no preference among the films about which to use for exhibition prints; he will choose whatever looks best. Byron quietly exchanges film holders, takes notes, and says to me: "Looking at one of the nineteenth-century prints and then looking through the ground glass is strange—you get disconnected from time. You actually get dizzy."

Standing next to Klett and Byron as they work, thinking about the chert and the brass artifacts separated by centuries, if not millennia, is like watching a Polaroid print of time slowly develop in front of you. The context that's being taken here is not just spatial, but also temporal, a complex enough enlargement of our sense of place that it's easy to imagine the vertigo Byron is describing.

After three hours of setup and waiting for the light, the rephotography is all over in seven minutes with the taking of eleven shots. As soon as Klett dismantles the Polaroid setup, Byron moves in and places his own tripod over the vantage point for a "QuickTime" panorama of the scene with his 35mm Nikon. Taking eight pictures in rapid succession around 360°,

the results will form a seamless cylinder inside which a viewer can sit and absorb the surroundings.

While Byron, in turn, packs up, Klett goes into the stone house and carefully pulls out one of the artifacts from off the rotting couch in the front room. It is an exquisitely eroded book; he places it open-faced on the concrete doorstep and positions his large-format camera and tripod overhead for a close-up. "Our Nation at Dead Center" reads the top of the verso, or left-hand, page. "Exercises and Activities" reads the recto heading. When finished, Klett takes out his palm-sized digital camera and snaps an image, which Stu will upload onto the Web along with the day's field notes that I'm writing. When finished handling the book we all wash our hands. The inside of the house is littered in copious rodent droppings and this is hantavirus territory, an often fatal pulmonary disease most commonly found in exactly these conditions.

The final shot at the site reverses the roles of assistant and photographer. Mark holds up to the sun a wafer-thin translucent square of plastic for Byron to photograph. It's a message recorded by the "First Presidency" to the "Families of the Latter Day Saints" that was inserted into a publication of some kind and it's in pristine condition. The light shines through the grooves of the record, a visual pun on the illuminating words of the prophet. I wonder what succor they offered the residents here, who must have needed all the faith they could muster in order to survive the lonely winters when the road was made impassable by snow and mud, then the hot and dusty summers. The record goes into the expedition's artifact collection.

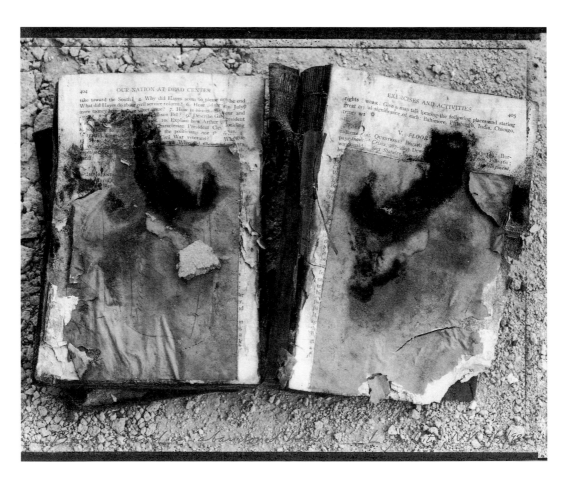

Mark Klett, Our Nation at Dead Center, *book found inside the house at Logan, Nevada,
7/4/98.*

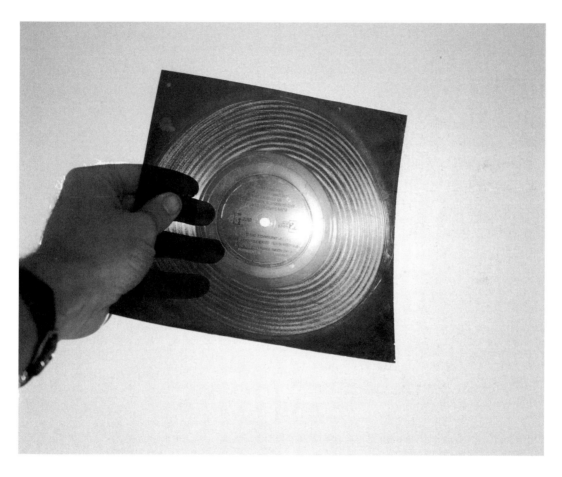

Byron Wolfe, *Found in a magazine: "A Message to Youth and Young Adults from the President of the Mormon Church,"* Logan City, Nevada, July 4, 1998.

We leave Logan at one o'clock and retrace our way back down out of the mountains, pulling off for lunch when we find the Shaman Hill site we were searching for in the dark last night. Everyone makes sandwiches on the tailgate of one of the trucks, then takes them over to a shady spot in an alcove by the petroglyphs. The slightly spooky figures of "Pahranagat Man" are all around us, blocky bodies with outstretched limbs pecked into the rock, eyes left blank. The rock art with its obscure geometries, its bighorn sheep and snakes, remains definitively uninterpreted despite the efforts of generations of anthropologists. Pahranagat figures tend to occur near tinajas, the wind-sculpted bowls that hold intermittent rainwater on top of the rocks—but no one knows, for instance, if the association was practical signage or ritualistic symbology.

Before driving back down to the highway we stretch our legs by walking around the area and examining the moderate lithic scatter left on the ground by previous inhabitants. Like most desert dwellers, Klett is fascinated by what is found there, boxing up cartridge shells and spent bullets, used targets, disintegrating toys, and sun-warped records that he stores in his garage. Personally, I favor small rodent skulls and scraps of rust, but these are just variations on a theme, our fascination with the longevity of our species. America, and especially the West, has few ruins. We pick up our reminders of the past where we can, though today we caution ourselves out loud that anything over fifty years old on federal land is classified as historical evidence and not to be collected. Here, in the protected area, it's wisest not to take anything, lest we disturb future excavations by archeologists.

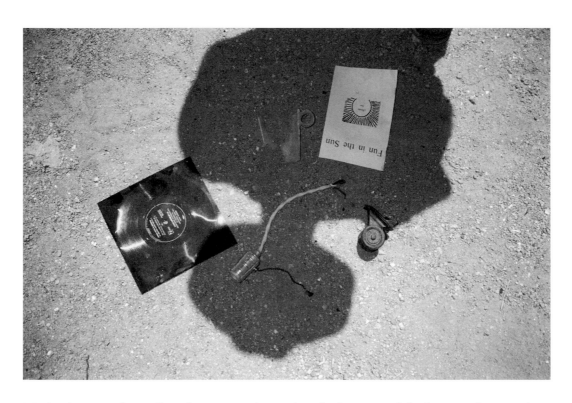

Mark Klett, *Artifacts collected at Logan: electrical cord, plastic record, broken cup, "Fun in the Sun" brochure, 7/4/98.*

After Byron makes an audio tape of the door swinging on a nearby outhouse, its creaking a properly existential counterpart to the open view from the seat of the Big Empty, we roll down to the highway and make a left to the south, intersecting a few minutes later with State Route 375, the infamous Extraterrestrial Highway. Although Highway 50, over a hundred miles to the north, was identified in the 1980s by Life magazine as "the loneliest road in America," any Nevadan can tell you that 375 is the less-traveled byway. Sure enough, we pass only three other vehicles on its entire ninety-six-mile length. We roll by what the UFO-aficionados have labeled "the Black Mailbox," supposedly a prime spot for viewing alien aircraft—or at least the newest aircraft under development at the nearby Area 51 on the Nevada Test Site. The mailbox, belonging to local Steve Medlin, has since been repainted white numerous times by the annoyed rancher who, like most longtime residents, apparently has witnessed plenty of strange aircraft, such as the Stealth when it was being developed, but has never seen an alien.

The preferred method for sightings out here is to recline in the desert on folding lounge chairs while wrapped in a sleeping bag, binoculars in hand. You will, indeed, see unfamiliar shapes with no running lights cut black silhouettes across the Milky Way, accompanied by weird hollow whispers unlike those made by conventional aircraft. Like avocational petroglyph hounds, the UFOers are out to collect evidence in the desert that we're not alone in time and space. We stop for some gas and cold drinks in Rachel. The small outpost of a couple dozen mobile homes is our only fueling stop until Tonopah, our stop for the night, which is still a hundred miles to the west. Rachel bills itself as a watering hole for aliens,

and signs in the gas station offer guided tours, though to what we're not sure. So much land has been withdrawn from around the test site by the Department of Energy that you can't even get within viewing distance of Area 51 without a strenuous climb to one of the mountains near—but not even adjacent to—the outermost perimeter of government property.

Back on the road, I've switched places out of Mark's truck for a ride in the much quieter station wagon. This gives Toshi, who was riding with Byron, a chance to shoot some video from the lead vehicle, and affords me the opportunity to get acquainted with the younger artist. Originally interested in environmental sciences and landscape photography, Byron married seven years ago and now has a two-and-a-half-year-old child. Being in the awkward position of cultivating his career while raising a family at the same time, he came to the conclusion that his life and work were disconnected, that his photos were "only information others might be interested in." Byron chose to study with Klett because "he's successfully solved some of the problems" of connecting work with life, his photographs bearing "a real strong narrative quality." Byron isn't talking now about Klett's rephotographic work, but what the teacher calls his "own work," thousands of original photographs of the desert Southwest that document in a matter-of-fact way how humans intervene in the landscape.

Byron's work now displays some very close affinities with Klett's, such as deliberately including the photographer in the frame and writing descriptive text by hand at the bottom of the pictures. But there are other reasons he chose Klett as a mentor, among them his way of sustaining his work while teaching. Klett is unusual in that he maintains what Byron calls "a healthy working practice," sometimes doing so by making pictures with his students. He

usually attempts to process and proof them as soon as possible, not putting off the follow-through until later, a practice he also follows in the field. It's a disciplined approach, and one encouraged by the use of a Polaroid, that keeps his artistic output high while he teaches a full load at Arizona State, a lifestyle Byron is clearly keeping in mind.

A few minutes before our turnoff onto Highway 6, which will take us the last fifty miles into Tonopah, we pass a dead snake on the road. Our small caravan stops and turns around, then unloads the usual assortment of cameras. Klett doesn't haul out the Toyo, but instead shoots with a handheld 2¼-inch-format Mamiya. Byron and Toshi each have one, too. Producing larger negatives than a common 35mm camera, and using a virtually vibration-less electronic shutter, they take exceptionally sharp images. Next to such beautiful instruments my compact point-and-shoot Canon appears trivial. It's a great little reference camera that serves me well, but I admit to a momentary case of gear lust, which I suspect will haunt me throughout the trip.

Everyone photographs everyone else photographing everyone else photographing the limp reptile, all of us milling around in the road for a good ten minutes with no other vehicles in sight. To the north of us Railroad Valley, the second longest valley in Nevada, stretches away over the curvature of the earth for almost 120 miles. We're out of the Pahranagat drainage, which leads into the Colorado River Basin, and up into the Great Basin, that largest and coldest of all the American deserts, a series of interconnected valleys filled with alluvial debris thousands of feet deep and separated by more mountain ranges per square mile than any-where else on Earth except Afghanistan. Nevada, almost all of which is in the Great Basin,

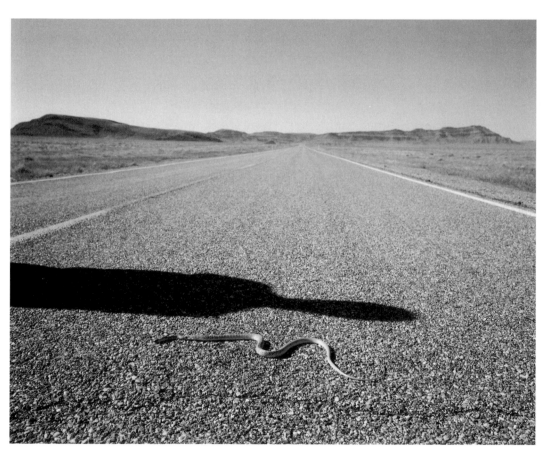

Mark Klett, *Dead snake, road to Tonopah, 7/5/98.*

alone hosts 316 separate mountain ranges, many of them over 10,000 feet high. It's one of the truly enormous landscapes on the planet, and standing here with the late afternoon sunlight streaming over the peaks and into the valleys, it's making Mark and Byron and me quite happy. We're used to the Great Basin and cherish the mental freedom we feel without anything obstructing the middle ground of our vision, and the lack of strong verticals such as trees and buildings. Toshi, raised in Japan, is not at all sure about such huge and uninterrupted space, and he's not disappointed when we get going.

It's 7:30 P.M. before we've managed to check into our hotel, transferred all the computers and camera equipment out of the parking lot and upstairs in borrowed grocery carts, and returned downstairs to walk through the slot machine aisles and claim the corner booth in the coffee shop. Stu is still in the room he and I are sharing, trying to locate the nearest server to connect us to the Web, a choice between the equidistant cities of Reno and Las Vegas.

"Tonopah," muses Byron as he stares out the window: "centrally isolated."

We eat quickly, Byron and Mark wolfing down their meals as fast as I do, a rarity, and Toshi's not far behind. Stu hasn't shown up by the time we're paying the bill, and when I return to the room he's still trying to figure out how to get us onto the Internet. I settle in for the next couple of hours to write up my notes about this first day of the trip, while next door the others go to work editing images. It's 10:45 before Stu gives up and goes to eat. I'm finished with the field notes and go to see what the others are doing. Three desktop computers and several drives are connected to each other with over thirty cables in the over-

heated room. Mark and Toshi are squinting in front of three monitors aligned in a row, while Byron balances another Powerbook in his lap. They're simultaneously editing Toshi's video and Mark's digital still images. The light in the room is blue and murky, and it occurs to me we're still near the edge of the Nevada Test Site.

"Jesus guys, this looks like something out of a sci-fi conspiracy flick."

Mark turns and narrows his blue eyes at me. "There are no aliens," he deadpans tersely, then picks up his cell phone and barks into it: "Security, we have a situation here!"

Mark and Byron grin, but Toshi is so locked into his sequences that he doesn't even notice. I wave them goodnight and back out into the corridor. Stu returns from dinner just as I'm getting to sleep around 11:30, and we both wonder if this is how long the days will be for the entire trip, which is scheduled to last for two weeks. But, then, in comparison with what O'Sullivan's days were like in the 1860s, this isn't so bad. Not at all.

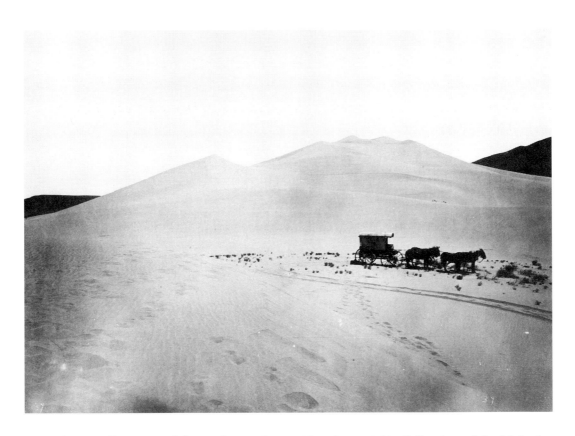

Timothy O'Sullivan, *Sand dunes, Carson Desert, Nevada*, c. 1868. Collection of the United States Geological Survey.

Chapter Two

A BRIEF HISTORY OF PHOTOGRAPHY AND TIMOTHY O'SULLIVAN

James D. Horan begins the second chapter of his 1966 book, *Timothy O'Sullivan: America's Forgotten Photographer,* by tracing the artist's lineage from Daguerre, the inventor of the daguerreotype, through Samuel Morse, the inventor of the telegraph and avid photographer, who in turn taught Mathew Brady how to make daguerreotypes. Brady knew O'Sullivan as a neighborhood child growing up on Staten Island, and it was to Brady's studios that the young man apprenticed himself while still a teenager. But it's instructive to start earlier in the history of the medium.

The word *camera* came into English from the Latin, and Webster's *New World Dictionary* lists its primary meaning as stemming from the German "kamara," not as an optical device but as a "vaulted chamber." It gives the first example in English for camera, therefore, as "the private office of a judge." The *Oxford English Dictionary* starts out its definition of camera with the Aryan root of *kam,* which may have meant curved or bent—hence the vaults in the chamber, not merely a flat-ceilinged room, but an exalted space. The *OED* likewise then refers the reader to the definition of *chamber.* The first mention of the word in English as an optical device comes only in the early 1700s, when it was used to describe a *camera obscura*—"dark room."

Aristotle is credited with first noting the principle upon which the *camera obscura* functions, describing how a round image of the sun passed unaltered through the angular lattice of wickerwork; we also know that in the eleventh-century the Arabian Alhazen used some version of the device to observe solar eclipses. Leonardo da Vinci described how light, let into a darkened room through a pinhole, would form an inverted image of whatever was

outside, and artists seeking to understand perspective used it as a mechanical device to make mathematically correct their great narrative paintings of the period. A few decades later, in 1568, Danielo Barbaro, writing from the University of Padua about the use of perspective, showed how the image could be sharpened by inserting a lens into the aperture, and how one could enter the room to trace and color the scene with the utmost accuracy from nature.

In the room of the *camera obscura*, art and science still cohabited the same space. The first optical box was large enough for the artist to walk into; not until 1778 were the English able to reduce it down to a transportable size, but we still think of a camera, even if unconsciously, as a miniaturized room wherein we seek the truth. The camera is the vaulted chamber of a judge—our eye—which is attempting to discern reality. It is wise to remember, however, that the root means "curved," that light can bend, and that our perceptions of reality tend to be refracted through our individual viewpoints. Also bear in mind that the camera "obscures" that which is outside its angle of view.

By the early eighteenth century light-sensitive salts were being put under stencils and exposed to light, producing silhouettes. Lithography was invented shortly afterwards, and the quest was on for a mechanical technology that could mass produce images on a printing press, as well as for a device that would automatically copy nature without the intervention of a skilled artist to trace and color the projections of the *camera obscura.* In 1826 the Frenchman Joseph Nicéphore Niépce made a "heliograph" from his studio window, an eight-hour exposure fixing the image in his *camera obscura* of nearby rooftops on a highly polished plate of pewter. In 1837 Louis Daguerre, a painter of large historical dioramas who

had been in communication with Niépce, used a new version of the process to make a detailed picture of a corner of his studio. Two years later his process of fixing images onto silver-coated copper plates was divulged to the public during a lecture to the French Academy of Sciences, and soon thereafter he published a seventy-nine-page booklet explaining in detail how to construct his camera and produce daguerreotypes. By November of that year cameramen were passing each other on the Nile, and in 1841 Frenchmen were taking pictures by the thousands of scenes from Central America to the Middle East.

Samuel Morse was in Paris during the public unveiling of Daguerre's invention and quickly had one of the cameras constructed for his own use, returning to the United States in the fall of 1839 and exhibiting one of his views of the Unitarian Church taken from the third floor of New York University. By now, climbing up to obtain an interesting view was becoming a cliché, a well-entrenched tradition since Niépce's rooftop shot. It was as if a view from above imitated the gaze of the Creator and was thus more to be trusted, a crude but effective way of aligning scientific veracity with religious faith.

Mathew Brady was a young aspiring artist who moved to New York City in his teens, working first as a leather-case maker while learning how to make daguerreotypes from Morse, either through public lectures or private lessons. In 1844 he opened a gallery on Fulton Street and Broadway, immediately captured first prize in a prestigious photography competition, and set about amassing what he called the "Gallery of Illustrious Americans." Within five years he had taken portraits of everyone from Dolley Madison to Daniel Webster and John Quincy Adams.

"In the meantime" is a critically appropriate phrase to use in tracing the development of photography, as so many different photo-chemical techniques were being pursued simultaneously. While Daguerre was working on copper, the English scientist William Henry Fox Talbot was experimenting with recording images from his *camera obscura* on paper bathed in salt and silver nitrate. Fox Talbot, who stubbornly insisted chemistry was the modern-day equivalent of alchemy, defined photography as a "chemical art" and invented the photo negative—which meant his "talbotype" could produce as many positive prints as needed, something impossible for the daguerreotype. Within months another famous British scientist and one of Talbot's friends, Sir John Herschel, invented the "hypo," or fixing solution, a key piece of the puzzle. Talbot combined his and Herschel's inventions to produce what was apparently the first photographically illustrated book, *The Pencil of Nature*, in 1844–46.

In 1851 an important advancement was made by an English sculptor, Frederick Scott Archer, who invented a process using a sticky liquid called collodion. First discovered in 1847 as a means to protect wounds, collodion, Archer found, could fix images on glass plates. Like the talbotype, this process produced a negative, but on glass, and required a shorter exposure. That same year yet another Frenchman, Blanquart-Evrard, came up with the idea of coating paper with egg whites, producing "albumen paper," which was stable over time because it was not sensitized until the photographer prepared it just prior to printing. The stock was smooth of finish, required an exposure to a negative of only seconds instead of minutes, and could be mass produced. It became the print medium of choice for

the remainder of the century. At one point the largest American manufacturer of albumen paper used up to 60,000 eggs per day. By the mid-1850s the first photographic book using albumen paper was assembled, a folio of 125 prints made from paper negatives taken by Maxime Du Camp while documenting a trip to the Middle East with Gustave Flaubert.

Although the wet-plate glass negatives didn't require long exposure times compared to daguerreotypes, requiring only thirty seconds or so for landscapes, the collodion process as a whole took seven steps to prepare a plate, expose it, then fix the negative image in hypo. It was tricky, took immense amounts of practice and had to be done with only orange-red light admitted into the darkroom. But albumen prints produced from wet-collodion plates, along with a host of other photographic fads such as tintypes and stereoscopic views, quickly and almost completely displaced the daguerreotype and talbotype. Brady followed each of the trends closely, opening five more galleries throughout New York City during the 1850s. His eyesight was slowly failing, however, and in the early part of the decade he hired a Scotsman, Alexander Gardner, to be his general manager to run both the New York stores and his elaborate new gallery in Washington, D.C., whereupon the young Timothy O'Sullivan enters the picture.

Born in Ireland in 1840, Timothy O'Sullivan came to America at the age of two with his parents who were escaping the potato famine. O'Sullivan grew up on Staten Island, at the time a relatively rural area where several notable photographers made their home, Mathew Brady among them. Horan reports that Brady's niece and only surviving relative told him in 1954 that O'Sullivan worked for Mr. Brady as a child, thus picking up his trade.

O'Sullivan leaves us no letters or journals, save some photo captions and a few official and unavoidable government documents, such as his application to the Department of the Treasury in late 1880 for the position of Photographer to the Treasurer. He held that post for only five months before retiring back to his father's house in Staten Island, where the photographer died of tuberculosis in January 1882 at the relatively young age of forty-two. Tracking O'Sullivan's movements through his early photographs is also difficult, as it was customary at the time for a gallery to stamp its name on the work of all its photographers. Brady's establishment was no different. Not until after the start of the Civil War, when Gardner left Brady over this issue and O'Sullivan later joined him, did an individual photographic presence, a unique body of work, emerge for us through numerous negatives bearing O'Sullivan's initials.

By 1861 photography could claim three major areas of imagery: landscapes, architecture (including historical monuments, such as the Pyramids), and portraits—all subjects that would stand still for the requisite amount of time necessary to fix an image. Action photography was still out of the question, but in 1855 the Englishman Roger Fenton became the first combat photographer, taking a horse-drawn wagon as a portable darkroom into the Crimean battlefields while under fire. He returned with over three hundred negatives and held exhibitions in London and Paris. There were no pictures of men in action, the work still limited to landscapes (the battlefields), architecture (the fortifications), and portraits (of officers and their men)—but Fenton had worked in the middle of the action, part of his wagon's top even being blown off by enemy shells. Photojournalism was born with the reproduction of his images through wood engravings printed in the newspapers.

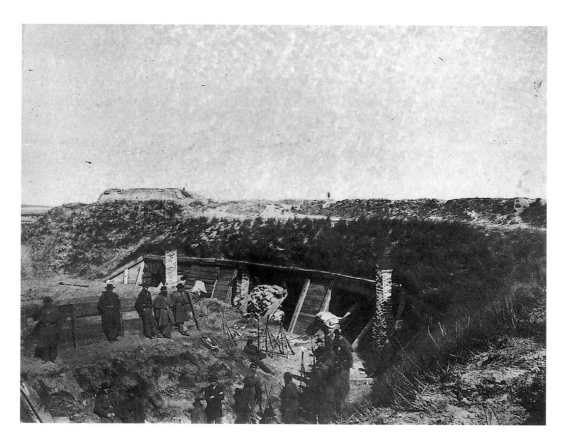

Timothy O'Sullivan, *North Carolina, Fort Fisher, Pulpit,* January 1865. Still Picture Branch, National Archive at College Park, Maryland (control number NWDNS-165-SB-79).

When the Civil War broke out, Brady was not unaware of the responsibility of photography to bring images of it before the public, or of the subsequent financial opportunity. Taking O'Sullivan with him as his assistant, Brady led his photo wagon into Virginia in July 1861, accompanying the Union troops on their way to their first battle, Bull Run. From shortly after this point on we have a reasonably consistent body of work identified as O'Sullivan's, images characterized by their steadfast lack of romanticism, their unflinching matter-of-fact gaze, and the photographer's adoption of bold vantage points, often elevated ones which exposed him to direct enemy fire. Each plate required somewhere between fifteen and thirty minutes from preparation through fixing, much of it spent crouched in the wagon and thus blind to the advancing action around him, hardly a secure position. Even while outside he was saddled with his bulky camera and tripod, another limitation on mobility. That O'Sullivan, Brady, and many of the three hundred other photographers documenting the Civil War survived to bring back over seven thousand negatives remains a miracle.

Gardner, now in direct competition with Brady, received an assignment to copy documents for the army, and named the younger photographer as his field superintendent in 1862. O'Sullivan already had a recognizable and formal vocabulary for composing his pictures that would serve his needs throughout the remainder of the war. In his views of men and artillery the formations are strong horizontals played off against bleak horizons dominated by a forlorn line of trees, the strategies of warfare coupled conclusively to the lay of the land. In others, corpses of the newly dead, their arms thrown back and their spines arched as if in supplication to agony, randomly litter the foreground. Death is a chaos juxtaposed

against the orderly rows of living soldiers. And always there were pictures of fortifications before and after the battles, photographs for the most part devoid of human presence, or perhaps with just a solitary figure in the distance to lend scale to the immense earthworks thrown up in defense of strategic positions.

The Civil War remains fixed in our national consciousness as a particularly bloody and tragic conflict, but there is no evidence to suggest it was any more horrific than any other war in the history of the world. The technology had changed and more people could be mowed down faster during a single battle, certainly, but our perception is not founded on a per-capita measurement of misery. It arises partly from the fact that we had, for the first time, widely disseminated and incontrovertible proof of the agony thrust under our noses by the photographs. The camera will obscure a large part of the world at any moment, given its narrow field of vision, but it also thoroughly reveals its subject by freezing a moment in time and space for our extended contemplation. O'Sullivan's photographs to this day continue to arrest our attention, despite almost a century and a half of bloody images paraded before us since. We could not then, nor can we now, easily turn away our eyes to escape these visible effects of our political and moral decisions.

In 1867, after he was finished printing up the Civil War images, the twenty-seven-year-old O'Sullivan signed on with Clarence King, a scientist trained at Yale and two years younger than he, to be the official photographer for the first of the government's four great geographical surveys of the West. On July 3 O'Sullivan's converted Civil War ambulance, purchased in Sacramento, pulled out of that city on its way eastward for a three-year journey

across the most desolate and least-explored part of what was then the United States, the Great Basin. Loaded down with two hundred pounds of photographic equipment—chemicals, glass plates, and cameras—O'Sullivan was embarking on yet another photographic foray that would shape our national mindscape. It was also to be one of the few times for over a century that science and art would share on equal footing the vaulted chamber of a camera.

While O'Sullivan was dodging artillery shells on the fields of Gettysburg in July 1863, Clarence King and his best friend were riding horseback across the plains, following the Frémont Trail into Nevada and up to Virginia City, where King worked briefly in a mine. They crossed the Sierra in August and boarded a Sacramento riverboat headed downstream to San Francisco, hoping to obtain employment with Josiah Whitney's California survey. On deck they ran into William H. Brewer, Whitney's second in command, himself a Yale graduate of the Sheffield School of Science. King and Brewer hit it off immediately, spending the remainder of the surveying season climbing mountains and working in northern California, all the while discussing everything from the effects of glaciers to the use of photography in the study of geology. King was soon promoted as the assistant geologist to Whitney, discovered fossils in the gold-bearing shales of California, became the first preeminent mountaineer in the history of the Sierra Nevada, and helped survey the Mojave Desert.

What he saw during his exploits, from the glaciers of the Sierra to the crater of Mt. Lassen and the deeply eroded riverbeds of the Southwest, led him to hypothesize that both the

gradual forces of nature and its violent upheavals formed the geology he had surveyed. Years later, in 1877, he would present a controversial graduation address at the Sheffield School entitled "Catastrophism and the Evolution of Environment." This was to be a direct challenge to the strictly uniformitarian viewpoint held by many leading scientists, with King proposing an early version of what scientists now refer to as "punctuated equilibria." This debate over how we describe the processes of nature continues today, involving fields as diverse as paleobiology, astrophysics, and the mathematics of complexity theory. King had put his finger on one of the key questions surrounding how human beings perceive the world: whether as a slow and uniform evolution of higher and higher life forms, or as a much more chaotic place where change is inevitable but sometimes violent and unpredictable. As of now the latter view seems to be winning. King's corollary belief, however, even though perhaps only a politically motivated one, that catastrophe was God's way of kicking evolution onto successively higher levels of achievement, would raise an eyebrow.

But before he could formulate his ideas clearly enough to espouse them to his peers, King had much exploring left to do. He started with his expedition to survey the arid lands of the Fortieth Parallel, an idea he had hatched in the fall of 1866 while gazing across the Great Basin from atop a peak in the Sierra. Trading on his connections to Whitney and others, he secured a coveted sponsorship from the army to explore the desert east of the Sierra and gathered together the first of the civilian expeditions to traverse the West. Instead of hiring a few generalists to accompany military leaders mapping out the strategic moves in the westward game of Manifest Destiny, as had the leaders of the army expeditions in previous decades,

King gathered together scientific specialists in several fields able to compile a deep geography of the region to be explored. This enabled him to move beyond the mere cataloging of species and geological forms, and to conduct an analysis of what was discovered, a model for most scientific explorations to the present day.

Photography, which had been tried in western exploration as early as Lt. John C. Frémont's journeys in the 1840s, but never with unqualified success, was now going to get its first thorough field test as a scientific tool. Widely admired after the war as a tough and daring character, Timothy O'Sullivan was an obvious choice for King; not only was he an experienced field photographer, but he had been able to direct an unhesitant lens upon the violence of man. Presumably he would be able to do the same when faced with the geological violence of nature.

Over the three-year course of their work the seventeen scientists and camp assistants, usually accompanied by a twenty-man detachment of mounted troops, tracked across a five-hundred-mile-long, hundred-mile-wide cross-section of Nevada, Utah, Wyoming, and Nebraska. They ended the exploration where the Platte River emptied into the Missouri at that imaginary vertical line of the Hundredth Meridian where, very much in a coincidental reality, the arid lands ended. O'Sullivan drove his stocky ambulance with its various horses and mules over dry lake beds and up sand dunes, in the heat of summer along the borders of sulfurous marshes in Nevada, and by moonlight over the frozen crusts of forty-foot-deep snowdrifts atop the Wasatch Range in Utah. Plates were smeared by dripping perspiration and they cracked in the cold. But all along the way he turned that dispassionate gaze, which had served him

so well to document and perhaps even survive the horrors of the Civil War, upon a land that Americans considered the most barren and godforsaken in the country, yet one that O'Sullivan found visually inviting. Horan quotes Robert Ridgeway, the young ornithologist King had hired, as describing the Humboldt Sink as "the most desolate and forbidding that could be imagined," but O'Sullivan described it as "a pretty location to work in," discouraged not at all by the alkali flats and putrid seasonal swamp, but only by the mosquitoes.

O'Sullivan descended nine hundred feet down into the mines of Virginia City and made the first underground photographs of miners at work. He lit magnesium ribbons in order to get his exposures—a somewhat hazardous practice given the known pockets of inflammable gas nearby, but typical of O'Sullivan's determination to push the boundaries of his medium to its technological limits. He climbed up the five-hundred-foot-high Sand Mountain east of present-day Fallon and made one of the most well-known images of the West ever taken, his wagon and four mules standing patiently in a landscape so barren that it is with actual relief we see the footprints of the photographer leading from the wagon into the immediate foreground.

Often breaking off from the main party, O'Sullivan marched across the desert in order to photograph not only the mining camps, but also ordinary buttes and eroded tablelands, hot springs and glaciers, illustrating how the geology of the region had been blasted open and carved through by both mankind and nature. The pictures he left behind set the standard by which landscape photography in the region is still measured. And it is a primary stratum of documentation that Mark Klett has been excavating since 1977.

King's Fortieth Parallel expedition was just the first of the four great surveys, and O'Sullivan also worked on one of the others, George Wheeler's ambitious travels west of the Hundredth Meridian. On marches as long as eighty hours, and through temperatures sometimes up to 120°, O'Sullivan added Death Valley and the Grand Canyon to the many western locations that he was the first to photograph, Logan City among them. In all, he spent seven years on expeditions, documenting a West that was on the cusp between military occupation and settlement by civilians, a mixture that still exists vividly today. The United States Army, which had swollen to almost a million persons during the Civil War, had shrunk rapidly to around 25,000 by the time Wheeler graduated from West Point in 1866. Wheeler's 1871 survey was an attempt by the army to recapture its status as the leader in scientific exploration, a battle which it later lost to Clarence King, who formed the civilian-run United States Geological Survey in 1879 and became its first director. The army then took on, and to some degree invented, the necessity of protecting settlers from Indians in order to maintain a rationale for its survival as an institution. The military has yet to leave the West.

O'Sullivan, never formally tutored by any academy, pictured the region as a land that somehow resided outside the conventional frame of the European painted landscape. Despite his lineage descending directly from the scene painter Daguerre, he seldom composed the landscape in a series of carefully receding fore-, middle-, and backgrounds leading the eye peacefully into the distance—the way the Dutch, the French, and then later the English tended to view and paint the picturesque. Nor did he fall into the temptation of the sub-

lime, a tradition that swallowed his colleague, William Henry Jackson, who accompanied F. V. Hayden on his expedition into Yellowstone.

Jackson was in some ways technically a more proficient field photographer than even O'Sullivan. A close friend and fellow expeditionary artist was the painter Thomas Moran, who inculcated in him the romantic creed of the great English painter J. M. W. Turner: what was important was the essence of the reality, and not its literal appearance. Jackson would go so far as to alter his negatives in order to heighten the drama of geological features—so it would appear not as it was, necessarily, but as he thought it should be. Jackson tended to go for the scenic climax and, accordingly, his work was used by Hayden to convince Congress to increase appropriations for his expeditions, and eventually to name Yellowstone as our first national park. In a sense, Jackson was the first and ultimate tourism photographer. Science had taken a back seat to scenic manipulation in the supposedly objective chamber of the camera. Viewing his work, we always feel that we're in the presence of a trophy taker, the heroic photographer balancing on the precipitous edge of the canyon for the sake of the picture. As Klett points out, when Jackson placed human figures in his photographs, they appear on a level with or above the landscape. They often stand with their hands on their hips, as if to say: "We're in charge here," or "What can we use this for?"

With O'Sullivan we walk steadily through a landscape that has no pretense to being pretty or romantic, an aesthetic already well established in his Civil War work. When a figure appears in one of his photographs, he is often beneath and dominated by the view, sometimes even partially hidden or hard to find. Furthermore, Clarence King was a founding member of the

Society for the Advancement of Truth in Art, and proselytized the viewpoint that images of nature made by artists should be free of manipulation. O'Sullivan took his photographs under the direction of the geologist with an eye fixed firmly on the underlying forces and structures of the region—whether he was literally crawling underground with miners or climbing obscure ridges to document the unusual fracturing of rocks. There's no discerning now what O'Sullivan's aesthetics were, and whether or not he considered himself to be a scientific documentarian or an artist. He did have, reportedly, a large ego, and the rephotographic work has proven that he was not above tilting his camera to isolate the evidence of geological process—but it always seems to be in service of the land itself, and not of a romantic creed. As a result, Klett and others find his work more genuinely poetic by contemporary standards than the more studied effects of Jackson's work.

It's also important to note that, although Wheeler showed O'Sullivan's photographs to Congress while in search of support, King's earlier survey had been funded for three years in advance. He didn't need scenic photographs to lobby for appropriations, and O'Sullivan was free to develop his landscape aesthetic as he saw fit, which he did increasingly as he was given greater and greater latitude by both leaders to wander and work at will. Wheeler, however, would bring his entire survey force to a halt for hours at a time to allow O'Sullivan to capture the right light in a photograph. It is hard to believe that Wheeler, ever the military man eager to force hard marches at the drop of a hat, would have been so accommodating in the service of art; it's more likely that he valued O'Sullivan's ability to capture powerful images that he could use to advocate for continuing his budget.

This web of histories—the intersecting tensions of science and art, the civilian and the military, through which landscape photography is woven—is very much on my mind this morning as we prepare to leave Tonopah. Klett earned his first college degree in geology from St. Lawrence University in New York in 1974, and during the next three summers worked for the USGS surveying the outback of Wyoming and Montana, an era when coal reserves were being mapped out for possible mining. Prior to graduating, he had even discovered a fossil during a geological survey in North Dakota. Mark Klett hasn't simply rephotographed the territory that King and O'Sullivan, as well as Hayden and Jackson, explored over a hundred years ago. He has participated in their tradition as a scientist and artist, but Klett's science is not stuck in the nineteenth century anymore than is his aesthetic. There's a reason that in his own work Klett often deliberately lets his shadow appear in the frame of the photograph, as did O'Sullivan occasionally. It's his way of saying: Don't take a photographer's frame of reference for granted. A photograph might look objective, even scientific, but it might not be the same picture you would make.

Where Jackson's photographic ego tries to persuade you that his view is the one and only and best reality, the works of O'Sullivan and Klett lead us somewhere else. As a contemporary photographer, Klett is always aware that our presence in notating the earth changes its reality, a postmodern sensibility that has roots as deep in quantum physics as in the classrooms of the Visual Studies Workshop in Rochester, where Klett received his Master of Fine Arts degree in 1977.

But this morning, after a sound but too-short sleep in the motel, the person I'm most

tempted to compare Klett to is that militarian Wheeler, who routinely forced his men on twenty-four-hour slogs through the desert. Stu's truck, the alarm for which will absolutely not shut up, is disabled. Mark is holding his hands over his ears, shaking his head, telling Stu we have to leave in order to capture the next photo, and trying to figure out how he can arrange to catch up with us. I have a premonition of Mr. Richard Stuart, formerly of Tempe, stretched out on the desert, one hand extended toward the horizon, the other clutching an empty canteen, steam wafting up from his Nissan Pathfinder which sits, its hood up, behind him in the distance.

Chapter Three

THIRD VIEW:
JULY 5ᵀᴴ: TONOPAH TO AUSTIN

The day didn't start out as a disaster. Despite the heavy motel curtains everyone still woke up at seven, and half an hour later we were all downstairs for breakfast. The plan was to take advantage of the room until checkout at eleven, then hit the road for Austin 116 miles to the north. Stu would keep trying to get our images and text to the Web site, which is hosted by a powerful computer known as a "server" at the Institute for Studies in the Arts on the ASU campus. Meanwhile, Byron would edit his sound recording of the swinging outhouse door, which will be posted on the Web site with a photo he took looking out the door. With this lonesome acoustic signature playing over and over again in the background, Mark would lock himself in the motel bathroom to wash his negatives from yesterday, which would then await printing upon his return to Tempe.

Back in the room—and before stretching out the clothesline in the bathroom he'll use for hanging the negatives while they dry—Mark put on the CD-ROM for me to review that they made from the Third View trip earlier in the summer to Colorado. He had read over my field notes written last night and was concerned they were a little too polished, a problem he thought pervaded the work from the previous year. The image that floated up on the CD was one of a leather-bound journal. Clicking through the pages was like turning the leaves of a very handsome twentieth-century imitation of a journal from the last century. I saw what he meant and promised to not belabor the prose too much.

Despite the slightly too slick design of the material, though, one feature of the CD-ROM captured the field experience so accurately it was spooky, a window you could float over any part of the photos, either the original O'Sullivan ones, or the Second and Third Views.

The window vignetted the corresponding section from another photo of your choice, any view overlaid on any other view, so you could skip from 1867 to 1997 and back to 1977, moving the cursor around as if it were a window into another time, an eerily accurate simulacrum of how we're shifting back and forth among views as we travel through the country. Part of the editing that we're doing on the road is not just for the Web site, but for what will be the CD-ROM from this trip. Exhibitions, books, Web site, CD-ROM—they will all be different ways of exploring the mental terrain we're constructing from the physical one. I shook my head, took notes, then went to help Toshi, who was draining meltwater out of the coolers and repacking them with fresh ice. It's a nice low-tech maintenance activity I could grasp without serious thought, and also a relatively cool one in the heat that was already gathering outside.

Finished with the coolers, Toshi and I rounded up a couple of shopping carts and started transferring computer equipment back downstairs. Byron left his sound editing reluctantly in order to unplug the thirty-plus cables connecting everything, then came down with us to repack the station wagon, a complicated problem in higher-dimensional mathematics.

This was what we were doing when Stu's truck alarm went off, a ululating siren that sounded like it belonged in a World War II air raid.

Stu turned off the ignition, rubbing furiously at his dark bushy goatee. "I don't get it," he said. "I had this thing disarmed before I left." He tried the ignition again and the banshee cranked up. Leaving the engine running, Stu hopped out of the truck and opened the hood, which of course made the sound even louder. He stuffed a T-shirt into the blaring mouthpiece. It didn't cut the sound at all.

"Where's your remote-control gizmo to turn it off?" I hollered.

"In Tempe," he yelled back. He reached into the cab and turned off the truck.

For the next hour he tried every conceivable combination of pulling wires and fuses to circumvent the alarm, which was so loud it was amazing that blood wasn't running out of his ears as he tested his options. When he finally gave up and yanked out the fuse for the alarm from underneath the dash, he inadvertently disabled the ignition. It seemed this was part of the alarm's function, a way of preventing thieves from hot-wiring the truck. Klett was circling the Nissan and rubbing his jaw, checking his watch. He knew we'd have to be in Austin no later than two o'clock if he was going to make a rephotograph today, and it was already quarter of twelve. While Stu went to call the Auto Club the rest of us headed over to the nearby market to stock up on food for dinner. When we drove back to the truck Stu was sitting in it with a disgusted look on his face.

"Someone's on his way," he says to Mark.

"Well, look, we don't know if he's going to be able to help you or not. You might have to get this thing towed back to Las Vegas, in which case you'll have to rent a car and catch up to us." Klett pulls out a road map and once again goes over how to find us. "Here's Austin and we'll be working in town. It's not a big place and you'll be able to see us. Kyle's supposed to be driving in from Colorado to meet us there, too, so don't worry. You'll both find us." He gives Stu his cell phone number. "Now listen, if it's getting toward dark, though, don't try and find us. We'll be camped off a dirt road somewhere in the mountains above town and you won't be able to see us. Just get a motel room or something and call. OK?"

No fuss, no muss, Klett just parses out our next move and our Webmeister nods. Born in Massachusetts, Stu took off after high school and drove to Arizona, sight unseen, to go to college. An accomplished carpenter and head of the scene shop for the ASU theater, he also owns and manages a small multimedia production company while he's getting an MFA in art. Stu is used to crises of stage and screen, and takes all this with equanimity, though he's mildly embarrassed by the flap his evil klaxon is causing.

We quickly repack the gear from his truck into the other two vehicles which, by the look of their sagging springs, is putting them over their theoretical load limits, then wave good-bye to Stu who's sitting in his truck with feet dangling out the door and twirling his sunglasses in one hand.

"This isn't going to work, you know," I predict to Klett. He shrugs.

"He'll figure it out." I wonder how many times King and O'Sullivan and Wheeler had to make decisions like this out here a hundred and thirty years go, splitting up their parties to accommodate circumstances such as broken wagon axles and low water supplies. Probably every other day—but with no towing service, cell phone, or iced drinks sitting in coolers.

To get from Tonopah to Austin you backtrack on the highway going east, then turn left into the Big Smoky Valley. Although crossed earlier by the legendary mountain man Jedediah Smith in 1827, it was named by Frémont in 1845, who was the first European to travel the length of the valley, a journey that took him three days, compared to what should be about ninety minutes for us. The nickname he was earning on that trip was, ironically, the name-

sake for Stu's truck model, the "Pathfinder." Frémont found a haze-filled valley bordered by the largest mountain ranges in what would, just over a decade later, become central Nevada. The Toiyabe Range to our left has one ridge that hangs above us at over 10,000 feet for fifty miles, parts of it still holding heavy cornices of snow from last winter, a snowline that culminates in Arc Dome at 11,788 feet. John Muir climbed the peak as part of the Transcontinental Triangulation Survey in 1887, which set up one of their heliotrope stations on the summit. Using mirrors to reflect sunlight, the government surveyors signaled to each other from peaks as far away as a hundred miles, part of an ambitious effort to measure the size of the earth. The idea was that Nevada was large and empty and high enough that they could measure it without interference from trees, buildings, weather, or much of anything else. Remnants of their cabin are still on the mountainside, but now Arc Dome is part of the largest wilderness area in Nevada.

Just seeing the snow up above helps us feel a little cooler down in the valley, where it's almost a hundred degrees out. We have the windows down, not running the air conditioning to save strain on the engine as we go as fast as we can up to Austin. Loaded down as we are, we're also thankful for the strong tail wind we've picked up.

To our right, and well within view of any backpackers who might be high above us on Arc Dome, is one of the larger gold mines in the world, a cyanide-leaching operation with an open pit 8,000 feet long, 7,200 feet wide, and descending more than 1,200 feet deep. The area has been mined since 1906 and has gone through an irregular series of escalating activities with ever-larger machinery. Using a system since 1991 that can move 135,000

tons of ore a day, the mining operation first leveled its namesake, Round Mountain, then excavated another cubic mile of dirt below grade. We start passing the displaced dirt, the tailings, at 628.9 on Mark's trip odometer, the newest piles of which are being added to even today, a Sunday, and pass the oldest ones, which have grass growing on them, at 632.3.

As we drive on and on past the funereal embankments of waste I ask Mark when he started working with computers. "I only started in 1988 or so, word processing on a Mac, not using images or anything until about four years ago when I was looking for another way to print images and got Photoshop. I realized the technology was getting close, but there wasn't enough affordable memory. In 1996 it all came together and I started working with digital images. But, you know, I'm still committed to making objects, to making prints."

The road makes a long s-curve, bending first northwest to Carver's, where the largest structure is a highway maintenance station, then recurving back north toward Highway 50. We're about halfway to Austin.

"In a way" continues Klett, "we're just doing what O'Sullivan did, working with the latest technology available. What I'd really like is to do a photographic book like *Second View,* but have a CD in the back."

"What other photographers do you admire?" It's a standard question to ask artists when interviewing them, but you never know what kind of response will come back. Some people have well-defined lists, but others resent the implication that they model their work after that of others.

"Well, . . ." Klett starts, then stops. "I go between liking a lot and then nothing. Linda

Connor—I like the way she composes space, the timelessness. And Robert Adams. Some Japanese photographers like Araki." He pauses again. "Sometimes I work more against what I see than with it. Mostly what I like is work that's engaged with the world and with layers of meaning, like Kienholz's sculptures, or what Helen and Newton Harrison do. I like strong conceptual and formal work—but for my own work I want an empirical basis, not an ideological one, something I can use my intuition with."

He turns quiet and I ponder the work of the Harrisons, former artists turned environmental engineers, who often propose modifications in the landscape as urban reclamation projects. Their work, as both conceptual documents to be exhibited and working plans for construction, includes unearthing historical land-use patterns, conducting research into local environmental conditions, and restoring the land as sculptural earthworks. Using photographs, text, cartographic overlays, and bulldozers, they create farms and wetlands as metaphorical settings where the collision of nature and culture can be made visible. They are neither exactly artists nor scientists—their works are both experiment and gesture. I say they are "former" artists because I'm not exactly sure, despite their institutional affiliation with the Visual Arts Department at the University of California San Diego, how to categorize their profession. In fact, what they may be doing is emulating more the spirit of the talented eighteenth-century dilettante than anyone professional. It's a valid pursuit and, as far as I'm concerned, as well housed in an art department as elsewhere—but they have raised the ire of more than a few critics and artists who dislike the radical confusion of disciplines, an opinion Klett has also had to face about his own work.

I'm happily making notes to myself when the truck quickly slows and then turns around so Mark can photograph a weathered billboard urging us to "Visit Historic Austin on the Loneliest Road in America." The sign is the only vertical element on the valley floor within miles and, as is typical in the Great Basin, the hyperbole is gently peeling in the harsh extremes of the desert weather. We have a way of trying to label the landscape out here, as if all the emptiness is just too great a temptation for a loud shout, which is what a billboard represents. No wonder Highway 50 isn't the loneliest road; if it ever was, it sure hasn't been since they've been advertising it so noisily.

Twenty minutes later at 2:00 P.M. we crest the 7,484-foot Austin Summit. To our left and right stretch the northern end of the Toiyabes, peaks which are surprisingly green for this time of year. Groves of aspen higher up flash their leaves, advertising an afternoon breeze. Ahead of us the road drops steeply down a 6 percent grade in a series of hairpin turns into Austin. Beyond that it's all open space to the next chain of mountains and the next beyond that, the Desatoya and Clan Alpine ranges standing above dry lakes that stretch out as white salt flats.

We're right at the time limit to make the first rephoto of town, and while waiting for Byron's station wagon to gasp its way to the top of the pass, Mark starts scanning the terrain for the likely vantage point. The Second View shot was taken by another team member, Gordon Bushaw, so he's not sure where we have to set up. Byron pulls up behind us and we start down the hairpins. It's a little disconcerting, the driver taking with one hand what turn out to be slightly declining radius turns, our tires protesting the ever-tightening

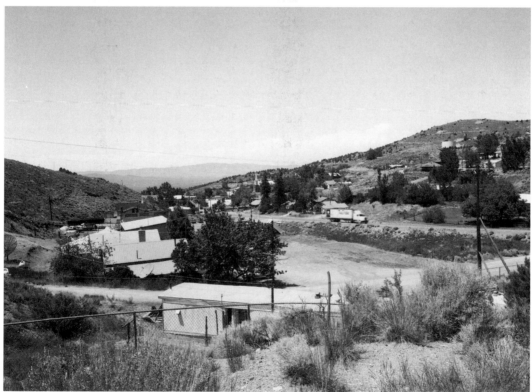

(Top left) Timothy O'Sullivan, *Reese River District looking down cañon,* 1867. Collection of the United States Geological Survey. (Top right) Gordon Bushaw for the Rephotographic Survey Project, *Austin, Nevada,* 1979. (Bottom) Mark Klett and Byron Wolfe for Third View, *Austin, Nevada,* 1998.

arcs, while semi-trailer trucks in the opposite lane hog much of the road out of necessity. The whole time Klett is glancing back and forth between the eight-by-ten black-and-white print in his other hand and the closest hillsides. He must be watching the road, too, because we make it to the edge of town in one piece. Without any fanfare Klett takes turns immediately into the city park, drives by an improbably green lawn surrounded by sagebrush, parks, then walks directly to the vantage point.

"How did you do that?" I ask, exasperated not so much by the driving as his ability to calculate mentally the vantage point out of an old photo, an ability as mysterious as if he were a bat echo locating a door in the dark.

"Well, I dunno," he says, shading his eyes with his hand, Byron bringing up the camera and tripod. They set to work immediately. "First of all, what we're really doing is rephotographing the Second View picture. This road, the town, it's changed a lot since O'Sullivan, but not so much since Gordy Bushaw shot here in 1979. See the church over there with the white spire? And then that other church and spire? See how they line up with the ridgeline . . . ?"

I do, indeed, see all those things in both the photograph and the town; looking at the O'Sullivan picture in the copy of *Second View,* the book we carry with us for reference. I can even spot one of the church spires there. But I still don't understand how he found it on the fly. "Practice," he grunts, mounting the camera onto the tripod. By 2:20 he's disappeared under the black T-shirt. "Shadows are a little later, but not much. Doesn't look like a lot has changed; the trees are a little bigger." He backs away from camera, picks up the tripod, moves a few inches back and left, takes a test shot and compares the results, frowns,

takes another look, moves the tripod, takes a test shot. It seems every time he presses the button on the cable release a semi-trailer truck just happens to be in the frame, pulling slowly uphill through town, until I realize he's doing it deliberately.

It's not just the scenery that's being rephotographed, but how what is going on in the landscape has changed. In O'Sullivan's time there were over a thousand mining claims being worked in this valley and on the hills. Austin was a boomtown. The current population is around three hundred. There look to be twice as many structures in the O'Sullivan's view as in the Second View or today's, though his is barren of trees and there must be at least a couple of hundred around town by now. Even with a magnifying glass it's difficult to find anyone in O'Sullivan's photo—are they all working in the silver mines?—and only a couple of wagons. Bushaw's view at least shows about a dozen trucks and cars—though still no people or evidence of movement.

The test shooting goes on for several minutes until Klett decides that Bushaw's camera was in the same line of sight but higher. He backs up behind a small sagebrush, extends the tripod head as high as it will go; he's still only seventy-five inches above the ground, and it looks like Bushaw must have been at least seventy-nine or so. He looks around for something to stand on, and Byron brings up our largest cooler, which has built-in wheels.

"This way we can have lunch, too!" Byron brightly declares. It's true, we've driven straight through in order to try and make the shot, and Byron must still be a growing boy. He has the most insistently voracious appetite of anyone I've met in a long while. Nonetheless, it's all talk. They keep working without a break. There's not much for me to do except keep an eye out for

Stu's silver-blue Pathfinder. Every now and then Mark checks the signal on his cell phone, but it's weak and there's no way to know if he can reach us from the other side of the mountains.

The breeze that was shaking the aspens up higher has now reached down to our elevation about nine hundred feet below the pass. Even though the air is light, the tripod is so overextended with the heavy camera on top that it's shaking, and Mark is worried that things will blur as he shoots.

I'm so busy watching for Stu that I don't pay much attention to the dark metallic green Toyota king-cab pickup until it noses up almost to the camera and a fit, deeply tanned, pleasant-looking guy in his late thirties pops out. It's Kyle Bajakian, the photographer who had been Mark's assistant for three years prior to Byron. He now works in Snowmass, Colorado, as the assistant director of the photography program at Anderson Ranch, a respected artist colony and conference center. The work stops momentarily as everyone shakes hands and I'm introduced, realizing that there's a friendly line of succession gathered here among Klett's graduate assistants.

The three photographers also share a heritage in common with O'Sullivan, and even Fox Talbot. Kyle received a Master's degree in photojournalism before he, like Byron, went on to earn an MFA under Klett. There always seems to be this mixture within Klett's circle, some objective correlative, like Byron's environmental sciences or Kyle's journalism or Mark's own geological studies, that balances with the supposedly more subjective making of art. I can't help but think this is also the nature of photography, which brings the outside through a lens and inside the geometrically formed room of the camera.

Mark and Byron go back to rephotographing what they can for the next forty-five minutes, and Kyle unpacks his sound-recording gear to capture the background noise from below our hillside perch, the soundtrack of a guy who has come out of his double-wide to cut up firewood with a chainsaw.

By 3:30 the shadows have moved so far that it's time to quit for the day. As they dismantle the camera and tripod, I scout around the edges of the crumbling concrete pad that sits immediately behind us. Surrounded by four metal pipes painted white with red stripes, and with conduits leading out of the ground with wires still dangling from them, I've been assuming it was some kind of platform for an electrical box. But, picking up a rectangular frame of clear Plexiglas and showing it to Mark and Byron, we discover that it bears aluminum plates on each side, one with "Property of U.S. Environmental Protection Agency" inked on it, the other with "Austin, Nevada, DOBSTA025, Route 11" stamped on the other. Now that we look around, we realize we've seen these kind of pipes before by the gas station in Rachel, where they surrounded a radiation-monitoring station; that's what, presumably, used to sit here.

We're a good 150 miles north of Pahute Mesa, the northwest corner of the Nevada Test Site where a huge bomb test was conducted in late 1968, and about 65 miles east of where the one bomb test was made in Nevada outside of the Test Site, Ground Zero Canyon outside of Fallon. I'm guessing this is one of, if not the, northernmost monitoring stations that was maintained in the state until recently. Even here, with no obvious military presence in sight, the effect of the army's incursions throughout the desert in the last century is pervasive.

Byron takes the plastic scrap and puts it with our other artifacts, and we retire to the park where an arbor over a picnic table offers some shade. We make a late lunch, then stretch out on the cool grass. It's not nearly as hot as it was in Tonopah and on the drive up here, but the sun has been intense all day. Despite constant slathering of SPF-30 sunscreen and wearing hats, we're all sunburned and it's only the second day of the trip. We're looking at topographical maps for Austin Pass, thinking about where we might camp tonight, when the cell phone rings. It's Stu, who's still in Austin at 5:55, way too far to make it here before dark—and in any case, the truck isn't exactly running at the moment.

Mark is raising his eyebrows. "You're kidding. You what? Unbelievable. When? OK." We're all sitting up in the grass, waiting for news. He puts away the phone.

"Well, they got the truck started and he made it as far as Carver's when it died. Maybe the alarm damaged his alternator or something. Anyway, he had to get towed back to Tonopah and he's left the truck parked at the Ford dealership where they can try to fix it tomorrow morning first thing. He's in a motel and still trying to get our stuff up on the Web, but there's some kind of problem with the server on campus." Mark pauses. "And he has the gas line for the stove, so we have to come up with an alternative for cooking dinner."

Toshi and I lie back down in the grass. Mark, Byron, and Kyle, who have all camped out together before, can figure it out.

Just after eight o'clock we're parked up in the piñon-juniper highlands around 7,000 feet. Three portable tables have been set up to define a kitchen, a fire is crackling, and the nightly

ritual consumption of liquids begins, a daily battle against the massive dehydration typical of life in the Great Basin. Juice, water, and bottled iced tea disappear by the gallon. Kyle gets out his garlic press to prepare condiments for the infamous Klett chili they'll cook over the spare stove he's brought from Colorado. Both he and Mark have elaborate wooden camp boxes they've built with numerous cubbies for utensils, dishes, pots and pans, spices, even dish towels. Byron sits on one of the coolers to carve out a long pointed stick from a branch. Mark breaks out the cans of draft Guinness stout we bought in Las Vegas at the supermarket, a sensible morale booster. Kyle, however, with no small flourish, takes out two glasses from his box and pours me a dram of single-malt whiskey from the Isle of Jura. This is, I decide, a man who travels in style.

A little over a half moon rises as the last of the day's light is twinkling off a repeater station far to the south. Just then the phone rings in the truck, where it's plugged into the cigarette-lighter socket. It's a totally incongruous sound given the remoteness of our campsite on a jeep track off a dirt road and miles from the highway, and we all laugh a little self-consciously, as if caught farting in an opera house. It's someone calling Mark from ASU, apologizing for the problems with the server, and saying that Stu should be able to phone everything in via modem by morning. Klett thanks him, says good-bye, and puts the phone back in the cab of the truck.

"I think what we should do tomorrow is get a couple of motel rooms in Austin, spend the day making the next rephotograph, and maybe even redoing the one we did today a little earlier in the day so it's closer to the light in the original. Stu should get here and by tomorrow night we'll have two more days of stuff to get up on the Web. I'd rather camp,

but . . . I think we need the time to catch up. We should be able to do this with a satellite dish, and not have to worry about finding good phone lines."

I think Klett's joking until Byron stops his carving to reply.

"We've been talking about that. I think by next summer we can do all this with just three of the G3 laptops and an uplink." I blink and take another sip of the scotch, remembering that rebels in Afghanistan use satellite phones with dishes no bigger than the tin dinner plates we'll be eating off of tonight to communicate with various leaders around the world. Why not? All Klett & Company are trying to do is connect a field project to the Internet the way a scientific party or military force would do it; this just happens to be a cultural expedition. King and Wheeler used messengers on horses to ferry back letters, journals, maps, and exposed glass plates, often losing the contents of the saddlebags to accidents of weather, thievery, and rugged terrain, not to mention hostile tribespeople.

In Tonopah the guys were complaining that the data compression algorithms they were using on the photo files were degrading the quality of the images, bleeding out the skies, deepening shadows, and deleting fine details. I'm not sure Mark would agree, but it's all a matter of noise-to-signal ratio and redundancy. O'Sullivan never sent all his plates out with one rider; as a result, we have photographs that survived, which we looked at today in the Second View book. Stu is trying to send up digital images fed directly from camera into computer—but Mark also has the hard negatives and Byron his 35mm QuickTime panoramas. The information survives in one form or another, which, I concede, is an odd way to think about art. No doubt it's the scotch.

It's after ten by the time we eat. Shortly thereafter Mark takes the stick that he and Byron have been taking turns carving all night long, finds a small clearing nearby, and pushes down the sharpened end into the ground. He draws a circle in the dirt around the two-foot-tall stick, which casts a distinct shadow in the bright moonlight, and everyone gathers.

"This," he announces, "is the stick game. And here's how it's played. Select a token of your choice and put it on the circle where you think the shadow of the stick will hit the ground when the sun first hits the stick."

That doesn't sound too hard, I figure, and dig in my pocket for a coin.

"Just remember," Klett adds, "the sun may come up behind a tree, so it's not necessarily where it rises. And you can't put anything on the ground that's too wide, either!"

Kyle stands with his head tilted back and arms outstretched east and west, taking a bearing from the North Star. The rest of us mill around the edge of the circle. Mark puts his piece down first, then Byron and Kyle. I think they're all too far south and put mine a good foot to the north. Toshi goes last.

"This is a game I invented with a friend who was a client on one of the photo workshops we run out in the desert. What this is about is paying attention to where we are." Klett is subdued, not exactly prayerful, but obviously respectful. It's a good way to end a day.

July 6th: Tonopah

This time Kyle is the first one up, making coffee by 6:30. He and Klett sleep in their

respective trucks, so while Byron and I are packing up our tents they set out cereal, bagels, cream cheese, and fruit for breakfast.

Klett has won the stick game, Toshi is second, and I'm farthest off. This is totally humiliating, I think to myself; we're in the Great Basin, my home ground, and I'm putting sunrise about where it would be if it were October here—or we were in Bogota during March, as Mark points out. I vow to do better tonight.

Mark and Byron will go to work on the second of the rephotographs; after taping the morning's work, Toshi and Kyle will go into town during the afternoon to interview people, as well as locate a place to stay. I'll wander at will.

"So Kyle, don't get into what you did in Colorado last summer. We don't want you being the journalist here." What Mark is saying is very much like what he was trying to explain to Stu in Logan about this work being less documentary in nature, and more like incidental context. "We're not looking for anything, but finding something. So, if you find an artifact from the radiation station and when you go into town maybe it comes up in a conversation—you're keyed into it. That's not the same as asking: 'What's it feel like to live next to the Test Site?' You'd get two different kinds of answers."

I write down in my notes that he's after the context not of the place, but of the process we're engaged in.

"It's about discovery," Kyle adds.

"Right," confirms Mark.

It take almost three hours to eat breakfast, repack the gear, clean up the campsite, and

64

drive back into town. Kyle leads the way at the site, slowly backing his truck into and slightly up the hillside on the other side of the road from where we were standing yesterday. The view that Mark rephotographed then was down canyon, over the houses and trees and into the Reese River Valley. This other view taken by O'Sullivan looks north and straight into the hills across town. In his photograph there are hundreds of individual scars on the hills—mines dug over every square yard of ground—and not a tree to be seen. In the center of the picture is a large mill building, one of three that were operating here at the time. In Bushaw's Second View there are a few tailing piles, a handful of buildings and trees, an exposed RV park across the highway, and road construction where the drive into the city park and our green lawn now exists. Today the RV park is screened by a line of cottonwoods and the piñon-juniper forest has crept steadily down from the mountains almost to the edge of town. A green baseball diamond sits between us and the highway, which is busy with the truck traffic that seems to stop only at nightfall. I wonder if it's a point of pride for the truckers to say that they've driven the Loneliest Road, then decide it probably has more to do with the growth of Ely on the eastern edge of the state.

The biggest change, as far as we're concerned, however, is that the actual ground from which the earlier photographs were taken no longer exists, scraped away when the road was widened recently. Klett is sitting on top of the pickup and directing Kyle into position. He gets close and asks for the camera and tripod, which Byron hands up, but after looking into the ground glass decides that he needs to go back a few inches. Three of us push the truck back by hand six inches. Then forward four. Back eight. Back another six, then another.

Forward six. This goes on for an hour as Klett lines up power lines and telephone poles with the horizon in the Second View photo. Bushaw was a high-school math teacher when he met Klett, and his calculations back-triangulating the vantage points, done in the days before hand-held calculators, are notoriously accurate. Klett is quite secure, therefore, in using the Second View photos to do the preliminary alignments, checking them against the O'Sullivan photos only after getting close. In between stints of putting my shoulder to the doorframe, I write up notes about the conversation I had with Kyle while riding down from camp this morning.

"I was Mark's student and assistant for five years, really close to him for the last three. I first saw him give a talk in Boston. I got a BA in English and Environmental Studies at the University of Vermont, and I was at Boston University getting a Master's in journalism and photojournalism. I worked as a newspaper and freelance photographer from 1990 through '92, took workshops, and was broadening my notion of the poetry of photography. When I saw Mark's stuff, saw what he was doing with the Water in the West project, documenting how water was used in the Phoenix area, I chose to go to ASU because of him. What he and the others in that project were doing—they were artists working toward journalism, and I was a photojournalist working toward art."

Kyle is telling me this as we're driving, once again, down through the hairpins; although he has both hands on the wheel, his gaze is as distracted from the road as Klett's had been.

"What Mark's doing now is reinventing himself and his work. His work in the last book,

Revealing Territory, it's so recognizably his. He's always saying to his students that an artist has to constantly reinvent himself, and that's what he's doing, trying to get beyond a look at the West that's completely ironical."

I finish my notes, realizing that Klett hasn't asked for the truck to be moved anytime during the last few minutes. Byron is handing up film to him.

"Did you get the vantage point?" I ask.

"Well, pretty close," Klett replies. "I've got most of the minor indicators lined up just right, but without the ground being the same . . . I just have to shoot so the major visual elements look right, even though I think the tilt of something isn't exactly the same. I've taken the science of this about as far as I can, so I'm fudging for art."

A small dust devil comes toward us, the morning erupting from dead calm into a miniature cyclone. Everyone hangs on to their gear, Mark on top of the truck with the camera vulnerable to every breeze. The whirlwind passes with its load of loose papers and tumbleweed. He's shooting at an eighth of a second, a slow exposure that gives him great depth of field with his lens stopped down to f/22. I remember that other photographers I've been with in the Great Basin buy really fast film so they can still shoot at 125th of a second or faster because of the wind that's always blowing, or threatening to, in the desert.

Mark shoots from 10:30 to 11:30, and I make a circuit of the vehicles counting up gear. We're toting eleven optical cameras and twelve lenses, four tripods, two each of digital still and video cameras and digital audio recorders, two laptop computers and two desktops, and more than fifty other miscellaneous altimeters, binoculars, headphones, microphones,

developing tanks, film holders, compasses, Zip and Jaz external drives, monitors, and yards and yards of cables and cords.

And four mid-sized Leatherman tools in everyone's belt. I feel left out. The tools are basically folding pliers with various knife blades, saws, screwdrivers, and tweezers that are tucked away in the handles, kind of a cross between a small toolbox and a Swiss Army knife. They use them for everything from carving the stick for our sunrise game to fixing lunch, from disarming Stu's car alarm to modifying camera mounts on the tripod. I think they're a throwback to the pocketknives of the last century. No doubt O'Sullivan would have been infinitely grateful for one. When I show the list to Mark over lunch at the Toiyabe Cafe in town, he estimates we're hauling around over $100,000 in equipment. Not counting the Leathermen.

As planned, the team splits up for the afternoon. Mark and Byron redo the shot from yesterday and pin down the shadows just a bit more precisely. If Klett has been "fudging for art," as he puts it, it certainly goes against his grain. Toshi and Kyle find a motel with good phone lines, book us two rooms, then wander the town looking for stories. Austin has two gas stations, three markets and three restaurants, four churches, and five bars. It's a town where the numerical priorities are ripe for anecdotal context. Mark finishes shooting at three, and we take the truck for a drive around the edges of town. After taking some pictures with the Mamiya of houses across town, and snapping shots out the window with the digital camera as he drives slowly through the neighborhoods and around one of the churches, we go back to the park and lock the hubs for climbing the steep dirt road up Central Hill.

The summit is a field of lupine, Indian paintbrush, and penstemon, bright blues, reds, and oranges highlighted in sunshine against the battleship gray thunderclouds building up to the west. Below us, Austin is a mixture of nineteenth-century brick buildings and double-wides with satellite dishes; from up here the late-blooming wild yellow roses that grow by many of the houses, a hallmark of the town, are invisible. Prowling the hilltop we stumble across a pit full of rusted paint cans; a few feet below is a bleached Coors carton. Two steps farther and it all becomes clear: we're standing on top of the large white "A" painted on the rocks. It's the traditional sign of civilization in the arid West, where language on the land can be read for miles, the capital first letter of the town name whitewashed on rocks above home. Seen from this vantage point, though, it's a rock art assemblage, a contemporary geoglyph, an architectural landscape element, and a shrine to those weekends in high school when you could climb a hill, drink beer with your friends, and paint the town.

The obsession is with frames, perhaps the overarching theme of art at the end of this century. We're eating dinner at the International Cafe, a block up from our motel, and Toshi is videotaping everyone's eating styles, which tonight range from American fork and knife for steak, Italian fork and spoon for pasta, and chopsticks for something that resembles Chinese food. After dinner we'll adjourn for another full night of computer work.

Stu—who a couple of hours earlier drove into the motel with his truck fixed and its alarm system ripped out from stem to stern—had, amazingly, gotten the Web site up and running with all the images and text he had on hand. Gesturing with utensils in hand, he describes

what people will see when they bring up the site, a random selection from one hundred images. The theory is, every time you get the site, you enter through an image you haven't seen before—a sense of discovery, in short.

That's one kind of frame. Driving back down Central Hill this afternoon, Mark stopped the truck, balanced improbably on a hill so steep it was hard to believe we weren't sliding down it regardless of the brakes, and took a picture through the windshield of crisscrossing dirt roads at the bottom of the hill. He was very careful to make sure that not only the frame of the windshield was in the picture, but also tried to see if he could get the rearview mirror in the shot as well. It was a typical Klett setup: a nonpicturesque view, inclusion of the vehicle from which he was shooting, and probably a glimpse of the artist and his camera. Another kind of framing.

How photography in the West got from the brutally descriptive photographs taken by O'Sullivan to the self-aware postmodern ironies of the late twentieth century has everything to do with how our uses of the land changed from exploration to exploitation, from irrigation to conservation, from cattle range to subdivision. And with how our view of reality overall has shifted from the carefully constructed, if mostly invisible, frame of scientific objectivity to the more obviously relativistic one of the museum's picture frame.

THE EVOLUTION OF LANDSCAPE PHOTOGRAPHY

Amerika in the nineteenth century was a society preoccupied with expansion, the growth of its population from both births and immigration driving the extension of its boundaries from the East to the West Coast, the increase of commerce, and a rising standard of personal wealth. During that century the entire human race worldwide doubled in number, but in America a population of just over five million people living within 868,000 square miles in 1800 had ballooned by 1900 to seventy-five million dispersed over three million square miles. Given such a history, it's understandable that our country remains obsessed with the numbers and nature of demography, the vital statistics that underlie our political representation, allocation of resources, and how we continually attempt to remake land into a series of landscapes suited to the purposes of that population. The overwhelming visual fact of our country is not the myth of an endless frontier, but the effect of population upon the land.

The culture of a society—its habits, concepts, arts, and sciences—simultaneously reflects, informs, and influences its people. Photography is no exception and, by virtue of its being a medium that originated during a time when both art and science were concerned with documenting and categorizing the world, it is arguably even more integral a part of the relationship than many other manifestations of culture. Part of the power of photography has to do with a simple fact of cognitive neuropsychology: 80 percent of everything we learn comes to us through our vision. Another part of it derives from the quantity of images to which we are exposed: between newspapers, magazines, books, billboards, and stills flashed on the television screen during news programs, we scan thousands of photographs every day.

In its infancy photography was declaimed to be the ultimate mirror of reality, "writing with light" in a dark room. Daguerre and Niépce stated that their works were, respectively, the spontaneous and automatic reproduction of nature as received in the camera obscura. The daguerreotype, because its exposures took so long, necessarily presented a very static but detailed reality, one well suited to the primary concerns of natural science at the time, the accurate observation and classification of the world. The idea that photography was the ultimate realistic medium was so widely adopted that it virtually drove by rhetorical force painters and sculptors away from representational styles and down the road to Impressionism and, eventually, abstraction (though the Dutch astronomer Christian Huygens already had declared in 1622 that, because of the camera obscura, painting was dead).

But photography was adopted also, within only a few years of its invention, by American businessmen and politicians for propaganda, who used it to promote everything from investing in mines to ticket sales for the railroads. In fact, the phrase, "to read a photograph," is an indication of how much power we have transferred from what was formerly our primary instrument of disseminating information—the text of books, journals, and signs—to the images that in the twentieth century at first augmented, and then replaced the letters, words, and sentences.

By the second half of the twentieth century, within a hundred years after O'Sullivan had started his apprenticeship with Brady, a deep cynicism regarding the veracity of the photographic image was in place. Partly this had to do with advances in science which, starting in the nineteenth century, showed how electricity, pressure, and drugs could produce the

sensation of light in the nervous system. Vision itself was not a physiological standard of objectivity produced solely by external illumination. The early twentieth-century discovery that light could be both wave and particle did nothing to shore up our belief in a monolithic visual reality. The chamber of the camera obscura, the body of the camera, lost its architectonic ability to awe us into automatic respect.

Further, as the advertising of consumer goods became the dominant financial force behind what were increasingly visual media at mid-century, most obviously television, our visual innocence was deconstructed by cultural and media critics, who analyzed how photographs and film could be used to manipulate our emotions and thoughts. The American quest for a hard-headed reality that could be quantified thus produced a dilemma for photography. If photographs could be used to sway public opinion on behalf of politics and commerce, and the results could be measured in public opinion polls and marketing surveys, the same numbers could be used to demonstrate how subjective were the vantage point of the photographer and the perceptions of the viewer.

Public trust in the ultimate veracity of photographic images was finally and unalterably changed—not destroyed, but certainly changed—with the advent of the computer and the ability digitally, flawlessly, seamlessly to remaster the image. No longer was light let into the sacred interior room to be fixed immutably on film; now it was captured by a hand-held computer, stored in memory, and manipulated at will. We now can look at, for instance, the color magazine photograph of a powerful sports utility vehicle perched improbably on a mountaintop, an image that is obviously falsified, yet so adept are we at discounting the

technique that we read through what has become a transparent manipulation—and are still motivated to buy the glorified pickup truck that we don't need. Nowhere is all of this more evident than in the evolution of photography and landscape imagery in America, the context within which Mark Klett does his work.

Photography of all kinds spread throughout the culture far faster than any would have thought as the fashionable studios of the professional daguerreotypists multiplied rapidly across the country, and in 1880 the technology became available for full-tone photographs to be printed simultaneously with text in books and magazines. At the same time the government and railroad companies spent millions of dollars (more money than spent on the surveys themselves) to publish lavishly illustrated reports of the expeditions, which were meant in no small part to encourage the exploding population of the eastern states to move west. Starting out first with engravings and lithographs reproducing the work of survey painters, such as Thomas Moran, then tipped in prints by photographers such as O'Sullivan and William H. Jackson, eventually the books became less scientific and more overtly promotional, using photography as proof of the habitability of the West. Photographers later commissioned directly by the railroad companies went so far as to include water as a noticeable feature of the landscape in each of their pictures, regardless of how arid the surrounding environment.

The next surge in the public's experience of the medium occurred when George Eastman introduced the Kodak camera in 1888. It was a simple box with a fixed-focus lens that sold

for $25; the price included a factory-loaded roll of film and processing for twelve pictures. The next year he changed the base of his film from paper to a clear plastic, making it possible for amateurs easily to develop their own film. Within half a century of its announcement to the public, photography had escaped from the purview of the wealthy expert to everyone in the middle class. According to a Kodak Company press release, the number of individual images taken in America by 1982 exceeded 10.5 billion. In 1998 Keith Davis, the director of the Hallmark Photographic Collection, put the annual figure at 17 billion snapshots.

Eastman declared there to be two classes of amateur photographers, the casual taker of memoranda and the "true" amateur who mastered all aspects of the art. This was a particularly pragmatic, American way of extending a distinction that had been argued in Europe since the 1850s. For the sake of brevity, and with full acknowledgment that the history of photography sometimes seems as convoluted and self-contradictory as that of physics during the same period, the essential question regarding art and photography can be summarized as follows: If photography is just an objective medium recording reality, or nature, how can it be art, an activity which we take to represent truths underlying the surface appearance of things? The question was compounded by the timing of photography's birth, when Western European artistic sensibilities were in the full sway of Romanticism, the proponents of which insisted that the genius of art began where scientific rules ended, and that artists could reveal more profound truths about the universe than could the mechanical engineers and scientists of the industrial revolution. That photography was a mechanical

(or chemical) art confused everyone, the artists and critics and public alike. To paraphrase John Szarkowski, the former director of the Department of Photography at the Museum of Modern Art in New York: is photography a mirror of reality or a window into the imagination? This conundrum is what photographers face as they endeavor to rescue the integrity of their images from absolute cynicism at the end of the twentieth century. It doesn't help that we now understand photography and science, both of which may have the appearance of being objective, to be embedded in the social conventions of the moment, to be frames which exclude data that don't appear to fit the picture.

In the 1840s, and in contrast to those photographers using the camera to document landscapes, architecture, and human likenesses, others considered the light as paint, camera as paintbrush, and film as canvas, and made allegorical daguerreotypes of historical reenactments and theatrical scenes. The photography wasn't itself exactly the art, but a set of tools used to document something that was. The following decade saw the rise of actual pictorialism, when photographers began to foray beyond painstakingly careful reproduction and into self-conscious manipulations aimed at reproducing the effects of paintings by the Romantic and Symbolist painters. Instead of lighting a subject to capture as accurately as possible its features, for example, the angle and intensity of the illumination would be altered for dramatic effect. The focus of the lens was softened, dropping details but adding atmosphere. The retouching of prints, and even occasionally of negatives, became commonplace, the latter causing a rabid controversy as it was tampering with what was seen to be the baseline of

a sacred objectivity. The print was only one of a series, but a negative was unique, and it was, therefore, heresy to doctor it, which might threaten the social consensus of reality itself.

Peter Henry Emerson, an Englishman trained as a physician, gave a lecture in 1886 to the Camera Club of London during which he proposed photography to be better than drawing and etching because it was absolutely accurate in its perspective, and second only to painting in the visual arts because it lacked color. He saw photography as a scientific art which should deliberately imitate how the human eye saw nature. He continued to lecture and publish textbooks, advising his students to use a soft focus, but avoid retouching as a clumsy and inferior technique. He reasoned that, because the human field of vision is not uniformly focused, the central area of the photograph should be clearly defined and the edges blurred.

One example by Emerson from 1888, "A Winter's Morning," which is reproduced in Beaumont Newhall's *The History of Photography* as "Pond in Winter," looks very much like something Currier and Ives might have produced; the viewer's eye skates across the foreground of the icy pond to land by a dark figure in center ground, which is framed by a dark tree thrusting its bare branches dramatically upward into the sky. Clearly built upon the conventions of European landscape painting from the 1600s onward, the picture entices the viewer to become reflective upon life and death, and the loneliness of the human spirit, and also upon structure and order in the natural world. Within three years of making "Pond in Winter," however, Emerson renounced his "naturalistic photography" and began to champion a style that accepted the technical limitations of the medium.

Peter Henry Emerson, *A Winter's Morning,* 1887. Photogravure, 7 x 11⅜ in. (17.8 x 28.9 cm). The J. Paul Getty Museum, Los Angeles.

A young American studying mechanical engineering in Berlin submitted photographs to an international contest judged by Emerson in 1887 and walked away with first prize. Emerson commended the photograph of Italian children gathered next to a fountain as being honest and without any artificial sense of composition. The student was Alfred Stieglitz, who upon his return to New York City in 1890 began to lay the groundwork for what we now categorize as modern photography. Working his way up through the field as editor of *The American Amateur Photographer,* and as vice-president of the Camera Club, Stieglitz had, before the turn of the century, established an international reputation for pushing technique. He considered experiments applied to the negative or print to be acceptable if they were in pursuit of an artistic end, but preferred "straight" photography, achieving his desired results by manipulating no more than lens, camera, and emulsion—an aesthetic very much in line with Emerson's revised notions.

Stieglitz held an exhibition in 1902 of like-minded art photographers, calling the movement "Photo-Secession." The founders included such notable artists as Eduard Steichen and Gertrude Käsebier. They loaned works from its collection around the world and published one of the most influential photography journals of all time, *Camera Work,* which ran from 1902 through 1917. The legendary gallery of the group, "291," is credited with bringing modern art, as well as art photography, to America. Steichen, then living in Paris, recommended Rodin and Matisse to Stieglitz, and other Europeans shown at the gallery included Cézanne, Picasso, and Braque. Among the Americans were painters such as Marin, Hartley, Dove, and O'Keeffe.

Stieglitz took portraits and street scenes, and photographed the buildings of New York, and, toward the end of his life, clouds by the hundreds, a series which he called *Equivalents,* indicating that the photograph were visual analogs for his thoughts and emotions. His photographs were steeped in lush blacks and grays, his luminous whites hovering within the slightly softened focus of the pictures, whether they were a shirt or a cloud. Stieglitz looked for what photography could do better than painting, where it could stand on its own aesthetic. He also stressed that fine art photography was more likely to be achieved by a professional than an amateur.

In the last issues of *Camera Work* Stieglitz published the work of Paul Strand, an artist who believed in utilizing the fullest range of tonal values possible to explore the medium—but not in trickery of any kind. Often credited with making the first abstract photographs in New York, and thus bringing modernism to photography in America, he also photographed both people and landscapes and was perhaps the first art-oriented modern photographer of note to work in the Southwest. Strand could isolate a picture of cups or rocks, the actual content didn't matter, and turn them equally into strict studies of form. Following closely on the heels of Stieglitz and Strand was a young California artist who attempted to raise the purity of unmanipulated images to the level of a Platonic ideal.

Born in 1886, Edward Weston made professional soft-focus portraits early in his career, but in the 1920s he began consciously to sharpen his images. He used an 8x10 view camera and printed contacts directly from the large negatives in order to preserve as much detail as possible. Weston attempted to previsualize completely the results beforehand and found

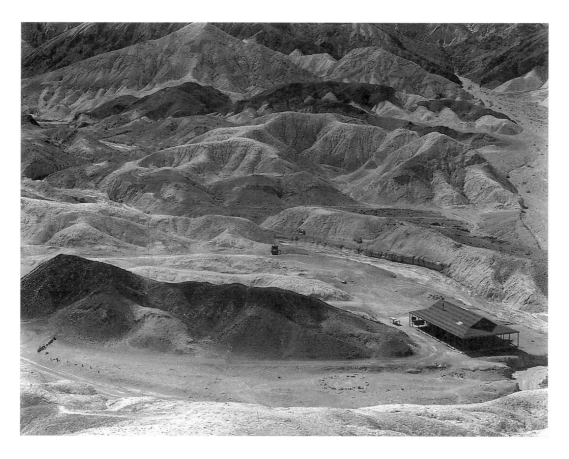

Edward Weston, *Old Bunk House, Twenty Mule Team Canyon, Death Valley,* 1938. Gelatin silver print, 18.8 x 23.9 cm. Collection of the Center for Creative Photography, Tucson. © 1981 by the Center for Creative Photography, Arizona Board of Regents.

a lens he could stop down to f/64, which gave him an immense depth of field in which everything from the farthest mountain to the dirt at his feet would be in focus. So much detail was compressed into the eighty square inches of his prints that the subjects, whether sand dunes or nudes, became too much for the eye to view as simple reality, and viewers tended automatically to elevate their contents into the category of abstract form. His working methods produced photographs of such preternatural and mesmerizing clarity that he found himself in 1932, along with fellow artists Imogen Cunningham and others, a charter member in a society that adopted the nomenclature of his lens for their name: "Group f/64," which that year held its first exhibition at the de Young Memorial Museum in San Francisco. Their stated aesthetic, based on Weston's and Strand's straight approach, was definitely antipictorialism, a final rejection of the soft focus considered to be an archaic holdover from the sentimental art of the Victorian era.

Weston was the first photographer to receive a coveted Guggenheim Fellowship, awarded in 1937 in response to his request to continue documenting the West. He used the funds to photograph in places as abstractly stark as Death Valley, and the results were published three years later in book form by the Automobile Association of America as *Seeing California with Edward Weston.* The purpose of the book was to promote tourism, the use of images by a credible fine art photographer, a person supposedly disinterested in mere commerce, being a traditional strategy western boosters used to buttress up public faith in the veracity of the images and the attractiveness of the region. The strategy was simply a continuation of the linear narratives into which photography had been shoehorned since the survey

photographers in order to promote commercial interests. Weston's crisp and formal pictures of Death Valley thus became more like reproductions in a museum catalog than direct evidence of danger in a hostile environment, a context which in fact suited the area's recent designation in 1933 as a national monument.

Among the members of f/64 was a trained musician, Ansel Adams, but before considering his remarkable influence on our perceptions of the American landscape in general, and of the West in particular, it would help to return to the work of the survey photographers as they documented the West. For with Adams the lines of their work and the modernist impulse come together to establish the trends and countertrends Klett navigates.

As early as 1845 photographers were making daguerreotype panoramas and stereographs of Niagara Falls for the viewing pleasures of the middle class, tourism in America for the most part still a privilege of the wealthy. The country was too large for anyone but the upper class to take the time, trouble, and expense needed to tour it, and photographs met the growing appetite of a population intensely curious about the national landscape, particularly the rumored wonders of the West. But, while O'Sullivan and Gardner were still photographing the Civil War, that need was being met by painters such as the German-trained Albert Bierstadt, who was painting his first big hit for eastern audiences in 1863. The oil painting entitled *The Rocky Mountains, Lander's Peak,* was a visual epic that measured six by ten feet and presented the West as a Romantic stage which could not fail to inspire acts of heroism, or at least imagined ones.

Bierstadt was painting out of a popular European aesthetic. His profound compression of lakes, waterfalls, glaciers, and cloud-shrouded peaks into a series of dizzying visual ascents was inspired by a widespread public desire to experience the sublime, where nature had been sculpted beyond the picturesque and into a realm both beautiful and terrifying in its scale and contrasts. Scenic climaxes such as the high peaks of the Rockies and the granite monoliths of Yosemite were world-class examples of the Romantic landscape. Much of our culture's visual representations for these peaks had been articulated earlier in paintings of the Swiss Alps; the surveys' need for photography in the West was another matter, however. Although Bierstadt used a stereoscopic camera in the field to take photographs as visual aids for his work, he deliberately foreshortened his horizontal depth of field (the pragmatic ground of civilization) in order to accentuate the vertical (the more spiritual realm of the distant peaks). Bierstadt's large landscape paintings thus tend to be more fiction than fact. The leaders of the four great surveys sometimes justified the cost of hiring and equipping their photographers to the government by saying the medium was a sober and scientific tonic to the exaggerations made by painters such as Bierstadt.

The surveys, though, were simply exchanging one agenda for another. Landscape photography in the West has always had a political dimension to it, even when it was ostensibly confined to documenting geological strata. Most of the notable mid-nineteenth-century landscape photography was funded first by the government surveys, which were sent out in response to corporate pressures to locate and develop mineral interests (hence the origin of the name of the U.S. Geological Survey). When the era of the great surveys was over, the

railroad and mining companies themselves took up the job. The same images by William Bell and O'Sullivan taken for the Wheeler Survey in the early 1870s, for instance, which were reproduced at first only in government reports, were soon arranged into more marketable books as narratives with extensive captions praising the opportunities for economic development in the region. O'Sullivan's mentor, Alexander Gardner, produced an album in 1867 of 127 pictures along the route proposed by the Kansas Pacific in order to sell stock to investors and to build a passenger base. A. J. Russell did the same for the more northerly route taken by the Union Pacific.

The central fact of the West in the nineteenth century was perceived to be space, a vast and unpeopled territory. Despite the presence of Native Americans, trappers, miners, and other precursors, the perception was an illusion created at least in part by the photographers. The space was presented as both natural and symbolic, a wide-open environment that seemingly required massive feats of human engineering in response, and one that appeared physically to embody a democracy based on an ever-expanding economic horizon. And, despite direct evidence in some of the photographs, particularly those by O'Sullivan and Gardner, that the West was a territory primarily devoid of water, trees, and natural forage, government agencies and developers carefully framed their pictures with captions that effusively praised the agricultural potential of the region. They led people to see the space as one where they could breathe free and build a self-sufficient life away from the squalor and constraints of the eastern cities. The reality they faced upon settling in the region was at harsh variance with such optimism, a dissonance that seeded what has become the westerner's traditional

distrust of government, and perhaps contributed to our society's eventual distrust of photographs—even though the pictures by themselves, for the most part, did not lie.

At the time the most photographed city of the West, and perhaps of the entire country, was San Francisco. It was not only the country's gateway to trade with the Far East, but also our first mining town of any size. Its hills with their neatly arrayed houses looking down upon the bay were tremendously photogenic, and the business community had a vested interest in presenting the city to easterners as an attractive place for investments. Among the many professional photographers working in the city was Carleton E. Watkins, who had moved there from New York. A boyhood friend of railroad magnate Collis Huntington, Watkins first traveled to California in 1851 to work in the tycoon's Sacramento store. After moving to San Francisco and apprenticing himself to the city's most successful daguerreotypist, Robert Vance, he opened his own studio in 1856. The earliest known Watkins photograph was taken in 1858 to settle a land claim for a mercury mine in San Jose. In 1860 he was photographing Frémont's Mariposa gold mine in order to provide proof of its productivity for investors.

Not far away from the mines was Yosemite Valley, where Watkins forayed the following year, producing views that Bierstadt would see at the Goupil Art Gallery in New York, which would inspire him, in turn, to visit Yosemite in 1863. Watkins had a particularly rigorous, some say almost geometrical, way of organizing space in his photographs. His panoramas of Yosemite display a hard-edged grandeur equal to, but utterly different from, the golden atmospheric tones of a Bierstadt. The photographs helped persuade President Lincoln to declare the valley a preserve for public use, an action that led to the establishment of the

national parks system, and one of the earliest instances when the landscape of the American West was acknowledged by politicians to have a symbolic value that was apart from resource extraction. Although concern was already growing across the country that the overdevelopment of land would necessitate some preservation of open spaces, in a way the national park system was also America's way of saying it was confident enough of its economic successes in the West to set aside climactic scenery just for the pleasure of the public.

Watkins went on to photograph Yosemite for Whitney's California State Geological Survey, and King hired him to fill in for O'Sullivan during an absence from his survey in 1870. He photographed the railroad route to Tucson, the early agribusiness of Kern County, and the Comstock mining district in Nevada. In many ways his career paralleled that of Jackson and O'Sullivan, and he served many of the same commercial and political interests of the time. But he stayed in one place longer as a photographer than did Jackson, and he lived longer than O'Sullivan. This enabled him to produce what today some consider to be his most prominent works, the California mining photographs.

In both a startling contrast and similarity to Watkins's large-format prints of the scenic valley, which he sold through his Yosemite Gallery in San Francisco, he turned that same unsentimental gaze for decades on the hydraulic gold-mining operations of the Sierra foothills. While Yosemite Valley prospered from increasingly favorable public attention as a protected place, the industrial sublime of the mining operations was losing its charm. The destructive power of the hydraulic monitors—immense jets of nozzle-guided water used to wash down entire mountainsides in the quest for gold—became inescapably repugnant to the

public. The jets smashed into and drowned workers, while the runoff silted up the Sacramento River delta and ruined the downstream fishing industry.

In 1860 Watkins was photographing to create, in essence, propaganda for Frémont's mine, which failed soon thereafter, but by 1870 his famous photograph of the Malakoff Diggins gold works had achieved a peculiar ambivalence. Huge streams of water jet in from both sides, arcing behind a slightly curved log that has been dragged into the center of the lower foreground to frame the action with a resonant shape. Almost invisible are two miners, one on each of the far sides of the picture by the nozzles. Three more tiny figures are placed in the center of the scene, just in front of where the blasting streams of water pour toward the base of a waterfall that flows out of the forest and over the edge of the excavation.

Even ignoring the filter of our contemporary sensibilities, which leads us to read the picture as describing environmental rape before economic development, it's obvious that Watkins isn't pulling any punches. The fierce and formal organization of the visual elements does nothing to soften the impact that the hydraulic mining is having on the land. The barren scene is one of a landscape condemned. His final mining photographs made in the 1890s are troubling portraits of the industrial sublime, where machines and engineering assemblages, not the grand works of nature, inspire a deep unease. Working as a survey photographer, but also billed as an artist with a gallery, Watkins began, perhaps, to prefigure the movement of photographers away from corporate sponsorship in support of the exploitation of natural resources, to what will become their work on behalf of preservation a few decades later in the twentieth century.

Carleton E. Watkins, *Malakoff Diggins, North Bloomfield, Nevada County, California,* c. 1871. Albumen print, 15¾ x 20⅝ in. (40.01 x 52.39 cm). San Francisco Museum of Modern Art. Purchased through a gift of the Judy Kay Memorial Fund. Photo credit: Ben Blackwell.

Ansel Adams grew up in a house overlooking the San Francisco Bay. Born in 1902, he was raised in a family whose father was a devotee of Ralph Waldo Emerson and a dedicated amateur scientist. Adams was a hyperactive child who had great difficulty in school; he was also a prodigy who taught himself to play the piano when he was twelve years old, a discipline he practiced nearly to the point of becoming a concert pianist. In 1916 the fourteen-year-old Adams convinced his father to take the family on a vacation to Yosemite (a place he continued to visit every year until he died sixty-eight years later), and Adams took his first photographs there that summer with his father's Kodak box camera. In 1920 he spent the first of four summers as caretaker for the Sierra Club's headquarters in the valley. One of his very few surviving photographs from the period is a typically fuzzy pictorialist view of the forest, "Lodgepole Pines, Lyell Fork of the Merced River," which bears a resemblance to an early Steichen photograph from 1899, "The Frost-Covered Pond," both of them stylistic descendants of Emerson's "A Winter's Morning."

As the young Adams experimented with various photographic techniques in and out of the darkroom, he soon began to drift away from the pictorialist aesthetic for a more direct and optically accurate style, but one which used dramatic natural lighting to reveal his subjects. In early 1927, while taking the final photographs for his first portfolio, "Parmelian Prints of the High Sierras," Adams found a conceptual breakthrough. Climbing at midday to a vantage point from which to photograph the great northwest face of Half Dome, he waited for sunlight to come around its southern shoulder to illuminate the granite, and thought about how the picture was going to come out.

After taking one shot with his customary yellow filter, he realized that the sky would appear as a medium gray without a great deal of contrast to the granite mass; working quickly with his one remaining plate, he replaced the yellow filter with a red one and made what has since become one of our signature images of Yosemite, "Monolith, the Face of Half Dome." The heightened tonal values of the negative push the viewer's attention away from both the white snowfield in the lower left and what is now a black sky in the upper left. The cyc is forced to ascend the immense vertical striations of the granite, producing a palpable sense of elation. Adams had made a picture of the natural sublime unlike any before him, but it wasn't exactly a matter of realism. By visualizing beforehand not just how a photograph might appear, but how he wanted it to turn out, he used photography to fulfill his imagination. To Adams, this wasn't just a technical leap, but an intellectual one: he was photographing an idea, not merely physical reality. The results were optically correct, but not as the naked eye would see the landscape. This preconceptualization would dominate his work for the rest of his life and was a method he attempted to codify in books as his "zone system" for the thousands of photographers eager to obtain similar results.

The next year he held a one-person exhibition at the Sierra Club in San Francisco, the first of the more than five hundred shows in which his pictures appeared during his lifetime. In 1929 he traveled to Taos, New Mexico, to collaborate with the writer Mary Austin on a book. While there he met the modernist painters Georgia O'Keeffe and John Marin. He returned the following year to complete his work, this time meeting Paul Strand, who had a decisive influence on his life. Looking over the older man's negatives, talking about

photography and Strand's friend Alfred Stieglitz, Adams realized he would have to give up his dream of being a concert pianist and devote his life full time to photography. He returned to San Francisco, opened a studio, and began accepting commercial work as a professional photographer.

Writing a column for a local paper, *The Fortnightly,* he reviewed a show in 1931 by Edward Weston, who became a lifelong friend. The next year the two men, along with their colleague Imogen Cunningham and others, formed Group f/64. Adams went to New York in 1933, where he finally met Stieglitz, the old master later giving him a show during 1936 at his gallery, An American Place. Adams, an avid mountaineer who owned one of the rare sets of albumen survey prints made by O'Sullivan, whom he considered a "topographical photographer" and not an artist, began to roam the West in search of material, and in 1941 took what has been labeled the most famous photographic image of all time, "Moonrise, Hernandez, New Mexico." It is a view that has become so sought after by amateur photographers that the inhabitants of the town erected a barrier so that the same vantage point could not be obtained and the photograph not be duplicated.

Adams made many brilliant and lyrical landscape photographs before 1941 and continued to take pictures of everything from industrial constructions to portraits, but "Moonrise" exemplifies the hallmark style of his epic photographs. It is composed with a series of horizontal bands that contrast light and dark—in this case a dark foreground, the white graveyard crosses of the middle ground catching the day's last rays of sunlight, the background of dark mountains outlined by white clouds behind them, and in the black of the sky, a low moon. The

eye cannot help but ascend his scenes. Adams makes us understand that, as John Szarkowski noted in his introduction to *Ansel Adams: Classic Images:* "the landscape is not only a place but an event." It was a strategy Bierstadt would have understood.

With "Moonrise" and the other images that followed—photographs such as "The Tetons and the Snake River" (1942), "Winter Sunrise, The Sierra Nevada" (1944), "Mount McKinley and Wonder Lake" (1947)—Adams fulfilled a role that Szarkowski saw as bridging two traditions. In his introduction to *Ansel Adams: Classic Images,* Szarkowski said: "He was perhaps the last important artist to describe the vestigial remnants of the aboriginal landscape in the confident belief that his subject was a representative part of the real world, rather than a great outdoor museum." Ansel Adams is where the visions of the survey photographers met the art of modernism. He matured as an artist just as offset printing technology made possible the dissemination of high-quality reproductions in books, and as the nation's universities were setting up post-WWII baby-boomer art departments. In addition, Adams worked late in his life and even employed an agent to promote these classic images. His followers became legion.

If landscape photography in the West always has its political dimension, then Adams's work is no exception. Elected to the board of directors of the Sierra Club in 1934, the photographer was sent to Washington, D.C. two years later to lobby for the establishment of the Kings Canyon National Park, using his photographs as prime evidence to help make the case, and thus beginning a long commitment to influencing public policymakers on behalf of the environmentalists. *This Is the American Earth* was, in 1960, the first exhibit-format

picture book released by the Sierra Club. Featuring photographs by Adams and text by Nancy Newhall, it was the beginning of a publishing program designed to sway the public in favor of preserving the remaining open spaces of the American landscape. By presenting forthrightly beautiful photographs of both the intimate and the epic scales of pristine wilderness lands, the Sierra Club hoped to show what would be lost if Americans continued to insist on unchecked development by a growing population.

The pictures of Ansel Adams are perhaps the last innocent landscape photographs. The problem was that, despite the attractiveness of his pictures, and those by other photographers presenting a natural world devoid of human presence—artists such as Philip Hyde and Eliot Porter, for example, who filled pages of magazine such as *Arizona Highways* with perfectly empty landscapes—everyone knew that the landscape didn't really look that way. The photographs were satisfying only at the most basic level of aesthetics; in terms of capturing a more complex reality, they definitely cropped out more than they included.

Landscapes, of course, aren't the only subject of photography. Eadweard Muybridge, for example, was led to photograph Yosemite when he saw the photographs of Watkins, but we remember him more for his studies of a galloping horse made in 1878. George Eastman was wandering the decks of a steamship and snapping pictures of fellow passengers with a Kodak in 1890, and Atget started documenting the streets of Paris in 1898. When straight photography became acceptable, and film and cameras became advanced enough to capture action in the streets, the primary concern of mainstream photography turned to documenting the human condition. Lewis Hine photographed the plight of child laborers and

emigrants on Ellis Island, presenting his images as overtly subjective, but nonetheless potent enough to force changes in the social system. Dorothea Lange, a close friend of Ansel Adams, captured the misery of migrant farmers during the Dust Bowl years, and Henri Cartier-Bresson took a 35mm Leica throughout the streets of Europe. At some point documentary realism was bound to collide with the arcadian idealism to which Ansel Adams and others had taken the landscape. This would be a somewhat ironic turn of events, as O'Sullivan's work, both the Civil War and survey photographs, were primary examples of documentary photography. O'Sullivan's work had fallen into near total obscurity from which he was rescued only when an admirer—Ansel Adams—brought his work to the attention of Beaumont Newhall at the Museum of Modern Art.

To take just one example of how conflicted the objectivity of photography had become to the American public, of how contradictory could be what was left in the frame or excluded, look at two images from the Vietnam War published at the end of the same decade as the Sierra Club book. In 1969, photos provided by the American government show a victorious U.S. Army pursuing and capturing the Viet Cong, while an image by Robert Haeberle shows the terrified faces of women and children about to be shot at the My Lai massacre.

It is a bittersweet fact that two of Ansel Adams's most famous landscapes, "Mount Williamson" and "Winter Sunrise" were taken in 1944 from near Manzanar in the Owens Valley of California, where he was documenting the internment of the Japanese Americans during the war. Although Adams was anxious to be part of the war effort, and taught photography to army officers, he was also disturbed by the internment and published a powerful

book about the dismal situation, *Born Free and Equal.* How different his work and influence might have been, for better or worse, had he more often admitted into his landscape work the evidence of human interaction with the land. But then, Adams was himself a living embodiment of how contradictions would shape what would become known as the postmodern sensibility. While vigorously supporting the preservation of wilderness, he was turning out images commissioned by Kodak to promote tourism to national parks, and by Kennecott Mining to praise open-pit mining in the West.

Confronted by contradictory photographs, human beings do what they often do to resolve awkward and sometimes ambiguous moral evidence: they resort to irony, where the obvious or intended meaning of one thing becomes its opposite, a way of making the very medium itself visible by exposing the contradictions, which becomes in turn the actual subject matter. It's part of what defines postmodernism. By the 1970s work from the straight documentarians was beginning to influence a new generation of landscape photographers, and it was another Adams, Robert, who began to weave this remaining strand back into the landscape photography of the West. Appropriately enough, he titled his first book *The New West: Landscapes Along the Colorado Front Range.* Published in 1974 it, too, featured an introduction by Szarkowski.

A dark foreground band, a lit middle ground, the silhouettes of dark mountains in the background thrown up against a contrasting sky. . . . It might be a variation on "Moonrise," except the bright middle band in the photograph "Motel" (1970) by Robert Adams consisted

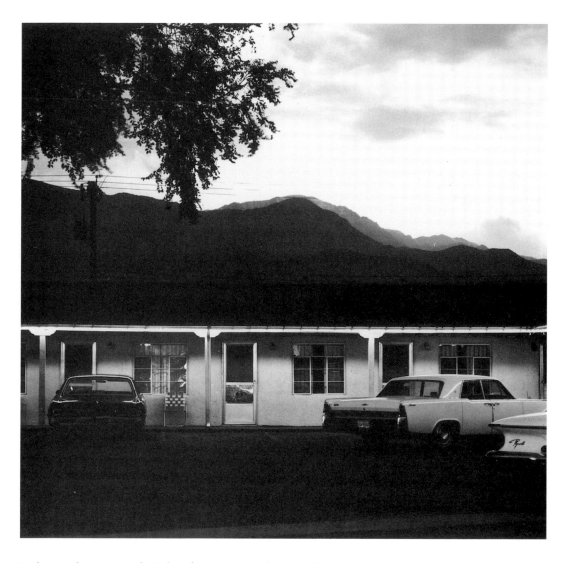

Robert Adams, *Motel, Colorado Springs, Colorado,* 1970. Courtesy of the Fraenkel Gallery, San Francisco.

of a neon-lit façade. The scene was still beautiful in its own vernacular way, but it was no longer Edenic.

Photographing off Interstate 25, Robert Adams found two telephone poles to frame a dirt road on the left, and on the right a "For Sale" sign. In a variation from another spot along the freeway stood a single tree in a field of weeds and wind-blown trash. This was now a West where nature was so severely circumscribed by development that the national parklands began to look like eccentricities in a vitrine. Robert Adams was relentlessly documenting what stands between us and the scenic climax of the Rocky Mountains, a suburbanism that not only swallowed agricultural fields and clear sightlines, but also devalued the idea that the built environment could even be well designed.

Along with the work of several other photographers, his *New West* photographs were included in an important show in 1975 at the George Eastman House in Rochester, New York. Playing deliberately off the title of the U.S. Army Corps of Topographical Engineers—the original nineteenth-century survey arm of the government responsible for exploring and charting the West—*New Topographics: Photographs of a Man-Altered Landscape* curator Bill Jenkins brought together work by ten contemporary artists who used a documentary style so neutral in emotional values that it was almost anthropological. It included photographers such as Bernd and Hilda Becher doing straight-on portraits of water towers and Lewis Baltz prowling around the sterile edges of industrial parks in Irvine, California. The artists tended to work in series, making it obvious that the human interventions were repetitive, pervasive, and devoid of imagination. Unlike the photographers of the previous century

who pictured the layered progression of geological time, they made aggregate portraits of an entropic world bulldozed into chaos by a society that was busy tearing up the landscape and replacing it with built forms completely out of context with the environment. Robert Adams's photographs of tract houses featured plastic flamingos by the front door—no more and no less out of place in Colorado than would be their live brethren.

Adams's work in the *New West* series, and later in the book *From the Missouri West* (1980), which features prints very much in the middle gray tonal scale, has a compositional formality which frankly acknowledges the banality of the subject matter while lending a hard-lit elegance to pictures of bulldozed waterholes and quarried mesa tops. The photographer acknowledges that he admires the work of both O'Sullivan and Dorothea Lange, and that his work has in common with historical landscape paintings the need to find order within an incoherent landscape. This order, though, is not anything he thinks that can be documented directly, but only suggested by visual metaphors. The tracks left by the earth-moving machines may appear totally random, for instance, but we read a purpose behind the behavior, and understand them to be part of a long-standing pattern of resource extraction in the West.

Robert Adams is working in distinct counterpoint to Ansel Adams, Eliot Porter, and Philip Hyde, who took their roles as photographers to hold up exemplary examples of landscape and let nature speak for itself. Even Philip Hyde, who has strived mightily for decades to exclude human beings and their traces from his pictures, now admits that the pristine desert he seeks is almost totally compromised by development and the military, the latter having

taken over increasingly large tracts of land in the West for exercising their armaments. It's not that Robert Adams thinks we shouldn't have such examples of pure nature, but he now considers such photographs, and the exhibit-format Sierra Club books, as relics of a landscape that has mostly disappeared from common view.

Another person in the *New Topographics* exhibition is an artist who contemporary Europeans take to be the paragon of the revisionist landscape photographers, Lewis Baltz. Starting with his series *Tract Houses* (1969–71) and into *The New Industrial Parks Near Irvine, California* (1974–75), Baltz established himself as a master at moving both his camera to the edge of urban creep and his vantage point to the edge of what a viewer can handle in a photograph. The works are so unblinking, and so perfectly poised on the point of their own blandness, that they demand a reordering of perception. Look at a Baltz photograph of a prefabricated tilt-up concrete slab warehouse and you will never pass one again without being aware of how it is placed within, yet manages to dominate, its surroundings by virtue of its generic nature. In *Park City* (1978–80), Baltz photographed over time the construction of a suburb high in the Utah mountains. The series moves through a panorama of the landscape prior to construction, a place already mangled by mining in the 1800s, its reshaping into lots, and then finally the construction of houses and condominiums styled from Cape Cod to Tudor. As if this bizarre collection of exterior styles weren't enough, he continues inside the houses where a newly installed bathtub floats in a well of naked drywall, and a room just textured awaits its coat of paint, the abstract patterns of the spackling a claustrophobic wallpaper.

In sum, the survey photographers in the West documented what was an arid land and fostered the perception of it as being a relatively empty space. Their works were shuffled by corporate interests into a context that encouraged the expanding population to move westward and develop the land. But as the western territories filled up, photographers used their works to encourage preservation of relatively pristine landscapes. Following the baby boom after World War II and the accelerating pace of development in the West, they were forced by suburban sprawl and an increasingly media-savvy public to acknowledge the wholesale loss of nature to the cultural landscape. They did so by refusing to excise what humans placed in front of, around, and in the wilderness, no matter how ugly or commonplace—a photography that examines its own role in how we construct reality.

Irony is a difficult ground to stand on, as it keeps shifting, and both Robert Adams and Mark Klett have called for the necessity of an art that moves beyond irony, that doesn't settle for easy visual puns and the one-tricksmanship that documentary, or social landscape photography can fall into, a tendency of which the Third View team is all too aware.

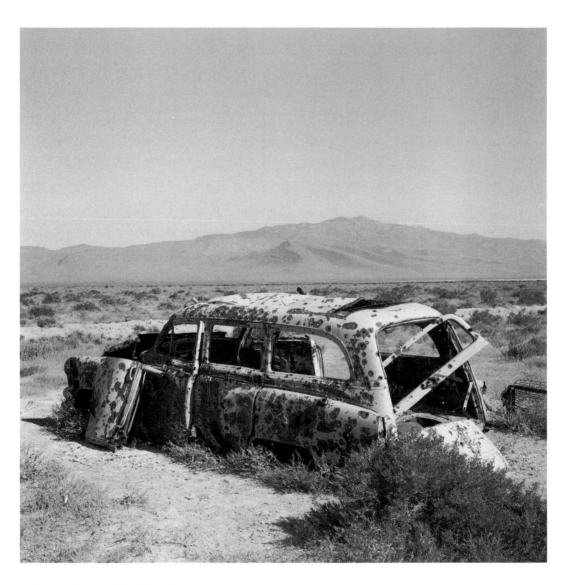

Kyle Bajakian, *The Cheetah*, 1998.

Chapter Five

THIRD VIEW: JULY 7TH: DIXIE VALLEY AND THE FORTY MILE DESERT

It is truly blistering at the northern end of Dixie Valley. Behind me is a set of hot springs that O'Sullivan photographed in 1868, a classic "desolation" shot. In the left foreground of the picture one of his portable darkroom cases is set up; in the center middle ground his wagon is hitched up to a quartet of patient mules, the rig positioned in front of the five hot springs. The background of the valley recedes into a white haze without a single vertical to disrupt it. It's obvious that human presence therein was overwhelmed by both the scope of the view and the implied threat of underground geothermal activity.

Today, as in Gordy Bushaw's Second View rephotograph, a dignified cottonwood survives on seepage from the springs, which themselves are now diminished in number and size from O'Sullivan's time. Lush dark tule reeds rim the small ponds and there's a line of green sagebrush leading downhill for a few yards, indicating subsurface water. It's two in the afternoon; Byron and Mark are on a hillside above and behind me at O'Sullivan's vantage point, and I'm left behind to guard the two vehicles and computers. The land we're on is fenced, posted Private Property, presumably belonging to the owner of the small ranch that's visible about a half-mile down the valley. Normally we'd seek permission before entering a private area, but no vehicles were parked in front of the low house, which looked to be pretty tightly buttoned up, so we just went for it. But, it's so hot we can't lock up the computers in closed cars, and it's wisest to leave someone to answer any questions if the rancher returns. I hide behind the lip of one of the dry fumaroles, trying to stay out of the photographs being taken, and pull off my T-shirt. A large collared lizard runs by, his attention more on the dragonflies than on me.

Thunderstorms are building up on three sides, though none are nearby. To the south the sky is clear, the valley nowhere near as hazy as when O'Sullivan passed through, and Fairview Peak is visible sixty miles to the south. Only nine miles down the valley, and just on the other side of the Fortieth Parallel, are the faint outlines of a huge geothermal plant shimmering in the heat. Its presence may signal one of the reasons why the springs here are drying up, as the operation diverts the groundwater.

Despite the maps, atlas, and GPS unit, puzzling our way here took so much wandering around on dirt roads that we were almost too late to make the rephoto. Much of the west side of Dixie Valley is scarred by a crumbling brown cliff over ten feet high caused by an earthquake fault that slipped in 1954, an indication of how geologically active the area remains. Geothermal springs in the valley number in the dozens, and finding the same ones that O'Sullivan photographed took patience. Now I'm worrying about whether or not Kyle, Stu, and Toshi, who went into Fallon for supplies, will be able to follows our cairns and notes we've left along the way.

Getting up in Austin at six this morning, Byron went to work loading yesterday's rephotographs into one of the computers, relinquishing his chair only when the rest of us started out the door for breakfast back at the International Cafe. He compromised by taking the G3 laptop with him so he and Stu could fuss with how the Web site could be revised so it's less formal and hierarchical. Over pancakes, eggs, bacon, toast, and gallons of orange juice and coffee, the group decided to split up in order to squeeze in the next rephotograph, "Hot

Springs in Dixie Valley," while restocking the coolers at a supermarket. Kyle would also thus be able to scout out the sites in Fallon that we would be rephotographing a couple days later. The only catch was that Mark had only a vague idea of where we would camp tonight, probably somewhere off the dirt road leading west from Dixie Valley toward Lovelock. And he wasn't quite sure we could make the trip today and into Lovelock tomorrow morning on only one tank of gas.

"We'll leave cairns for you," he'd said. "Let's stay together until we reach the turnoff from Highway 50. Just make sure you leave Fallon in plenty of time to reach the pass before dark so you can find us. And maybe bring some full gas cans. We'll have the cell phone in case anything happens, but if you don't make it, it'll throw off the work for the next couple of days."

"No problem," Kyle replied. By ten o'clock we were checked out of the motel, had topped off the gas tanks, and were rolling down into the Reese River Valley. Designating the trickle that runs through the valley as a river is an infamous joke. Despite the fact that you can cross it in one stride at any time, save during the occasional flood, in the 1860s swindlers sold stock in the Reese River Navigation Company, counting on the fact that maps of the time represented it as a substantial tributary of the Humboldt River to the north. The Humboldt itself barely qualifies as a river, much less the streams that feed into it.

This morning the valley had been inhabited mostly by the slowly drifting shadows of clouds, which Mark commented on several times, caused by a quilt-like pattern of stratocumulus in the middle atmosphere that hadn't yet consolidated into thunderheads. The big views down the valley and the straight road without any traffic opened up Klett's memory.

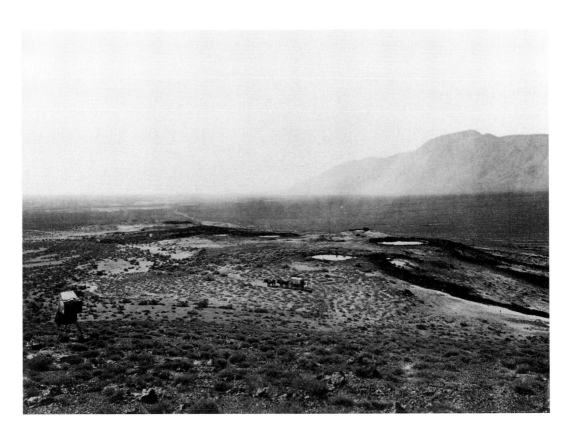

Timothy O'Sullivan, *Hot Springs, Smokey Valley,* 1868. Collection of the United States Geological Survey.

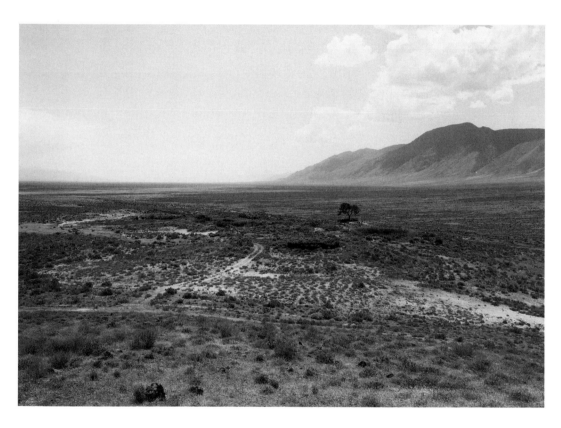

Mark Klett and Byron Wolfe for Third View, *Hot Springs in Dixie Valley, Nevada,* 1998.

"Twenty years ago we couldn't have afforded to stay in motels like we did last night. We used to load film in the trucks after dark, putting cloths over the windows." He was driving with one hand on the steering wheel, window down, his other arm draped on the door, which he then used to gesture at the view with an open palm. "Nevada's great, still unpopulated, not screwed up. The West is closing in on this kind of territory. When I was a kid our family would drive every other year from Albany clear across the country in our station wagon. We'd stop in Reno and I loved it—the rules were different in Nevada. I hate it when they fence in the land, when it gets all carved up into private property, like it is in New Mexico, and you can't just pull over to take a picture or camp." He sighed. "On the other hand, that's what interests me, the interaction between people and the land, not just 'pure' landscape."

He grew quiet for a minute, then noted how sunlight picked out layers of gold, green, and purple in the landforms and vegetation. The river may be minuscule but the valley is relatively well watered, and the low foliage was vibrant with color. Taking his hand off the wheel, he pulled out his digital camera and took an image. Behind us Byron and the others were lined up, a small convoy. "Ironic, isn't it? Florida's burning up this summer, and the desert's green." The momentary pensiveness was gone, and his customary exhilaration at being out on the road and not knowing exactly where he was headed had returned.

We drove up and then over the Desatoya Mountains, descending on the other side into the much drier Edwards Creek Valley, then curved left to go around the southern end of the Clan Alpine Range and into Dixie Valley itself. To drive on Highway 50 is to weave

across and through the folded terrain as if you were a shuttle on the loom of the Great Basin. As a result it's one of the most beautiful drives in the country—assuming, of course, that the cognitive dissonance most of us suffer in the desert, where we have trouble reading distances and scale, doesn't first drive you into existential despair, which is what I suspect is wearing away at Toshi. He's been getting quieter and quieter.

At 10:50 we turned off the highway onto the Dixie Valley Road, our route on pavement for the first eighteen miles, and then on dirt almost all the way to Lovelock. Byron followed us, the other two vehicles continuing straight for another forty miles west to Fallon. Our first stop of the day was to photograph a wounded green metal sign for "WONDER," in capital letters no less. Indicating the way to an abandoned mining town, the sign seemed more about the attitudes we take with us into the desert than an actual location. We are in awe of its emptiness, which, in our nervousness when confronted by a lack of boundaries, we promptly desecrate in order to leave a visible trace of our passage.

The only other upright structures visible in the valley ahead of us were a line of double wooden power poles and a low building atop a small knoll, the U.S. Navy's "centroid facility" marking a control point for the world's largest electronic warfare range. There used to be fairly active ranching in Dixie Valley, but pilots from the navy's Top Gun school in Fallon constantly practice dogfights overhead and make frequent bombing runs that cross the highway to fire live rockets at targets just a few hundred yards off the road. The navy bought out those ranchers who would sell, and chased off the others with supersonic booms, then moved in and burned down the buildings to clear their preferred field of fire. Now the

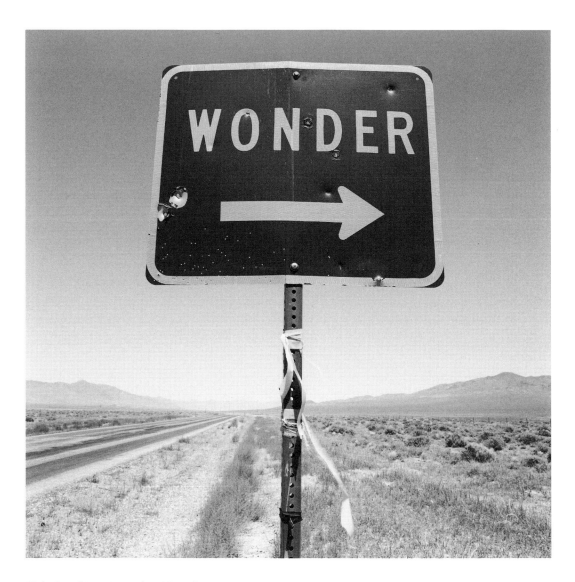

Kyle Bajakian, *Wonder, Nevada,* 1998.

southern part of the valley is virtually emptied of everything but derelict targets, which include the shot-up remains of school buses and troop carriers.

An hour later, almost at noon, we had our first map dilemma of the day. The *Nevada Atlas and Gazetteer* is notoriously inaccurate and was no help in extricating us from the maze of enormous pipes and service roads in which we found ourselves entangled. First, we had passed by the geothermal plant and found ourselves at an unmarked intersection in the dirt. We picked what seemed the most used road, and Mark drew an annotated map for the others, leaving it under a small pile of rocks. Soon it was obvious that our choice would take us east instead of north, where Mark thought the hot springs that we wanted were probably located.

We went back to the intersection, revised the map, and took the road into the geothermal area. After following miles of zigzagging metal pipes over two feet in diameter that ended in a small salt marsh, we backtracked to the plant and located a drilling-rig foreman. After he pointed out the road we needed, I asked him why the pipes didn't run in straight lines. He answered that the design allowed them to expand and contract with the heat of the water—otherwise they'd simply explode. As we left, I wondered how the sonic booms affected the safety of the plant.

We returned to the intersection and changed the map again, which was becoming progressively more confusing, then found our turnoff, marking it with a second note, and made our way slowly up the valley. Klett performed his constant visual triangulations that, once again, zeroed us in toward the site. He'd stop every few miles to check the photographs

against the contours of the Stillwater Range, until we came close enough for him to see the only tree within miles, a definitive marker. We were driving without air conditioning to save gas, the windows down, and every time we came to a halt the silence would ring in our ears, an echo of the big empty I've become addicted to over the years. Now, sitting in the sun and watching a pair of F-16s do barrel rolls at the far end of the valley, I'm glad the jets are so far away I can't hear them.

Every fifteen minutes I raise my head to just barely level with the top of the fumarole to check on how the rephotography is progressing. When I see that Byron is taking his QuickTime panorama, I know they're almost finished and put my T-shirt back on. It's nearly three o'clock when they come down, and Klett's gotten over his annoyance at finding what he considers to be a prime historical spot on public land locked up behind barbed wire and metal fenceposts.

"A great shot. You ought to see the light behind that cottonwood; it's sublime, the whole valley just hovers behind this one backlit tree."

As we drive out past the ranch, we wonder if the owners ever walk up to the hot springs to see that view, the one tree in its visual balancing act with the landscape that stretches away so far on the other side.

McKinney Pass, at 6,800 feet and the high point of our route for the day, is only another half hour away on what turns out to be a wide and well-maintained country dirt road. Its elevation two thousand feet above the valley makes it a cooler, hence logical, place to camp,

and after checking out jeep trails left and right, we opt for the one going north, a steep climb that Byron's heavily loaded station wagon almost doesn't make. At the top of the hill are the remains of a utility shack that was held in place against the winter storms with steel rods and guy wires. The views are staggering, mountain ranges receding from us both east and west like outlines left on sheets of transparent blue tracing paper.

We drag out the coolers, carve up some salami and cheese, and prop ourselves up against a juniper so we can admire the view rolling away to the east. Behind us, gray and white anvil clouds mass over the playa of the Buena Vista Valley and other points west. Mark finishes his lunch and, restless for something to do, starts to elaborate the carving on his game stick with the Leatherman he keeps on his belt. Byron and I, faced with too much scenic climax, promptly fall asleep.

At 5 P.M. the phone rings in the truck, a bizarre wake-up call. It's Kyle. They're still in Fallon posting pages on the Internet from the phone company, where Stu has miraculously sweet-talked the shift-manager into supporting our effort. Mark warns them to leave no later than six—in the dark they won't be able to trace the 114 miles of scribbled notes we've left behind under small cairns.

By 7:45 the sun is low in the sky and we're getting anxious. Mark has carved his stick down to the danger point of breaking, so he attacks with the file on his multipurpose tool one of the half-inch scrap steel rods left by our camp. Over the next twenty minutes we all take turns hacking away at it, and to my complete amazement the Leatherman prevails. Mark has a new stick by which to measure the sunrise. He's just beginning to notch it so

he can attach some copper wire that we picked up as one of our artifacts, when the guys from Fallon drive up with heaps of vegetables for a stir-fry, the best meal we've had on the trip so far.

July 8th: Lovelock

Everyone breaks down camp the next morning except for Toshi and Mark, who set to documenting what everyone agrees is the hill's primary artifact, a weather-blown porno mag—"shooting layouts" for the Internet, we say. Once packed up, I train binoculars on the top of the Humboldt Range twenty miles to the west, where the massive terraces of a cyanide-leaching mine atop Gold Mountain glow in the morning sun. The Aztec-like shape of the berms sacrifice a clean horizon line for the sake of jewelry and other nonessential luxuries, which is how almost all of the gold mined in Nevada ends up. It's astonishing the amount of dirt that is moved, the diesel fuel and electricity consumed, and the poisonous chemicals that are let loose in the environment for the sake of each gold wristwatch.

This morning I ride down into the Buena Vista Valley with Stu, and as we contemplate the almost twenty-mile-long white playa at its bottom, he tells me that the guy who towed his truck back to Tonopah from Carver's is having an especially productive season. It seems that the El Niño winter has left the playas less than completely dry this summer. The geologists out prowling around the state, of which there are about two-hundred-and-fifty at any one given time working for international mining conglomerates that could care less about the skylines of Nevada, have been getting stuck by the truckload. "Serves them right,"

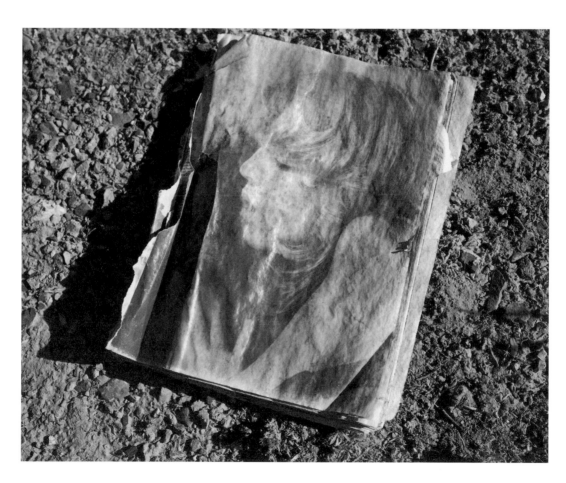

Mark Klett, *Pornographic magazine, "Porno Hill" camp, 7/8/98.*

I say to Stu, nonetheless remembering Mark's adventures as a mapping geologist for the USGS surveying coal fields in Wyoming.

We stop in the middle of the valley where a completely ventilated station wagon of indeterminate make and age rests on the alkali flat. Its yellow body is spotted with rust and bullet holes. "Cheetah," as Stu calls it, suffers the invasion of several camera lenses for the next fifteen minutes. Stu, who considers Third View rephotography a performance piece and not simply the capturing of images, crouches up to the wreck with his video camera running at waist level, then crawls inside from the rear to focus in on the dashboard. We find the fascia from the radio on the ground, its volume and frequency markings barely discernible, an excellent entropic artifact to add to our collection.

Twenty miles to the south jets from the Fallon Naval Air Station roar over Lone Rock, which is visible as a dark bump on the horizon. The primary target feature of the illegal and infamous Bravo 20 bombing range, and adjunct to the Dixie Valley Military Operations Area, it is now much reduced in height by constant bombing. The military basically wants a restricted air corridor that runs up the center of the intermountain West clear from Mexico through Nevada and on to Canada, an airspace that would allow them to develop and test ever longer-range flying weapons. Needless to say, their proposals over the last several decades to establish a restricted fly zone larger than most European countries has met with less than enthusiasm from western residents, even those of the most patriotic disposition. That hasn't stopped the various armed forces, however, from occasionally appropriating property in the Nevada desert by simply dropping bombs on it, which is how they acquired Bravo 20.

Back at the vehicles, Kyle discovers a two-inch gash from a sharp rock that has punctured his rear-right steel radial. He changes the tire, a hot, dusty, one-person job. Most of us just squat and watch, but Stu crawls under the other side of the truck and documents the work with his video camera. When he's finished, Kyle helps Mark pull a desiccated bird out from behind the other truck's front license plate. "Grille sparrow," announces Kyle. Roads in the West, even dirt ones like this, collect what rainwater there is, which runs off the crown to promote the growth of forage for small birds, who fly up confusedly from the shoulders as vehicles approach, a mutual road hazard.

It takes us until 10:30 to reach Lovelock, a thriving farm community of 2,000 people living next to Interstate 80, and the largest town we've seen since Las Vegas. The alfalfa that's grown in the fields outside town is irrigated by water impounded behind the Rye Patch Dam. It captures what little flow is left in the Humboldt River, which originates in the Ruby Mountains near Elko, almost 120 miles to the east. It's a modest enough end to a watercourse that once was briefly thought in the early 1800s to be the fabled Rio San Buenaventura, a purely mythical river supposed to flow from the Rockies to the Pacific, thus affording easy access for migrating capital from east to west. No such luck existed, however, either for the pioneers or the banks. What finally linked the two coasts were the railroads; the first transcontinental route, stretched by the Central Pacific across the Great Basin, followed the Humboldt River. The tracks pass just west of the Chevron garage where Kyle gets his flat repaired for $10, which I think one of the better bargains left in America.

We're back on the road by eleven, taking the interstate south to the Ragged Top Road exit where we'll begin our search for the legendary Karnak Ridge, which is where what some people think, myself among them, that O'Sullivan took his most arresting geological photograph. The sharply crenellated ridgecrest is a haunting image, well known to western art and history fans, a prime example of the nineteenth century's fascination with natural land forms so distinctly architectonic that they seemed to indicate a divine builder at work. Reminiscent to Clarence King of the ruins at a famous Egyptian temple, it is a site that played right into his need to show the world visible proof that violent vertical geological upheavals, and not just the uniform horizontality of erosion, advanced God's designs upon the earth.

The name *Ragged Top Road* reflects the jagged profile of the Trinity Ridge to our immediate right: the dirt track rises and falls, zigzagging north and south to take advantage of the easiest terrain. Last August Byron had tried to find the site, taking the next exit to the south. He wandered around for hours and thought maybe he could line up some of the features in the background of the photo, but he couldn't locate even the ridge, much less the vantage point. We drive through the range and circle around south on its back side, but don't spot any columnar jointing like that in the picture anywhere near the right location. The hills are dun and sage colored, and the valley on this side of the range is empty of everything save the obnoxious presence of high-voltage transmission lines sagging between their angular towers. Even Mark, who did the original preliminary research on the vantage point

twenty years ago, but who didn't have time to make the hike and had to hand off the assignment to Bushaw, can't figure out where the ridge is hiding.

By noon we're at an abandoned mining camp, a convenient place to park the vehicles while Mark explores up a wash. Toshi, Byron, and Kyle wander into a small deserted shed while Stu and I go poking around the mine works. Despite the promise of cool air near several black tunnel entrances, I'm as leery of them as if I were a little kid contemplating what's under the bed at midnight. Stu wishes he had some mirrors and a spotlight so he could bounce illumination inside the mines and go exploring. I tell him he's out of his mind.

Fifteen minutes go by, then thirty. Kyle, without saying anything, takes off in his truck after Mark. Sure enough, they return in another twenty minutes. Mark had gotten stuck at the end of the wash and was walking back to us when Kyle found him, took him back to the other truck, and towed him out. Now we all go up the wash together, leaving behind only Byron's wagon, which Mark says wouldn't make it. The wash isn't really a road, although it could almost pass for one until near its end, and Mark is careful this time to avoid the sandy spot where he'd gotten stuck trying to turn around. He hasn't actually found the ridge, but he thinks we can hike up the range and maybe spot it from the top of a peak. We park as far up the wash as we can, where it narrows in the sandy bottom, and where the Nevada Department of Fish and Game has constructed a water guzzler for chukar and other game birds. We put on our packs, then take off in a line up a small valley. Mark and Byron are soon far ahead, Stu and I following more slowly, Toshi and Kyle behind us and out of sight. I'm out of breath as we climb and curse my current status as a resident flatlander in Los Angeles.

We breech the ridgeline at two o'clock and before us is a sight none of us has seen before, and perhaps will never see again. In recent memory the Humboldt Sink has been a nothing more than a damp spot in winter, a dry and sterile playa the other three seasons, its once legendary marshes victim of the Rye Patch Dam. But today, this summer, this year, it's an immense marsh wrapping almost clear around the small mountains that delineate its eastern perimeter and merging into the Stillwater Wildlife Management Area, which stretches out of sight to the south in the Forty Mile Desert. Ten thousand years ago most of Nevada was still submerged under the Pleistocene's ancient Lake Lahontan, and this must be almost how it looked, the mountain ranges standing isolated, islands in a shallow inland sea. I beg someone, anyone, to take a picture for me, and both Byron and Stu comply.

Mark, in the meantime, is scanning the features around us. Sure enough, he finds what he thinks is Karnak Ridge below to the east. It's a recognizable feature once you pay attention to it, yet small enough that it's easily lost in the overall landscape. Byron and Mark extrapolate the lines of sight from the ridge, confirming its identity, then we take off to another small peak just to the south where we'll have a better view of the nearest dirt roads. From there it looks as if there's an approach from the interstate side of the range, so we hike back down to drive over and check it out. We're way too late to make a rephotograph, and while driving decide that we'll go into Fallon to find a motel for the night, then return tomorrow for the shoot itself.

Finding the nearest approach is easier said then done. We spend another two hours trying various access roads on the front side of the range, and it's almost six o'clock before we're

standing at the road point closest to the ridge. Black thunderheads are gathered around the peak we'd been standing on a couple of hours ago, and lightning marches steadily downhill toward our exposed position on what is a service road for microwave towers. We don't want to linger long, just enough to bemoan the fact that the hike tomorrow will be short but very steep. My lungs will get another workout. We're just about to leave when Stu discovers it's his turn for a flat tire. He doesn't have a puncture, but the road has been so rough that the constant jouncing on rocks has unsealed the rubber from the rim. Kyle and I sit in the Toyota listening to a Morphine compilation tape while Stu labors on. The mournful saxophone of the rock group is an appropriate dirge as the storm lowers around us.

It's not that we're an especially masochistic group, wanting to spend our lives wandering the back roads of the Humboldt Marsh and the Forty Mile Desert, but we've decided, somewhat perversely as it's turned out, to attempt a new route back to the freeway. Driving down from the Trinity Range just ahead of the rain, we tried to find a cutoff that would take us more quickly from Fallon to our hike. No such luck. At quarter after seven, following yet another incorrectly drawn road in the Gazetteer, we're clustered around a historical marker welded up out of railroad ties:

EMIGRANT TRAIL—40 MILE DESERT
TRUCKEE RIVER ROUTE—STARTING POINT
MARKER N. T.R.R. 1—DIKES OF OLD
HUMBOLDT LAKE ON EDGE OF DESERT

Bones, rust, and broken glass are heaped carefully at the base of the marker, a spot venerated by historians that commemorates the beginning of the single most deadly stretch for emigrants on the nineteenth-century transcontinental trail. A desert crossing that most attempted to make in a single long push within twenty-four hours, the trail became littered in the mid-1800s with oxen and horse skeletons, household goods, and shallow graves. This concrete evidence showed how disorienting the Big Empty was to a species more used to moving across a savanna, where trees marked off distance at regular intervals, and humidity thickened up the atmosphere enough that you never had to contemplate a horizon fifty or sixty miles distant.

Pioneer diaries of the crossing evince a near total despair at both the distance to be covered and the overwhelming sense of exposure. Everyone takes pictures of the marker, and in exchange we leave behind the radio fascia from the Cheetah wreck, our small way of honoring the difficulties.

We drop off the Emigrant Trail and head downhill, looking for a road that parallels the railroad tracks which go south from Lovelock across the Forty Mile Desert and into Fallon. Our foray ends in a damp flat thick with reeds, so I get out of Kyle's truck to scout ahead, climb an embankment, and find a salt marsh thick with canvasback ducks and herons. In a normal year we could drive over what would be a salt flat, follow the railroad, and meet the highway leading to Fallon. We turn around to go back up to the marker, where we think we can pick up a service road along the interstate before nightfall. Just before we reach it we receive the last light of the day, an indescribable mix of vermilion flaring on the cliffs

Byron Wolfe, *Offerings placed at the start of the Emigrant Trail desert crossing, the Trinity Range near Lovelock, Nevada,* July 13, 1998.

to the east and on a mile-long string of rusty freight cars. To the west the thunderstorms continue to flash on the Trinity Range, lightning bolts crisscrossing the setting sun. It's the most intense sunset I've ever seen, the drama almost embarrassing. Even Mark stops to photograph the improbable coloration, dumping pictures taken earlier in the day from the memory of his digital camera, seduced by what can only be labeled the Romantic Sublime. Stu washes the windshield of his truck so Toshi can shoot the scene from inside, a little commentary on the nature of sightseeing (and, perhaps, an enclosure for him offering some comfort in the midst of so many atmospheric theatrics).

By the time we reach Highway 95 and turn south, it's getting dark and more thunderstorms have moved into the Stillwater Range to our left. The desolate playa is intermittently lit by lightning flashes. The telephone poles following the highway are severely truncated, their lines almost within reach of a standing person's arm. The playas, when wet and under the daily assault of afternoon winds, are not a place where tall poles implanted in the ground stay rooted for very long. The dwarf poles and strobe-like lightning make the drive surreal and exhilarating, the landscape renewed for my memory by the weather and the excitement of the impending walk up to Karnak Ridge.

The first thing we do when reaching Fallon is head for dinner at the coffee shop next to the new Holiday Inn, a hotel we think will have rooms large enough for all the computers. We're so hungry, though, that right after check-in we head straight for dinner at the Stockman's Casino next door, leaving everything in the vehicles. We negotiate the aisles of clanging, buzzing, and flashing slot machines, which are more than a little dazzling after camping,

and manage to scarf down a quick meal. We get to our rooms at 10:30, unload the computers, unpack a few things, and go to bed. Tomorrow we'll once again split up the team. Mark, Byron, and I will go up Karnak Ridge in the morning. Stu, Kyle, and Toshi will spend their time removing miscellaneous parts of the vehicles that are hanging on by a thread and replacing them as necessary. Then they'll sort and repack all the equipment, do some marketing, and work on Web pages.

Before he goes to sleep, Stu grumbles about not being asked if he wants to go up Karnak, but also acknowledges that he's needed to work on the Web pages. Hired to be the team Webmeister, he's anxious to contribute more, a feeling I understand. It's hard not to want to grab a camera, start taking pictures, and try to fit them into the stream of images. That's what I consider to be a potentially fatal contagion for a writer, letting a viewfinder overwhelm the words, so I don't find it too difficult to hold the desire at bay. Stu, however, doesn't have any overriding aesthetic immunities and is in full grip of the excitement. We're a little frayed in terms of who's accomplishing what, the working methods of the group always a design-in-progress, and we could use some quiet time to reflect collectively about what we're doing. Maybe we can tackle that tomorrow at dinner, I think as I fall asleep.

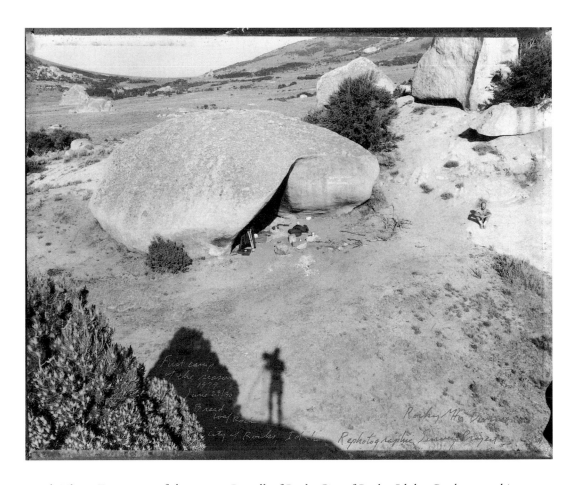

Mark Klett, *First camp of the season, Breadloaf Rock, City of Rocks, Idaho, Rephotographic Survey Project, June 29–30, 1979.*

Chapter Six

MARK KLETT AND SECOND VIEW

In the summer of 1979 Mark Klett spent a warm July afternoon in Lovelock's Pershing County courthouse examining geological maps for the nearby Trinity Range. He knew from descriptions in Clarence King's exhaustive 1878 survey report, *Systematic Geology*, what to look for—a ridge of columnar rhyolite sticking up out of a hillside somewhere to the west of town. As it turned out, he didn't have enough time to go into the field and locate the vantage point from which to rephotograph O'Sullivan's 1867 shot of "Crab Claw's Peak," as Karnak Ridge was then called, having to return to Sun Valley for a teaching obligation. He deeply regretted missing the opportunity to make one of the Second View project's most dramatic rephotographs, but he turned over his notes to Gordy Bushaw, his partner for that summer's fieldwork, who successfully found the spot and made the rephoto. What's of interest about the story is Klett using the geology maps to sleuth down the rugged formation first photographed by O'Sullivan, an otherwise obscure formation virtually invisible from the interstate freeway.

Henry Klett, Mark's father, had grown up on a farm in upstate New York and had been a flight instructor for the army during World War II. While stationed in California he'd met and married a San Joaquin Valley girl. After the war they moved back to New York, where he became a pilot for TWA, and the young couple started a family. In 1954, when Mark was two, they moved back to California in the family's Cessna, but soon returned east following a car accident that left his father with a crushed hip, which necessitated selling the plane. Mr. Klett, who had been the first person to sell televisions in Albany before moving to California, became a radio and TV technician and an all-around appliance repairman. He also worked

as a construction supervisor, and eventually designed and built the apartment house in which Mark grew up. For a time Mrs. Klett made ceramics, which they sold, in addition to imports from Africa and Asia, through a small craft business they owned.

When describing his early life, Mark Klett leaves the impression that it was mostly a happy time, and an interesting one, with the family's future never exactly tied down. He remembers in detail and with fondness the long cross-country family car trips taken during the summers with his parents, brother, and sister, particularly driving through Arizona to Mexico and California when he was eight, sleeping in the back, the suitcases lashed to the top of the car and a canvas waterbag hanging in front of the radiator. By the time he was sixteen he was making his first solo flights in a plane, flying before he could drive.

A perpetually energetic teenager who had long been fascinated by the mineral cases and natural history dioramas of Albany's state museum, he stumbled across photography not from any interest in art, but from a curiosity about chemistry. Visiting a friend his age who had taken up photography, he became intrigued enough to set up his own darkroom, an enthusiasm abetted by his mother, who took him downtown to the local photo store to buy supplies. His uncle had been a navy censor during the war and had left his father a variety of gadgets; among the sextants and barometers was an enlarger. Klett didn't even bother to take his own photographs at first, but simply printed old negatives taken by his father. After working his way through those, he bought a Kodak Instamatic just to have new images to develop. He wanted a single lens reflex for his sixteenth birthday in 1968, but received instead the more traditional emblem of passage into manhood, a shotgun, and continued to use

yet another of his uncle's relics, a 4x5 Graflex. The next year, when he was a senior in high school, he finally got his first "SLR," a much more modern and practical camera for a still novice photographer, and started taking pictures for the yearbook.

St. Lawrence University in Canton, New York, offered no photography classes when Klett started off as a freshman in 1970. As a substitute, he worked in photo services for the college, taking, once again, pictures for the yearbook, which gave him access to supplies and a darkroom. An extracurricular activity run by juniors and seniors, most of whom were majoring in geology, which would soon become his own course of study, photography continued to grow as a passion for Klett. He would stay up until two or three in the morning in the college darkroom printing pictures, sometimes making as many as fifty or sixty prints of one negative, trying to get the pictures of school plays and sports activities as perfect as possible. Tom Southall, who was then head of photo services and would eventually become curator of photography at the High Museum in Atlanta, handed over the reins to Klett when he was a junior.

During the winter session of his first year at St. Lawrence, several of the students decided to bring a professional photographer to campus for a seminar. The geology students wanted someone who fit their idea of what a photographer should be: a no-nonsense person who worked with a view camera, who was a master at the zone system pioneered by Ansel Adams, and who was noted for working outdoors. Ten or twelve of the students threw in fifty to seventy-five dollars apiece and brought exactly such a photographer to campus. The week that Paul Caponigro came to St. Lawrence it was twenty below zero, hardly the easiest conditions

under which to work, but Klett remembers it as a remarkable opportunity. While eating dinner with the students one night, Caponigro said he was trying through his work to "touch the hemline of God." Klett had never heard anyone speak like that before, much less about art, and Caponigro's inspiring statement seems to foreshadow indirectly the conflict between art and science that Klett soon would have to address.

Another telling memory is of working in the darkroom with their famous visitor. Caponigro, twenty years older than Klett and an artist whom the critics considered to be a brilliant heir to the modernist aesthetics of Stieglitz and Steichen, was a demanding technician in both the field and the darkroom. Klett says that they were two-thirds through processing some film one night, with him hanging on every nuance in the master's developing and agitating techniques, when Caponigro suddenly walked over to the corner of the pitch-black room and lit a cigarette, virtually a sacrilege in the carefully light-controlled photo lab. It took Klett some time to assess what this meant to him, but he eventually accepted the incident to signify: "Know when it's necessary to be precise, and when it's not, and don't be intimidated by technique."

In 1972 Klett was ready to abandon his studies in science for a declared major in art, but his geology professor, Mark Erickson, told him that he could do both. Klett wasn't sure what that meant—"taking pictures of rocks seemed like a dumb idea" is one way he put it—but studying geology offered the opportunity for long fieldtrips during the summer, which appealed to the restless student. In the summer of 1973, while mapping buttes in North Dakota and prowling through roadcuts for fossils, Klett was pulling up rocks one

afternoon with Erickson. Digging in the 70-million-year-old dirt and finding mostly fossilized remnants of leaves, he turned up something that looked like a horseshoe crab. He showed the fossil to his teacher, who, turning it over in his hands, immediately knew that Klett had found something special. A horseshoe crab wasn't an unusual find as far as fossils went, but its location in what would have been a prehistoric body of brackish water was absolutely unique. One of Erickson's professors, Bud Holland, had once studied with the famous paleontologist Kenneth Caster, who previously had hypothesized that the primitive horseshoe crabs were migratory, moving from salt water seas into brackish environments, but no proof had ever been found. As it turned out, this was it, a new species demonstrating the validity of the theory. Klett still has a plaster mold of the find, which bears Caster's name as the genus and Klett's as the species: *Casterolimulus kletti.*

When he was studying at St. Lawrence, Mark Klett had no real knowledge of nineteenth-century explorations, their history and methods, but he came away from his graduation in 1974 with more than just a B.S. in geology. Raised by multitalented and independent-minded parents, able to use both his hands and mind in the outdoors, and not a little addicted to the thrill of original discovery, he would have made an ideal member of Clarence King's survey party. After earning his degree in geology he continued to split his time between school and fieldwork, but now in winter as a graduate student in photography at the Visual Studies Workshop in Rochester, and in summer as a field geologist for the United States Geological Survey—the same USGS founded by Clarence King the previous century. It

was a time of both interior and exterior exploration for the slowly maturing photographer.

The Visual Studies Workshop, started by the artist Nathan Lyons after he quit the George Eastman House in a dispute, was then and continues today to be run along lines considered somewhat idiosyncratic by many academics. The faculty encouraged students to explore in depth and at great lengths a variety of aesthetics and photo-printing techniques, but it was also an environment which demanded self-discipline and initiative. Unlike more traditional and tightly structured Master of Fine Arts programs, it encouraged students to range freely across the history of multiple artistic media. It was a circumstance that suited the independent-minded young geologist, but no matter how liberal a setting a school provides, a structured mindset often seems to creep in. Klett characterizes the photography he did for his graduate thesis as being formalist and very tightly arranged. Studying color photography with Michael Bishop, he gained an appreciation for the photographic print as an object in and of itself, a prime tenet of modernism any contemporary artist must understand. On the other hand, in the work of anyone less than a mature master, it can tend to produce images that are less than dynamic. One print from the period, for instance, demonstrates how Klett would use a woven-wire fence as a middle-ground against which to juxtapose objects immediately in the foreground with those in the far background. The effect is a clever still life made outdoors, an almost mathematically calculated geometry of colors brought together from the close, near, and far picture planes onto one semiabstract surface. The result is handsome but calculated, technically a very competent study, but not a successful photograph in terms of engaging the viewer.

Mark Klett, Untitled [photograph from graduate school, Rochester, New York], 1976.

Perhaps the formalism was related, if unconsciously, to the fieldwork in the summers, when Klett was roaming the high plains of Wyoming and Montana triangulating geological features and potential coal-bearing strata from the landscape and the topographical maps of the USGS. It was exactly the kind of work that appealed to Klett, a mixture of mathematics dictated by the compass and his own geographical intuition. Spending days alone bouncing along in a pickup truck on dirt roads across some of the most open terrain in North America, Klett became a confirmed addict to a very specific kind of West—the unpopulated, the unfenced, the almost unnoticed. And perhaps those student photographs also speak to Klett's personal tensions generated by his shuttling between the wide sunny skies of the West and the more claustrophobic urban winter grayness of Rochester, and between the often contradictory demands of science and art.

The intellectual and emotional interplay between the two disciplines, science and art, is, of course, much more than simply a personal issue for an MFA student in the twentieth century. It has been a topic of concern for philosophers, sociologists, and artists ever since the scientific method was formulated by Roger Bacon in the thirteenth century and alchemy slowly began to give way to chemistry. The urge to reconcile the two cultures in order to obtain a more complete perception of the universe often leads scientists to describe the process of discovery in aesthetic terms, the "elegant beauty" of certain equations, for example. Likewise, artists are constantly attracted to scientific methods and models for inspiration. Spurred on by books such as Aldo Leopold's *A Sand County Almanac* (1949) and Rachel Carson's *Silent Spring* (1962), which used literary means to popularize biology in the analysis of the natural

world and our place within it, by the late 1960s and early 1970s a burgeoning awareness of ecology was leading both artists and scientists to think more holistically about how we perceive the world. What was the ecology of the senses?, they began to ask. C. P. Snow, the British novelist and physicist, had published a small but highly influential book in 1959 entitled *The Two Cultures*, in which he lamented the dangerous isolationism of the arts and sciences from each other. In the second edition of the book, published in 1963, he proposed a "third culture," a milieu in which the two cultures would speak to each other on equal terms.

These ideas percolating up in college campuses and art departments throughout the country had been molding the work of photographers only a few years older than Klett, a number of whom curator Bill Jenkins at the Eastman House brought together in the *New Topographics* exhibition. The show opened in 1975 and Klett was there to see the photographs by Robert Adams, Lewis Baltz, and others. In the catalog accompanying the exhibition, Jenkins described the artists as striving to diminish the role of style in their pictures, to "function with a minimum of inflection in the sense that the photographer's influence on the look of the objects is minimal." He characterized their collective stance as being "anthropological rather than critical, scientific rather than artistic." One would think that Klett would have applauded vigorously. One would be wrong.

Klett actually was offended by the show. Although he has since come to admire both the individual photographs and the artists, and Jenkins is, in one of those twists of fate common to the academic world, now one of his closest friends in the photography department

at Arizona State University where they both teach, at the time the collective rubric angered him. It made no sense to Klett the geologist, who, after all, spent his summers earning a living as a professional topographer, nor to Klett the artist, who by now had begun to cultivate a deep admiration for the nineteenth-century exploration photographers to whom the show's title was referring.

While Adams, Baltz, the Bechers, and others were at pains to take straight-ahead and uninflected pictures of contemporary landscape and its vernacular architecture, in no way could he consider their work "topographical" in the sense of systematically describing and mapping a terrain or place. Klett not only knew the territory they were photographing—the front range of the Rockies in the work by Adams and the tract houses of California in Baltz's, for instance—but he had his own relationship with the landscape of the West. To him the work wasn't showing anything new. Another note in the show that struck Klett as false was that the photographers pretended to a sense of neutrality, as if they were unbiased observers, a conceit he considered belied by their very selection of subject matter. While he might have agreed with what they photographed—he wasn't about to deny the creeping suburbanism of the West—the idea that the photographers were exercising a scientific approach irked him.

The show that Jenkins curated, however, was granted almost immediate and widespread status as a watershed event in the twentieth-century history of photography. It successfully captured the swing of landscape photography away from what was then considered to be the overblown romanticism of Ansel Adams to a tougher, supposedly more "truthfully" framed

view of the environment. And some of its photographers did, indeed, go on to map subject matter more systematically, or at least to play more consciously with the idea. Robert Adams produced *From the Missouri West* (1980), a somewhat erratic photo-journey across the West that nonetheless took its title directly from the nineteenth-century exploration reports. Baltz embarked on his *Park City* series, documenting over several years the construction of the suburb above Salt Lake City, a brutally serial and nonstylized synecdoche for the commercial exploitation of the region. And the Bechers have since produced several almost indexical volumes of industrial architecture, ranging from water towers to grain elevators. Although American landscape photography cannot be said to have since become solely topographical, most of it bears a traceable relationship to the show, either in resonance with or reaction against its aesthetic of visual inclusion. Klett's work is no exception.

Klett spent 1976–77 working as an instructor in the community program at the Visual Studies Workshop and finishing his studies. Prior to graduation he was approached by Ellen Manchester, a photo historian who had attended the Visual Studies Workshop several years earlier. Flying from Colorado upon not much more than the recommendation of a colleague that she go meet Klett, which he had made on what appeared to be their mutual interest in nineteenth-century western exploration photographers, she found herself impressed with the young graduate student's dual background in art and geology, as well as his personal fieldwork in the West. Manchester's own interest in the West stemmed from two sources. One, she loved the landscape, having once taken off from the East after earning a dual degree from Skidmore in art history and architecture to be a ski bum in Aspen.

She supported herself as a chambermaid and a waitress at night and skied every day during the winter. She stayed for the summer and managed a photo gallery in town, where she became aware of the photographs W. H. Jackson had taken the previous century.

She had since returned east, worked as a photo editor for the Encyclopedia Britannica, attended the Visual Studies Workshop at the recommendation of Beaumont Newhall, and ended up running the library and research center at the George Eastman House. But by 1974 she was back in Boulder, teaching wherever she could to make ends meet, and beginning to work on what would be the second source of her regional interest, co-curating a major exhibition to open in the fall of 1976 at the University of Colorado. *Great West: Real and Ideal* presented 450 photographs made since 1950 that dealt with how artists as diverse as Ansel Adams, Eliot Porter, Robert Frank, and Garry Winogrand dealt with the social landscape of the West. Among the notions that intrigued her, but that she was unable to deal with in the context of that particular exhibition, was how the photographic views of the region had changed throughout the decades since the first photographers had documented it a century earlier.

By 1976 she was teaching photography at the Colorado Mountain College by day and figure skating by night. She was looking for someone to help share the classroom load, hence the trip to interview Klett. She offered him a part-time teaching position as a photo instructor at the college, which is where he went after graduation. Klett brought with him JoAnn Verburg, another photographer and curator who had been working at the George Eastman house. The three of them had talked at length about the work of the nineteenth-century

Author : Fox, William L., 1949-
Title : View finder : Mark Klett, photography, and the re

=== HOLDINGS UPDATE ===

DYNIX #: 592039
copies: 3
holds : 0

#	BARCODE	CALL #	TYPE	STATUS	USE	LIB
1.	32815008309174	MAIN TR660 .F69 2001	BK	IN	0/0	DML
2.	-928567	VSW 04.1 .K645 Vie	VSW	IN		DML
3.	-920271	VSW 04.1 .K645 Vie c. 2	VSW	IN		DML

John — Sally asks that you
make a new label for this book

Julie

#, New, Back, Up, Delete(#-#), Replace Barcode, STatus(#),
SPine label, Status Reserve(#), Collapse Holdings(#-#)

too —
thx —

men, about how the views might have changed, and what a second look at the documented sites might tell them about the relationships between culture and nature. They were intrigued by the model of a working collaboration that the explorations offered, and by June of that year they had received a grant from the Visual Arts Program at the National Endowment for the Arts, awarded under what would turn out to be a short-lived special category designed to support photographic surveys.

Raising money for rephotography wasn't always an easy sell. The NEA panelists groused in 1977 that the proposed "then-and-now" project was nothing new, that it was more appropriately work for a state historical society, and that it was light on art. Still, they granted enough funds to send out Mark and JoAnn into the field for the summer. (In 1978 Ellen flew to Washington, D.C., to raise additional funds, but was unable to interest the National Geographic Society or the National Park Service, and she didn't even try the scholarly National Endowment for the Humanities.) Limiting themselves that first season to working just in Colorado, where Manchester at least had a rough idea of where some of W. H. Jackson's original sites were located, they soon developed the working methods they would use throughout the Rephotographic Survey Project's life. They tracked down old photographs and copied them for the fieldwork, organized tight travel schedules, and roped friends and colleagues into carrying gear. Ellen sent Klett into Denver to meet with Harold Malde, a geologist at the USGS who had co-authored a definitive paper on how to repeat photographs precisely enough to measure changes in landforms that matched the exacting standards of measurements otherwise made with transits. As it turned out, the two men had met once several

years earlier in Montana; Malde even remembered the campsite that Mark had recommended to him for the night.

The team worked that summer with borrowed equipment, but nonetheless managed to make twenty-seven rephotographs. By the next spring Ellen had secured a second NEA grant, and although she was not successful in capturing the interest of the Polaroid Foundation, she was able to convince the corporate marketing department to support the project. Two new photographers were invited to join the effort, Gordon Bushaw, a mathematics teacher who could perform the requisite calculations for triangulation even without a calculator, and Rick Dingus, a graduate student who was cultivating a keen interest in the work of Timothy O'Sullivan. Unlike the previous year, when the team had photographed together, Klett, Bushaw, and Dingus split up in order to cover more territory. By October of 1978 they had made another fifty-eight rephotographs in Arizona, New Mexico, Utah, Wyoming, and Idaho. In the third and final year of the fieldwork, only Klett and Bushaw were able to take to the field, repeating thirty-six of O'Sullivan's views in Nevada, Utah, and eastern California. The 121 rephotographs had taken the project over somewhere between twenty and thirty thousand miles of driving, laid down the standard for rephotographic accuracy, and finally had provided an arena in which Klett could begin to dissolve the distance between science and art.

The RSP team had rediscovered a working method that involved a certain sublimation of individual artistic ego in order to assemble a project, which was to say they went against the modernist stereotype of the artist as a heroic loner, as well as against the supposed supremacy

of a photographic print as an isolated artistic object. Their open collaborative attitude allowed them to pull into the project the work of historians and scientists from both the nineteenth and twentieth centuries, thus breaking yet another modernist rule. Instead of focusing on breaking tradition, they extended it by photographing the passage of time within it. They also had to learn to expect the surprises they found from the vantage points—that in some places a freeway or a reservoir now occupied what had been untrammeled space a hundred years before, but in others the landscape had obliterated all visible traces of people and their buildings. Change in physical space wasn't all that they found. As JoAnn Verburg wrote in her essay for the *Second View* book, they saw how the nineteenth-century aesthetic conventions, which exalted in sharply focused pictures of exotic locales, sought to position us in "a foreground that seems to give the viewer a place to understand and contemplate a greater, larger reality." The rephotography both acknowledged the earlier stance and foregrounded it for our inspection. We could, through the team's careful analysis of how the vantage points were chosen and the angles of view manipulated, see how King and O'Sullivan sought to find evidence to support the role of catastrophism in geology, which was, in turn, part of the momentous scientific discussion during the last centuries over the physical evolution of the planet and the life upon it. In its insistence upon rigorous methodology, the Second View project, which Klett now considers only one phase of the larger Rephotographic Survey work, was also an elegant reply to the New Topographics show.

By fall of 1979 it was obvious to the RSP team that their separate professional obligations were pulling them in different directions. Many more rephotographic opportunities

existed among the thousands of pictures taken by nineteenth-century explorers, but enough work now existed to support a serious publication. Klett and Verburg started work on essays, made prints, and arranged for publication with the University of New Mexico Press, an institution where Rick Dingus was to finish his Master's thesis on Timothy O'Sullivan in 1982.

During 1978, the second year of the RSP fieldwork, Klett and Manchester had left the Colorado Mountain College to assume a position they chose to split as, respectively, the assistant director and director of the photo department at the Sun Valley Center for the Arts and Humanities, a nonprofit organization that had a national reputation for bringing together writers and artists from all disciplines to work, teach, and occasionally cultivate a deeper understanding of the West. A young graduate student who would become a leading revisionist historian of the West, Patricia Nelson Limerick was one of the people who attended the legendary Institute of the American West there one year. Another visitor was the writer and former rancher William Kittredge, who would go on to help redefine the stories we tell ourselves that constitute the myth of the region. In 1981 Manchester hired a landscape photographer, Robert Dawson, to teach a summer workshop; a year later she ran into him at the opening of one of his exhibitions and they began a courtship that ended in marriage.

During the four years that Klett lived in Sun Valley he began to develop the basis for an original body of work (as opposed to the rephotography of others). He remembers a party following a staff meeting in the late summer of 1979 when he and Dave Wharton,

a printmaker, decided it was time to form "the first art disposal team" in order to rid the campus of some twig sculptures that had outlived their purpose. Ellen Manchester provided the matches, and Klett, for lack of another option, grabbed one of the 4x5 cameras used by the RSP that was loaded with Polaroid film. The team had been using Polaroid film for survey work because, among other reasons, they could quickly check the accuracy of their calculated vantage points, as well as their attempts to match the original image area, and the dimensional distortions nineteenth-century prints sometimes underwent. There was a deeper satisfaction in using the Polaroid film, though, one that arose from what Klett called "a conceptual and procedural counterpart to the wet-plate process used by the nineteenth-century photographers." He pointed out in his essay in *Second View* that both types of negatives were developed, washed, and dried in the field. Working with Polaroid film thus provided both an immediacy and a technical challenge that emotionally linked the RSP photographers to their predecessors.

Using the large-format camera on a tripod to make what might be considered spontaneous snapshots of the bonfire was a breakthrough act for Klett. Hardly ever shooting any pictures for himself while working on the RSP, Klett had taken some pictures of the team's camp in the summer of 1979 while working at the City of Rocks in Idaho. The following summer he actually managed to make some photographs that had no connection to the RSP whatsoever, a series of shots made at the annual rodeo in Hailey. Figuring he had nothing to lose, he submitted them to a competition sponsored by the Friends of Photography. Joe Deal, the judge and one of the original *New Topographics* photographers, chose Klett to

receive the Ferguson Award, which gave Klett the confidence in his own work that he had been lacking.

Using the award money, Klett took off in the fall of 1981 for a trip through Nepal, making the several-weeks-long classic trek around the Annapurna Massif in October. Fall is a prime trekking season in Nepal, a clear window between the summer monsoon floods and the winter snows, both of which tend to make the trails impassable. Although his group ran into a blizzard on the 18,000-foot Thorung La Pass, the trip was a success. Klett lugged along his 4x5 camera, continuing to treat it as if it were a 35mm SLR. He took snapshots which commemorated everything along the way: from fellow hikers eating lunch to Nepalese children playing on the graceful swings made from bamboo poles lashed together; from views of their clustered nylon tents pitched in bare fields to the wildly terraced villages perched on mountainsides. Klett soon learned how to plan his photographs before taking them, and to set up the tripod and camera as quickly as possible, otherwise the local children and villagers would crowd so densely in front of him that nothing else would be captured on film but grinning faces. He relished being a foreigner and documenting a journey, traveling in the style of a small expedition with Sherpas and porters. The value of the photographs, mostly printed on 16x20-inch paper, lies not so much in what they are—more or less conventional trekking photographs—as in how they were made.

Klett had come to photography from a fascination with chemistry. He printed up his father's old negatives at first, not interested in taking pictures so much as presiding over what seemed like an alchemical transformation in the darkroom. His early training as a

Mark Klett, *Bamboo swing, Kathmandu, 10/81.*

Mark Klett, *Returning to First Camp: now campground, Third View Project, City of Rocks, Idaho, 7/6/99.*

photographer was doing work for others, and then in graduate school with formalist arrangements that left him unsatisfied. The RSP work was a step forward, the formation of a small photographic community around a body of work that celebrated the scientific indexing of the world. But only in the Nepal photographs do we first see Klett working freely and consistently as himself, making photographs where he formed the vantage point in response to a fluid situation in progress around him, and one in which he was a participant, not just an observer.

Klett returned to America later that fall without a job, but soon applied for a position in Tempe at Arizona State University. The School of Art was looking for someone to start a collaborative photography facility—someone who could be a master photographer and printer for visiting writers and artists. Klett accepted the $17,000-a-year job and started the Photography Collaborative Facility, later to be merged with other print areas to become the Visual Arts Research Institute. Once again he was assuming a role as an artist in service to the work of others but, he also was given a new territory to explore, one in which he would soon utilize everything he had learned in order to produce series after series of his own work.

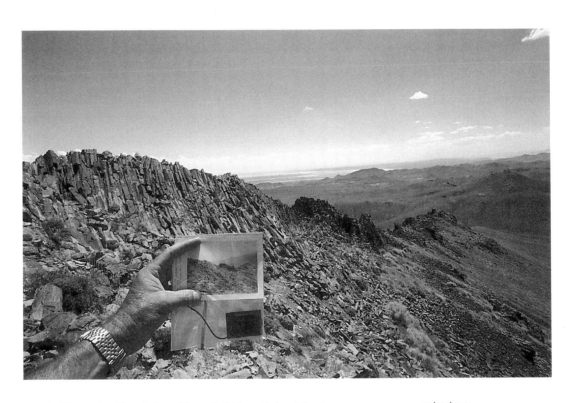

Mark Klett, *Artifacts left at Karnak Ridge: Polaroid print, compass, note, 7/9/98.*

Chapter Seven

THIRD VIEW: JULY 9TH: KARNAK RIDGE AND FALLON

The sun is already well up when I gently close behind me the door to our room at 6:45 A.M., leaving Stu to sleep in peace for a bit longer. I suspect he'll have his hands full today, cleaning up Kyle's and his trucks, exploring Fallon a little, and getting new material onto the Web—enough so that maybe he won't feel so bad about not going with us. By the time Byron and Mark are up, have the gear packed, and we've eaten some breakfast it's almost nine o'clock and Mark's anxious to get going. He thinks the rephoto needs to be done around noon, but we're unsure of how long the hike will take, not to mention what the complexities will be in establishing the vantage point, though we've copies of both the O'Sullivan and Bushaw photographs to work from. Driving out of town back north through the Forty Mile Desert, we pass four Hummers headed south. The gawky, vaguely prehistoric oversize vehicles are loaded with geologists and their field boxes, tripods, and presawn lengths of white PVC pipe for claim markers—all the paraphernalia needed for contemporary mineral exploration. The survey work that Clarence King began in the Fortieth Parallel exploration continues.

I'm riding with Byron this morning, the suspension of the station wagon considerably enhanced now that all the computers have been unloaded into the hotel rooms. Although we talk a little about how college photography programs are shifting ever so slowly from conventional into electronic imagery, a movement in which Mark is a willing participant, unlike many of his colleagues, mostly we're quiet and I'm free to reflect upon our goal for the day, Karnak Ridge.

The first photograph I ever saw that I can claim to remember as an O'Sullivan was a view of Karnak Ridge, though I'm not sure if it was a reproduction of Bushaw's *Second View* rephoto or the original O'Sullivan, a confusion that in and of itself is interesting. It appeared in the October 1975 issue of *Artforum* in an article about western landscape photography, a context that had a profound effect upon me, though it took years for me to realize how deeply I had been impressed. *Artforum* had long been held by artists and writers in Nevada as the banner publication of the avant-garde. It was the New York art magazine where we looked to follow what was happening not only on the East Coast, but also in Europe and elsewhere. To find an image from Nevada printed in its pages was to be granted status as residents of a recognized territory, a rare occurrence. In fact, at the time I could think of only three other images from the Great Basin that had appeared in *Artforum:* Robert Smithson's *Spiral Jetty* sculpture, which curled out from the shore of the Great Salt Lake; Michael Heizer's massive *Double Negative* cuts on Mormon Mesa; and, his utterly mysterious *Complex One*, an architectonic *mastaba*-shape in Garden Valley. What astonished me about the Karnak Ridge picture was that it was of a natural feature so compelling that it commanded serious aesthetic attention. It was neither a "beautiful scene" that would appear as a tourist photo in *Nevada Magazine*, nor an artwork that just happened to be constructed in Nevada; rather, it was a spooky and foreboding place that I couldn't locate in my memory. I'd never seen any other geological formation that resembled it, even after years of hiking and climbing all over the region, including on rhyolite formations near Reno.

The O'Sullivan photo of Karnak Ridge pictures a procession of vertically fractured rocks sloping up from the foreground and marching across the picture frame from the upper left to the middle right. The far horizon is completely obscured by haze, but the floor of the valley on the other side of the ridge appears oddly tilted; you're tempted to rotate the picture slightly one way or the other in order to make the valley floor even out. At first, and even second look, the scale of the ridge remains undecided. It wasn't until preparing for this trip and more closely examining the paired photo/rephoto in the book *Second View* that I realized the few bushes visible in the foreground meant that the columns were only dozens and not hundreds of feet high, and that the cameras must themselves have been slightly tilted in order subtly to amplify the scale. The other disconcerting aspect in comparing the two pages in the book was that, although the profiles of the ridge matched, the thousands of individual rocks in the pictures had, in many cases, changed positions from 1867 to 1979. Gravity and erosion had obviously been at work, slowly pulling down the ridge piece by piece. The two pictures were thus the same and not.

As it turned out, Alvin McLane, the man who had taught me to climb and introduced me to most of Nevada's far valleys and ranges, had submitted a report in February 1976 to the Bureau of Land Management recommending that Karnak, Trinity Range, Pershing County, Nevada be made a geological natural preserve. His suggestion was made in response to a threat of visual pollution that would be caused by the construction of a massive high-voltage transmission line by Sierra Pacific Power Company. Proposed for the northwestern corner of the land he reviewed, it would effectively bracket the views from Karnak Ridge. His

counterproposal pointed out that Interstate 80 and the railroad tracks already existed on the east side of the ridge, along with a 120-kilovolt transmission line. Why mess up the west side with more construction when Sierra Pacific could use the existing transportation corridor for the new line? He lost the battle, in part an ironic result of the national effort to beautify highways; the lines we had seen yesterday on the far side of the Trinity Range were the results—but he had made a strong case against them.

McLane presented Karnak Ridge as "a spectacular region," repeating King's assertion that "it is doubtful if columnar rhyolite is exposed on a grander scale anywhere in the world." He quoted King from *Systematic Geology*, who characterized the area in superlatives:

> It consists of a ridge more than a mile long and rising 300 or 400 feet above its surroundings, altogether made up of well developed prismatic columns, varying in size from two feet in diameter down to an inch. The cross-section along the ridge would show a sharp, roof-like form coming to an exceedingly thin blade, which bristles with fine vertical columns. Upon either side, in descending toward the foot of the slope, the columns are seen to incline from the centre outwardly, while at the middle of the ridge they are tossed into a variety of angles, but approach the vertical. The steep slopes are formed of sharply divided columns, still *in situ*, resembling a pile of architectural ruins and suggesting the name of Karnak.

McLane then went on to quote Arnold Hague's parallel description from the second volume of the expedition's reports, *Descriptive Geology:*

> The highest and by far the most interesting part of this region is an exceedingly sharp broken ridge trending approximately north and south, and rising about 1,500 feet above the surrounding hills, and 3,000 feet above the Humboldt Valley, to which the name of Karnak has been given, from its resemblance to ruins.

At the end of his report, where he notes the appearance of O'Sullivan's Karnak photos in the two Fortieth Parallel publications, in Horan's biography of O'Sullivan, and most recently in *Artforum*, McLane said: "With all the exposure that Karnak has received, it's hard to conceive why BLM hasn't made an effort to withdraw it for public retention. It is not for lack of knowing where Karnak is, for I have identified the area for them on at last two or three occasions."

Several times during the trip I've wished I had gone over the itinerary beforehand with Klett so I could have discussed it with Alvin. Not from any desire to rephotograph O'Sullivan's work, but because he's an expert on nineteenth-century exploration of the Great Basin, McLane has retraced almost all of King's footsteps. He not only could have told us exactly where the hot springs were in Dixie Valley, but could have directed us to Karnak, having first hiked there in October 1969, then again in November 1975. While looking out the window of Byron's station wagon and watching immense flocks of ducks rise from the overflowing Stillwater Marshes

to our left, I vow never to leave home again for a trip in the Nevada outback without first consulting with McLane. It's a promise I've made myself several times in the past, and one I've regretted not honoring every time I've failed to call him up before starting the car.

We regain the microwave tower road at just after ten, and by half-past the hour have started hiking up the rolling *bajada* to the base of the ridge, the alluvial fans that have spread out and then connected, their debris flows scored by numerous small gullies. Mark and Byron, even loaded down with the majority of the photo gear, start from behind me by several minutes, but soon are far ahead, rising into and then falling out of view as they cross the gullies. We've picked what appears to be a feasible break in the cliffs above us where we can scramble through to the western side and locate the vantage point. Mark's estimated it should take us forty-five minutes or so to hike from the car to the top of the ridge. I guessed it would take well over an hour, but it looks like Mark is right. The scale of this particular site, its size in my imagination, continues to elude me.

A horned toad scampers out from underfoot, dragonflies flit about in mating pairs, and a jackrabbit cuts out from under a Mormon tea bush, dashing from one bitterbrush to another, weaving a defensive pattern more intricate than anything the NFL could devise. The only other sound added to the familiar wheeze of my labored breathing is the wind whistling through the legs of the tripod that I'm carrying over my shoulder. The slog up the increasingly steep face of the ridge can only be described as gruelsome, I say to myself, but it only takes a mercifully short thirty-five minutes from leaving the vehicles to reach the bottom

of the columnar rhyolites. I balance carefully on larger pieces that have fallen and begun their slow descent toward the valley floor and pick out a rough staircase to the top and through the break. Just on the other side and sitting in the shade are my companions. Klett the geologist is turning over in his hands a forearm-thick piece of the rocks, which he thinks might be more accurately classified as an andesite. Beats me. The stuff fits King's description to a T: "The exterior of the columns, generally of a dark, almost chocolate-brown color, fades in many instances into a reddish-gray. The interior is exceedingly brilliant, pure gray, formed of a rather coarsely crystalline groundmass."

After a short breather we start an uphill traverse to the north, staying as high on the ridge as we can. Only another five minutes pass before Klett turns around, a copy of the Bushaw print in hand, and declares that he's standing on the vantage point, or at least damn close. The guys unpack their gear while I find a comfortable place to sit and watch. Mark has the 4x5 set up and disappears under the black T-shirt to take his first trial shot at 11:35 A.M. I settle back to contemplate the view and to ponder why King chose to name this place after the site of an Egyptian temple.

Karnak is a village on the Nile River at the northern edge of Luxor, and the site of the largest accumulation of ancient temples in Egypt, the greatest of which are the temple of Amon Re, which dates back to roughly 2600 B.C., and the impressive Hall of Seti. When photographers arrived to make the first daguerreotypes in Egypt during November 1839, they found piles of stone rubble out of which arose magnificent columns. The ruins of Egypt were the most impressive examples of monumental architecture accessible to photographers

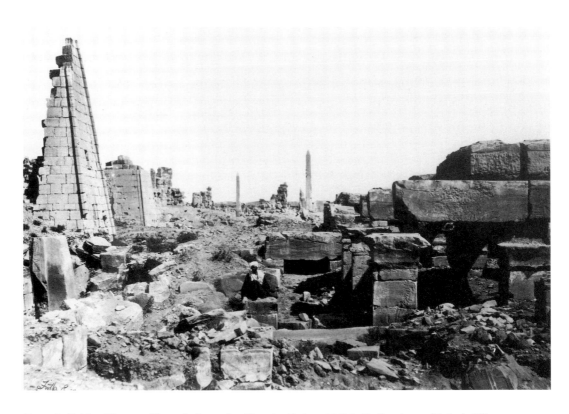

Francis Frith, *View at Karnak from the Granite Pylon,* 1857. Collection of Mark Klett.

of the time, and Karnak remains the world's largest extant religious edifice. Images taken of the temples quickly made their way around to Europe and America. Although Karnak itself had been photographed beforehand, for example by the amateur American architect John Beasley Greene in 1854, perhaps the most important early photographer to visit Karnak was Francis Frith, a Quaker entrepreneur from Liverpool.

Frith made three trips in the late 1850s to document the region, producing in 1858 and 1859 a monumental two-volume publication entitled *Egypt and Palestine Photographed and Described*. Producing a travelogue *cum* natural history, and a model for travel books ever since, Frith both copied the views of earlier lithographic artists who had preceded him to Egypt and set the parameters for the photographers who would follow him. Two thousand copies of the first edition were published and sold by subscription, which necessitated the printing and tipping in of 150,000 separate prints. At least one of the books made its way immediately to America, bought by a librarian at Princeton University. This deluxe edition was followed by a series of even more lavish albums, as well as a number of less-expensive editions. Frith and Company, the firm that he founded with the money earned from the early sales of his books, successfully specialized in printing travel photography until its liquidation by his descendants in 1971. Frith's books are notable examples of how photography evolved as a way to certify travel, to reduce experience to an image that can be treated as a commodity.

Frith went on to use his photographs not only as illustrations for travel books, but for also for Bibles, representing a widespread trend of the time to conflate the visual cataloging of

the world with both science and religion. The examination and deciphering of monuments, ancient temples among them, was cited specifically by Auguste Comte, the influential positivist philosopher of Frith's time and author of *Social Physics*, as a requisite means of scientific investigation. It's a gauge of how important Frith is in the development of photographic narratives that Klett keeps one of his albumen prints in his office at home. Appropriately enough, his "View at Karnak from the Granite Pylon" (1857) shows a general view of the ruins well before their restoration by several generations of French archeologists working with the Egyptian Antiquities Service. Like the ridge, the temple is a scene of entropy in progress, the polygonal stone columns breaking off into small pieces on the ground.

As I watch Mark and Byron do an awkward dance on the small ledge they're occupying—the drop on their far side long enough to ensure a serious injury, should one of them slip—I realize that I don't know for sure whether or not King saw Frith's photographs of Karnak while studying at Yale, or, less likely, whether O'Sullivan saw them in New York while working for Brady and Gardner. The point is, however, that King was familiar enough with the visual tradition in which they resided to have applied the exotic name here. When tracing in 1843–44 his great arc from the Great Salt Lake in Utah to Pyramid Lake in Nevada, John C. Frémont described the Great Basin as a desert province that could be compared in the American imagination only to the ancient regions of Asia. King was following in the footsteps of his illustrious predecessor, deliberately linking for his readers the newly discovered geological wonders of the Far West to what were defined in popular culture as the exotic locales of the mysterious Far East, a time-honored way in exploratory literature to

increase their touristic value. But, he was also writing in the style of scientific literature at mid-century, which identified the naked geology of the desert with the open book of divine architecture. By photographing and describing the outstanding features of the region, he was cataloging the territory in order to confirm possession of it for the United States government. He was also providing evidence for the scientific theories he supported—God disrupting the steady and uniform evolution of the planet with episodic geological violence in order to advance the progress of land and life.

One other photograph of Karnak Ridge by O'Sullivan appears in the Fortieth Parallel report. Taken from a few feet below and south of our position, it shows some of O'Sullivan's photographic gear sitting on a rock, his hat nearby, and what appears to be the head of a small mule, its reclining body hidden in the jumble of rough blocks. If anything, the severe primordial geometry of the columnar rhyolite is even more clearly defined than in the more widely recognized view. All together, the elements of the picture seem to say: Here is incontrovertible proof of the order within the earth, here is the instrument with which we take its measure, and there is the exhausted beast of burden needed to bring us to this precipitous place.

By now it's quarter after twelve, and the shadows have aligned themselves into place more quickly than Klett expected. He's been making minute adjustments to the exact placement of the lens ever since arriving. With so many sharp lines in the landscape as referents to Bushaw's picture, a perfect alignment seems oddly elusive and he begins to shoot. After making his customary series of rephotographs, Klett asks Byron to get into the picture. Byron

Timothy O'Sullivan, *Crab's Claw Peak, western Nevada,* 1867. Collection of the United States Geological Survey.

Mark Klett and Byron Wolfe for Third View, *Byron checking his blister, Karnak Ridge, Nevada,* 1998.

clambers down into the rocks with Mark giving directions, then bends down for a moment to examine a blister on his heel developed while hiking up the ridge. That's the picture Klett wants and gets, a slightly antiromantic antidote to the entire procedure. Klett also takes a shot with the camera as evenly aligned with the bubble level on his tripod head as he can get it, another kind of counterfix to the slight distortion created by O'Sullivan. While Byron climbs back up and makes his QuickTime panorama, capturing the gear scattered about and me sitting with pad and pen in hand, Klett climbs to the top of the rocks and dials up the hotel with his cell phone. He just can't resist telling the guys in Fallon, who are within line of sight with his position and recording the conversation: "Hi, this is Mark and we're calling from Karnak Ridge."

After we stow all our stuff back in packs for the hike down, we take a minute to scout the area for contemporary artifacts, in essence the trash that others might have left behind. We don't find anything, instead leaving behind a small cache of our own in a zipped plastic baggie under a small cairn. Mark drops in one of the Polaroid prints, Byron a note he quickly writes, and I the small compass that I've carried for years. It's our way of making tribute to O'Sullivan and we wonder out loud if someone doing a rephotographic shot here years in the future might find it. We've also decided that we'll each pick a small piece of the ridge to take with us, Mark noting that "I guess it's still legal in Nevada to pick up rocks."

A few yards uphill from us is another break in the cliffs, and we pick our way over to it, seeking both a quick descent and good examples of the unique formation to collect. While still above the notch I notice a series of small columns that look as if they were roughly

arrayed out like spokes from a circle. We gather around the vernacular monument and find in its center an old metal tobacco tin with faint lettering that reads: "When a feller needs a friend." The label that's been peeled off and left rolled inside has handwriting on it, but it's virtually unreadable after years of weather patiently penetrating the container. Like all the messages we leave behind, from grand temples to photographs to this modest note, the elements eventually erase them all.

It's three o'clock by the time we're at the two vehicles and headed back to Fallon. I've brought down with me a one-inch-diameter piece of the ridge about six inches long, something to keep on my desk while writing. Mark and Byron were slightly more ambitious, each lugging back doorstop-size polygons weighing upwards of ten pounds each, as if the camera gear hadn't been heavy enough. When we get back to town and display the rocks to the others, mock trophies from a photo hunt, Stu still seems downcast about not being invited along. Mark, perhaps in acknowledgment, announces that we're at midpoint for this Third View trip and suggests that we clean up, finish a little Web work, then have a nice meal at the Stockman's restaurant instead of gobbling down coffee shop food, an idea that definitely brightens everyone's faces.

Over dinner Mark opens up the topic of how we think we're doing. Stu, his background as a production manager coming to the fore, has two things to say, which at face value sound contradictory. First, there's what he perceives as our need to increase our productivity, to establish a daily working template that focuses on capturing clean key images for the Web.

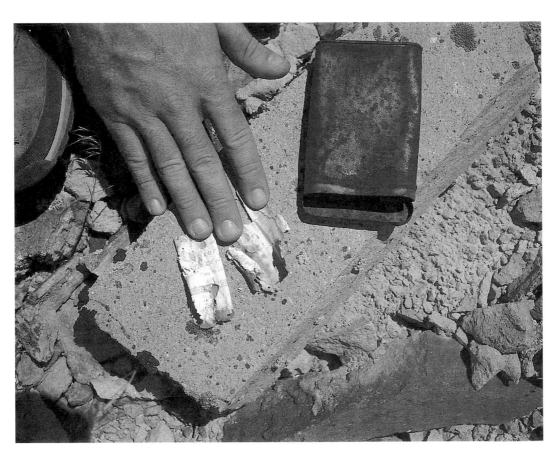

Mark Klett, *Tobacco tin with decayed paper contents, Karnak Ridge, 7/9/98.*

This would mean formalizing what we're doing half-assed already, which is discussing each night what we think is the most important metaphorical photograph, video image, or sound recording that best represents that day's site, then making sure we have enough time to edit properly and post it on the Web. The second need arises from Stu's status as a videographer in the graduate program: to make sure that each of us has time to do some work as an individual artist, to contribute equally to the image collection.

Mark lets each of us have a say, mostly variations on the points Stu has outlined, then he weighs in with the opposite of what I would have expected. Instead of going for increased work together, he urges each of us to set aside a portion of each day to go off on our own, even at the expense of production values, in order to discover things for ourselves. I realize that he's doing two things here. He's being a good teacher, telling us to think and see for ourselves, and to think about our own bodies of work. And he's making sure we're recharging our batteries, which will enable us to bring new viewpoints into the project. It's a smart resolution to the tension, which promptly drains away, the wine and beer no doubt helping, and a continuation of what he was telling Kyle a few days ago: Don't be a journalist; act more like a poet.

After dinner we sit with the computers, ensconced this time in Mark and Kyle's room, and preview the video that Toshi's been taking from the last several days. He has about an hour of assorted tapings from which a few minutes will be distilled as a sketch from the field. Stu and I beg off about 11:35 P.M., returning to our room next door, but Byron and Toshi want to stay up a little longer to edit some of the video and sound work. Before getting into

bed I check the weather out the window. Simultaneously an enormous bolt of lightning strikes a transformer a block away and a crash of thunder palpably concusses the window glass under my hand, followed by an immediate silence as the power goes down all over town. Within seconds a generator whines somewhere in the building and the lights are back on, but I feel sorry for the crew next door. Whatever they were right in the middle of doing on the computers will have been lost.

The storm lasts for only five minutes, several more lightning strikes continuing to wreak havoc with the power, the streetlights coming on, flickering off, then coming on again during a hard downpour. I crack the window and smell the opening of the desert as it is washed by the shower, turning away to get under the covers before the rain disappears entirely. Although I'm worried about how the guys must be tearing out their hair next door, I'm smiling as I fall asleep, the rain still falling.

July 10th, Fallon

The morning is all about frustration for some of us. The computer software has to be reinstalled and hours of work have been lost, plus the server in Tempe continues to act up. Here we are, walking around with thousands of more times the computer power carried on the first NASA shuttle that went up, and we can't manage to get information to people from around the country who are trying to track our progress. The idea had been to post the field notes and images each day, and to be able to receive and reply to questions as we went. It's a great concept, but we're caught in twin inflationary spirals of technology and expectations.

Unfortunately the technological capabilities aren't rising fast enough to meet the expectations. As if that weren't enough, the water in Fallon is so alkaline that Mark is having trouble washing out the negatives, which he has to rinse repeatedly before hanging on a line in the shower to dry, a decidedly low-tech, but effective solution he's used for years. Me, I'm lucky. I take my pad of paper and pen, sit in an empty alcove on the imitation mezzanine level of the hotel, and draft my field notes for transferring later to one of the laptops.

Checkout comes at noon, but Stu pushes it with the management and gets use of a free room and a phone line so he can continue to work with the Web site. The rest of us load gear into the vehicles, eat a quick lunch, and head out for Larger Soda Lake, driving west on the main commercial drag, which is a combination of Highway 50, the old Main Street (except it's named Maine Street, after the state, nothing in Fallon being exactly as it seems), and a depressingly long chain of new mini strip malls and fast-food joints. Four of the old change stations for the Pony Express are within spitting distance of Fallon, a town that has one of the densest historical backgrounds of any in Nevada, and I imagine the pony riders would have been thrilled to catch a hamburger and fries on the run.

The town got its start as a settlement of western expansion when Soda Lakes, where we're headed, was the terminus of the Forty Mile Desert trek, the most heavily trafficked trail on the way to California's gold fields following their discovery in 1849. In one year alone over 25,000 people made the journey, crossing their hearts and thanking their lucky stars when they got within sight of the lakes, which rest improbably in the middle of what was a relatively featureless plain. Eventually salt and soda were mined for export from the area,

scattered ranches and farms were established, and a post office and general store sprang up at the crossing of the roads leading to Austin and Virginia City and what was then the county seat, Stillwater. The big change came when Nevada's United States Senator Francis Newlands cut a deal with Teddy Roosevelt to establish the Reclamation Act of 1902. Work began on the country's first federal irrigation project with the construction of a dam in June 1903 on the Truckee River to divert a portion of its water toward Fallon. The ditch from the dam reached Fallon two years later but, even augmented with water from the Carson River to the south, utterly failed to moisten the sandy soils of the projected 400,000 acres to be reclaimed from the desert. Another dam was started in 1911 to create the Lahontan Reservoir on the Carson River, which eventually provided enough water to support in the early 1990s about 30,000 acres of alfalfa, over 70 percent of which is shipped out of state, mostly to California.

Constructing dams and impounding water was heroic work in the West through much of the twentieth century, a presumptuous habit we've exercised since the founding of the country, building to date 75,000 dams in America. Inhabitants of the Northern Hemisphere, in fact, have so dramatically altered the physical distribution of weight on the planet that we have literally slowed the rotational speed of the earth by a fraction of a second per year. How we engineered this can be calculated on my laptop, but there's no untangling the logic behind growing one of the most water-intensive crops known to mankind in the middle of one of the harshest deserts in America with federally subsidized water, only to ship the alfalfa over the Sierra, at no small cost in diesel fuel, to the farmers of the much wetter Central Valley of California—who are paid by the government not to grow the stuff.

All that being said, Fallon never fails to lift my heart, the inefficient use of water and the tacky plastic signs advertising speedboats for cruising on Lahontan notwithstanding. Frémont cottonwoods outlining a green oasis along the waterways are a welcome sight in summer, and as the nightly temperatures drop toward freezing in the fall and the big trees slow their photosynthetic tempo, the leaves turn yellow and gold. Fallon, like many of the older towns in the West, projects more than a little of the Midwest on its older streets, what for many Americans is an almost archetypal image of home. As we turn off the highway and pass some cottonwoods that are between five and six feet in diameter—they can grow over a hundred feet high and up to thirty-eight feet in circumference, given enough water— a trio of what I think are F-16s screeches overhead, a reminder of the other major industry in town, the U.S. Navy.

The first military airfield was built here in 1942, deserts being good places to train young pilots. Their crashes do damage to fewer civilians out here. According to a handout from the Churchill County Museum, the runway was extended in 1959 to 14,000 feet, the navy's longest, and in 1972 the base was promoted to status of a Naval Air Station. The Naval Strike Warfare College was established here in 1985, the Top Gun school moved up from San Diego, and now the base is command central for that enormous electronic warfare range just east over the Stillwater Mountains in Dixie Valley.

The early 1990s found Fallon in a very curious position. A prolonged drought in the Sierra Nevada severely diminished water flowing down the Truckee and Carson rivers, intensifying the fight among the developers in Reno, the farmers in Fallon, and the Indians at Pyramid

Lake downstream for water rights. The Truckee is the most legally contested river in America, and the farmers are the losers overall, unable to counter either the financial momentum of the suburbanization on the eastern slope of the Sierra, or the environmental and treaty claims of the Indians upheld in federal courts. Acre by acre the alfalfa crop in Fallon is diminishing as the farmers are forced to sell off their water rights. That would be enough to threaten the future of most towns in the West, except for the fact that the navy keeps increasing its presence, squeezed out of other parts of the arid West by the same creeping suburbs shifting the water politics. The results are a mixed blessing.

The old Oats Park School in the eastern part of town, which was in danger of abandonment, is being converted into a home for one of the best local arts councils in the region. A community college, founded in the early 1970s, continues to grow, as does the local history museum and archive. But agriculture is a chemically intensive industry, as is the military; the cancer rate in town is higher than it would be otherwise. And peaceably separating the testosterone-loaded fighter jockeys and ranch hands on Friday nights can keep local law enforcement on its toes.

The growth also means that places like Soda Lakes, a symmetrical crater large enough to host water-skiers this afternoon, are no longer surrounded by farms, but by a scattering of doublewides and prefab storage sheds. We drive up on the dirt road atop the eastern rim, park, and haul out the cameras. Kyle and Toshi take off to find some interviews, leaving Mark and Byron to wander back and forth lining up individual sagebrush with shoreline contours and the silhouettes of distant mountain ranges. It takes them from two

until three-forty-five to pinpoint the vantage, erosion having altered the shoreline of the lake, but once they have it, Marks says with satisfaction: "To a trained observer this will be a nice one, the kind the scientists like." He's referring to the fact that comparisons among the O'Sullivan original, Bushaw's second shot, and our third will provide accurate data about changes in the landforms and plant community. Unfortunately, this first shot was supposed to have been made around two, and the second half of the panorama O'Sullivan made here about three.

The wind has shifted from the southeast to the southwest and whitecaps now dot the water. The two photographers hurry to wrap up their series of shots, then hustle back north along the road to try and match the second one.

Two hours later they've finally found the position, but by now the whitecaps are trailing long lines of foam across the frothy lake, the shadows are so long that shooting is out of the question, and Mark can hardly keep his black T-shirt hooded over the camera.

"Well, this happens," he says as he collapses the tripod. "We lost several sites last year to wind. Let's go over to the other lake and see if we can at least locate our position there for tomorrow. We're going to have to spend another night here and drive to Virginia City tomorrow instead of this afternoon."

The smaller of the two lakes is easier to calibrate against the Second View photograph, and the guys are wrapping up their calculations by 6:20. Stu, who drove up to check on us a little earlier, has driven around to the far side, and we can see him casting a fishing line out into the calmer waters of early evening. The original O'Sullivan two-part panorama of Larger Soda Lake from 131 years ago shows three figures standing above the lake, and

one sitting. All four men carry shotguns. I walk a slow spiral out from the camera and count 106 plastic shotgun shells within a six-yard radius. It's disquieting to see that shooting takes place so close to where kids' bikes sit in the front yards of homes a couple of hundred yards away.

A green truck pulls up next to us with a man and woman inside, the owners of the property where we're standing. I grab the *Second View* book and go to explain what we're doing so Mark and Byron can wrap up. The conversation that takes place with Dave and Esther is revealing.

First, there's the issue of the fence posts we'd driven through, a series of green metal stakes planted in the ground but as yet unconnected by wire. Seems they planned to close off their quarter of the smaller lake about a year ago, which would have eliminated the only access wide enough to accommodate boaters headed for the larger lake. Dave says they've been too busy to finish the fence, but allows that the local newspaper did report at length the outrage of the local citizenry over the privatization.

Esther has remained quiet during most of Dave's spiel, but she's been examining the photos and rephotos in the book, intrigued as almost everyone to whom we show the book is by the changes around her made visible. She points out to Dave how empty the land they now occupy was over a century ago, and tells us that the Newlands Irrigation Project, when finally delivering enough water to irrigate the fields, raised the local water table. So much water flowed into the lakes that it drowned the soda mine on the shore. Now you can only visit the old machinery by scuba diving.

What started out as a potentially tense moment with landowners who have marked their territorial imperative with metal stakes turns out to be a civil exchange of histories. It's the first time I've been the one to show the book to local residents while we're working, and I'm deeply bemused by how this particular art project is taken to heart by people. My thoughts are interrupted by Kyle and Toshi driving up, who report they have great video of the site where Rag Town used to exist. Used by the emigrants as their camping spot after the desert crossing, and supposedly named after the sight of laundry hanging from tree limbs to dry, now it's a "manufactured home sales lot." It's a very sheer historical juxtaposition and they're anxious to review what they shot.

We pack up, return to the hotel where we've managed to re-book new rooms identical to last night's, then walk down the street for a leisurely meal at the Golden Rice Bowl. Back in front of the computers by ten o'clock, we watch videos by Stu and Toshi. Stu has videoed with breathtaking verisimilitude Kyle's wrestling match with his flat tire at the "Cheetah" site, the camera at undercarriage level capturing his subsequent dance with the jack handle and slowly lifting tire, which is choreographed to a fluent string of unusual expletives. It's a performance piece that to us seems to be a perfect simile for all our struggles with recalcitrant computers, bewildered hotel clerks, and the infamous afternoon zephyrs of Nevada. On the other hand, Toshi's almost poetic video notes on Rag Town are oddly moving. Shot almost casually, his vantage point moving to follow whatever interests his eye, it lacks the linear and narrative quality Stu has used, but assembles a picture of mobile homes beneath the flapping sales lot flags that is both ironic and touching.

While the videos play Stu is on the G3 laptop trying to dial up our Web site, but once again it looks like the server may be out, and there's still no feedback from anyone, a blow to his professional pride, though it's not at all his fault. Yesterday Byron had told me that one of the hardest lessons for photography students to learn is how to deal with disappointment, to accept failure. "Pictures seldom come out the way you plan," was the way he put it, and I wonder how Stu will accept that more sophisticated technology doesn't raise the probability of success. This is also why Mark has brought back from dinner tonight his fortune cookie homily: "Nature, time, and patience are the three great physicians."

"That's what rephotography is all about," he'd said at dinner when unwrapping the little piece of paper and reading it out loud to the table. "We have to get this into the artifacts." Kyle's epic swearing at the flat tire may not make it onto the Web site, but this little piece of found poetry surely will.

July 11th

The server is back up, the field notes are current, and we're checked out by 11 A.M. This time Stu will go with Mark and Byron to finish up the shooting at Soda Lakes, while I prowl around town with Kyle and Toshi. Our first stop is a shoe repair place in one of the mini malls to buy a tube of Shoe Goo. The toe on the sole of my left trail shoe was sheared off while I was descending the sharp debris beneath Karnak Ridge, the hiker's version of a flat tire.

At noon we enter the Churchill County Museum, a surprisingly comprehensive local history museum. Thousands of arrowheads collected earlier in the century are displayed

under glass in star-shaped arrays almost identical to the patterns on the hand-sewn quilts in the next room. Yet another gallery is devoted to tracing the flow of water from Lake Tahoe to Pyramid Lake and Fallon, and the most frequent subject of the historical photographs is the Newlands Irrigation Project, including the construction of Lahontan Dam. Kyle photographs stuffed birds in their cases, surprised to find one species that he was used to seeing in Maine, the Old Squaw duck, standing next to canvasbacks and pintails, all of them seasonal residents of the Stillwater Marshes northeast of town, at least in those years wet enough that water is left over from the irrigation to make its way out there. Toshi is entranced by and takes a video of the mannequin face of a brunette wearing a Victorian dress.

After lunch we drive out to check on the Soda Lake crew. Mark has successfully completed work at the larger lake but needs another hour to finish rephotographing the smaller one. Kyle and I decide to go on a quest for a bottle of single-malt scotch, and we drive to the nearest liquor store, a brand new establishment that on this Saturday afternoon is hosting a wine and beer tasting. Sure enough, tents are set outside what one can only call a "booze and bullets" store, that peculiar institution offering Jack Daniels and shotgun shells under a single roof. One-stop weekend shopping. We admire the modest wine selection and find the scotches downright disappointing, but the selection of 9mm Glocks and assorted semiautomatic weaponry we usually associate with urban assault scenarios is truly impressive. Amidst all the display of weaponry, I finally succumb to peer pressure and buy a "micro" Leatherman, the smallest model available, more of a key-ring accessory than a serious tool.

One of the places Fallonites go to consume their beer while expending ammo is a large excavation out by Soda Lakes, the last site we visit before leaving. Mark, like many artists who live in the desert, is a connoisseur of refuse; he picks through the discarded Big Wheels, Bud bottles, baby shoes, television sets and toasters, the women's pink pumps and men's suit jackets with a practiced eye, not finding anything inherently remarkable. Overall, the place looks like a dump, but it's not. That's across town. What's interesting about the site is that the objects in it, including the toys, are used for targets. This is the neighborhood shooting range. The integration of shooting into daily life is pervasive throughout rural America, but nowhere else as visibly as in the desert. You might see jet fighters loosing missiles overhead as you drive down the highway across Dixie Valley, duck hunters poaching the protected marshes, or photographers pointing and shooting with high-precision optics. We leave the sandy pit with a sense of relief and drive back down to the highway, ready to establish a new camp in Virginia City in the mountains to the west.

We soon pass Lahontan Reservoir, which is cresting today at the height of the summer runoff from the heavy El Niño winter. In a day or two it will start to lose water, up to twelve feet through irrigation draw-downs and evaporation. As we drive by the inundated shoreline, cottonwoods standing deep in the still rising waters, I wonder out loud to Mark if the irrigation district officials are correct in predicting a mild La Niña winter to follow. They've decided this month to keep the reservoir at record high levels in anticipation of such, a wise precaution. If they're wrong, it won't be stands of cottonwood that are submerged, but the fields of Fallon.

At the Silver Springs intersection several miles past the reservoir several hundred cars are gathered around neon-bright powerboats hitched to pickups. It's the registration site for a fishing derby to be held at Lahontan, a surreal sight in the desert that tempts Mark to take a picture, but we drive on.

5:00 P.M. The filly is lying on her side, legs splayed stiffly out, her belly just beginning to bloat. Her left shoulder and front knee are scraped raw where she hit the pavement after being clipped by a passing vehicle. Across the highway a half-dozen horses gather behind a fence to watch us photograph her, one of their feral cousins. Wild horses are so common now in northern Nevada that they're foraging in daylight along the highways. I want to touch her, to assuage the guilt I'm automatically assuming whenever around a wild animal killed accidentally by a human, but I walk away, leaving the guys to do their work.

This part of the desert is half stand-alone community and half bedroom suburb for the state's capitol, Carson City, which is less than an hour down the road. It's being filled in quickly with a depressing mixture of small housing developments, mini storage facilities, prisons, and toy ranchettes, a pattern of growth as common to New Mexico as Nevada. Anywhere else in the country the change would be softened and even hidden by vegetation and terrain; here it stands out on the arid flats like a skin cancer. We're close to the old Pony Express route, and the dead horse is a sharp reminder of the head-on collision between Old West romanticism and millennial exurban sprawl. A few miles up the road on the outskirts of Dayton we pass a hit-and-run deer, then a flattened skunk. My spirits stay low until we start to wind up into the mountains toward the largest historical district in America.

177

Byron Wolfe, *A wild horse who came looking for food, near Mule Flats, Nevada,* August 9, 1998.

A sprawling collection of gold and silver mines covering over a hundred square miles, the Comstock Lode was first opened up in the late 1850s, part of a backwash of miners retreating from the already staked-out gold fields in California. The discovery in the summer of 1859 that the hills here contained some of the most pure silver available to pick-and-shovel brought ten thousand people to Virginia City within a year, part of a migration that included some of my ancestors. My great-granduncle was born here, right about the time Timothy O'Sullivan was taking his photographs in the mines. George Lyman grew up and became a doctor in Palo Alto, in his spare time writing a series of novels and books about the heyday of the region, and amassing what was once described as one of the largest collections of Californiana in the West. Despite the overbearing crush of an estimated three million tourists who visit the area each year, the place retains its mystique for me.

Mark pulls off just above the hairpin between Gold Hill and Virginia City proper to check out what is now an open pit mine, one of the rephoto sites. In the 1980s an expansion of the mine threatened to swallow the oldest hotel in the state, but since the Second View rephoto made in 1979, not as much has actually changed as Mark had expected. Mostly erosion has been at work here, not miners. The perimeter of the pit is fenced off, and obtaining one of the vantage points during the next few days may be difficult, if not impossible.

Not until 8:30 in the evening do we find a place to camp off the dirt road that leads downhill from Virginia City through Sixmile Canyon. I dub our choice "Arsenic Flat" after the sickly white powder of mining effluvia that coats the ground. It's the only spot large enough to hold our four vehicles, tents, and cooking tables, but not a place I hope to stay in for more

than a night. Despite appearing to be what I joke must be an EPA cleanup site, we can see or hear numerous lizards, ground squirrels, deer tracks, and a marmot in the rocks above us, just barely visible in the fast-fading light. Kyle even spots a lazuli bunting singing from the top of a cottonwood tree, an addition to my haphazardly maintained life-list.

At 5,600 feet our campsite is located once again up in the piñon-juniper woodlands, and a small creek runs down to the confluence of the Sevenmile and Sixmile canyons, a rephoto site that, when O'Sullivan documented it, held a vigorous collection of mine and mill buildings. The last time I drove Sixmile Canyon it was in a Jeep over a deeply rutted dirt track. Now it's a paved road. During dinner, music from a county fair drifts down from Virginia City and a spotlight sweeps the sky. The periodic blasts of a whistle from the narrow-gauge steam engine floats owlishly through the hills. It's slightly idyllic, but earlier, as we turned off the pavement to probe up Sevenmile for our campsite, we passed several elaborate target arrays built into the hillside across the stream. It's the ever-present juxtaposition of nature to violence, which has formed a backdrop to much of Klett's work since moving to Arizona after completing the Second View work.

Chapter Eight

THE TERRITORY REVEALED

When Klett started work at Arizona State University in February 1982, the work he had been preparing to do for years was suddenly available for him to explore. Out from underneath the relatively formalistic strictures of the rephotographic methodology, and still mildly disoriented by the foreign languages, customs, and landscapes of Nepal, he beheld a desert territory fresh to his eye. Although on staff in the arts at the university, he was not burdened with the responsibilities of classroom and committee duties, and was thus able to undertake a decade of road and camping trips through which he would take free measure of contemporary life in the West. While retaining strong links to O'Sullivan and other nineteenth-century landscape photographers, often by visually quoting their vantage points and subject matter, Klett now used his experiences in Idaho and Nepal to inform his personal vision of the region.

Skilled at using the view camera quickly to capture moments in the field, and liberated by the knowledge that the memorialization of personal events was a legitimate subject matter for him, during the next ten years he produced series after series of Polaroid photographs, most of them bearing what would become his signature style for the period. The large-format black-and-white prints would include the encircling stain of developing chemicals peculiar to the Polaroids as a kind of frame within the frame, a visual device Klett discovered by happenstance in 1979 when using the Polaroid film back in Idaho. Other photographers were at pains to eliminate this evidence of the photographic process, a trend established by George Eastman and reinforced ever since by his corporate progeny when they removed the messy business of developing film and creating prints from the hands of the masses and

hid it in photo factories. Klett retained it as a way of reminding the viewer that his photographs were not only artifacts, but ones constructed in the field. In addition, most of his prints would bear writing along their bottom edges, descriptive journal entries penned in silver ink as titles that further emphasized the processing of the moment, similar to the recording practices of his nineteenth-century predecessors.

Klett published two books of images from this period in his life. The first was *Traces of Eden* (1986) from David R. Godine in Boston, a collection of nineteen photographs, three of them in color. The earliest picture, in acknowledgment of the photographer's own past, is that of a friend working in her Idaho garden during early September 1981. The most recent image included was a photo of the Sonoran desert floor; taken three years later almost to the day, a saguaro cactus in the foreground replaces the lawn and flowers. Whitewashed rocks spelling out *Phoenix* hover in the far background. The title, "Desert marker," is scrawled in the lower left-hand corner, establishing a dialogue between the two elements, one a signifier of our culture, and one of nature. The ever-present time of the natural world is contrasted—almost casually, so effortlessly does the juxtaposition take place—with the more temporary clock of our civilization.

The images in the book are bracketed with essays by the poet and novelist Denis Johnson, and by Peter Galassi, then an associate curator for photography at the Museum of Modern Art in New York, whom Klett had met just prior to beginning the rephotographic survey. As Johnson said in his essay, when the artist succeeds in representing the desert, as Klett does, the frame of the picture becomes itself "the border of sight." He had ceased reacting

to trends in historical and contemporary landscape art, and become one of a handful of people whose visual work defined the leading edge of our evolving relationship with the land.

The other book, *Revealing Territory*, published by the University of New Mexico Press in 1992, was a much larger selection of his nonrephotographic work. The 110 black-and-white images included some from the previous book and an important five-panel color panorama. The lead essay was by Patricia Limerick, who by then had become known for her recasting of the region's historical process as embedded in an "unbroken past," in sharp contrast to the traditional historians who earlier had contended that western history ended with the closing of the frontier. Her lengthy meditation weaves together the continuous economic and political realities of the West with Klett's unique ability to retain a historical awareness in his contemporary images while "creatively unsettling" our perceptions of the region. The book concludes with an appraisal of Klett's career to date by his old friend from St. Lawrence University, Thomas Southall, who traced his growth as a photographer from the RSP onward. The title of the book, like that of his earlier collection, had more than one meaning. *Traces of Eden* implied the dry desert was once a paradise: although dry, it had the virtue of co-existing with humans in a relatively undisturbed condition. Fragments of that earlier state of grace are still left in the landscape, and the photographs are what a literary theorist would define as a trace. The territory of the second book is both a place filled with evidence of our presence, and one devoid of vegetation where such things are revealed. The act of revelation is also a transformation performed through neuroscience, optics, and chemistry by the artist as the images unveil themselves through his eye, the lens, and in the darkroom.

Revealing Territory was an important publication in the world of landscape photography, and the range of Klett's life and work in the 1980s is most easily traced today through an examination of its plates year by year. As he told Thomas Southall after a book meeting in Albuquerque prior to publication, "This is the best I can do." The book was a summation of his work through the beginning of the 1990s; afterwards, he would take on a new set of challenges as he continued to help redefine and reinvent contemporary landscape photography in America.

The first year covered by *Revealing Territory*, 1982, gives us petroglyphs on a rock, a bullet-riddled saguaro, and graffiti on a subdivision wall, all in Arizona; the landing of the space shuttle Columbia at Edwards Air Force Base in California; Chaco Canyon ruins in New Mexico; and, "A portrait of the artist atop a small hill on his 30th birthday," Klett silhouetted so far away on a rock formation on Phoenix that he is virtually anonymous. Much of what he will grapple with throughout subsequent years is here—our violence against nature, technology in the landscape, the place of the artist in nature.

A much-reproduced image from 1982, "Campsite reached by boat through watery canyons, Lake Powell, 8/20/83," evokes several of these issues at once, a layering not unusual for a Klett picture. Appearing in both *Traces of Eden* and *Revealing Territory*, the image is, as noted by Limerick in her essay, "a streamlined version of rephotography." When viewing it some people will re-envision the Colorado River of Timothy O'Sullivan's time, when he documented Wheeler's exploration in 1871 from his boat nicknamed *The Picture*. Or they will remember the stunning color images made by Eliot Porter and others of Glen Canyon in

Mark Klett, *Campsite reached by boat through watery canyons, Lake Powell, 8/20/83.*

The Place No One Knew, a Sierra Club book published in 1963, a lament over the transformation of one of the most amazing canyons in the world into a reservoir to capture the silt prematurely filling up Lake Mead. Klett's photograph, which shows a powerboat anchored in a placid cove framed by dramatic sandstone formations, leaves us ambivalent. No matter how much we might decry the damming of the river, the artificially created recreational setting is exquisite. No matter how much we might lament the intrusion of campers in the landscape—in this case the figures themselves are absent, but their campfire is still smoking and a pair of lawn chairs sit nearby—we admit to wanting to be in the picture. It is, simply and quietly, inviting. Klett has made a series of Lake Powell photographs over the years, and in many, a modern boat echoes O'Sullivan's *The Picture,* just as Klett's truck often remind us of the earlier photographer including his ambulance in the frame.

Mutilated saguaros form a subset for Klett among several of his ongoing series that deal with violence in the landscape, a theme also worked extensively by fellow artist Richard Misrach in his series *Desert Cantos*. In *Revealing Territory*, a 1984 photograph of saguaros toppled in the path of a new golf course face a pair of the giant cacti in photos on the opposing page. One has a cactus standing on the edge of the bulldozed desert in Carefree, a luxury development that at the time was just being built near Phoenix. The multilimbed giant is handsome and healthy, so vigorous that its top projects out of the image proper and into the frame of the developing edge. Its companion photo is entitled "Shriveled saguaro, record dry spell, Scottsdale, Arizona," its arms hanging dejectedly downward. The implications are multiple: we can destroy the cacti or leave them be, and nature itself also does damage

to the vegetation. We're not the only cause of destruction loose in the landscape, though surely we compound it through terraforming and groundwater depletion. In contrast to its upright partner, the shriveled saguaro is one that will be bulldozed by the encroaching development because it doesn't fit the developer's conventional notion of beauty.

Two earlier images of saguaros flicker just out of sight here. One is O'Sullivan's "Cereus Giganteus" made in Arizona in 1871, a profoundly detailed albumen print of several saguaros that was included in Wheeler's report; the other is a well-known photo by Klett from 1982, "Bullet-riddled saguaro near Fountain Hills, Arizona." In the latter, an image reprinted from *Traces of Eden* and given prominence opposite the title page of the second book, a lone and dignified cactus is perforated through and through with multiple gunshot wounds, its short arms apparently lifted upward in a gesture of beseechment.

Using words such as *dignified* and *wounds* and *arms* certainly anthropomorphizes the cactus, but that is only to state how we perceive it, a helpless growth unable to protect itself being used for target practice. The rhetoric of the photographs, even if not overt, is not all that subtle, but neither is it uncomplicated. Klett knows he is "aiming" a camera and "shooting" a picture, which forces its own kind of dominance upon the scene. As in the case of the Lake Powell pictures, the interleaving of nature and culture is inescapable and the shades of gray nearly innumerable.

In 1984 Klett became involved in documenting the Central Arizona Project, a year-long study involving three other photographers. Sponsored by the Center for Creative Photography in Tucson to photograph the building of the 307-mile canal bringing water into Phoenix

Mark Klett, *Bullet-riddled saguaro near Fountain Hills, Arizona, 11/21/82.*

188

and Tucson from the Colorado River, it is a harbinger of much more work Klett would produce dealing with water issues. Plate 32 in *Revealing Territory* is a handsome example of the work Klett contributed to the subsequent exhibition and catalog. "Engineering oasis, Central Arizona Project canal awaiting water," taken in October 1984, is an example of how eloquent supposedly straight documentary photography can be. The five major parallel elements of the canal's bed, sides, and twin access roads run from the foreground toward the severe vanishing point of the desert, which is a ground darkened by an overcast sky. A patch of sunlight in the middle of the frame breaks across the canal, its horizontal band almost forming a crucifix with the vertical geometry. The emptiness of the canal proposes the ambition of the project against the folly of the desert, but where a lesser artist might have taken a straight shot of imperial waterworks, Klett has included a rain shower in the far right-hand background, once again complicating the picture. The desert is not without water; the issue is how we channel it.

Among the many notable images from 1985 in the book is one that provides a context for the Las Vegas Strip rarely seen in photography. On the highway between the city and Hoover Dam is a lone casino. It rises improbably alongside the road and is almost invisible until you are driving by the parking lot. But, at dusk from a certain point on the road, its brightly lit sign is just visible in the distance, totally surrounded by the arid and nearly dark hills. We wouldn't know exactly what it is, save for the title on the print. By paying attention to this single example of the neon culture within the otherwise empty landscape, Klett is able to highlight for us the city's physical context. He does it by slipping around

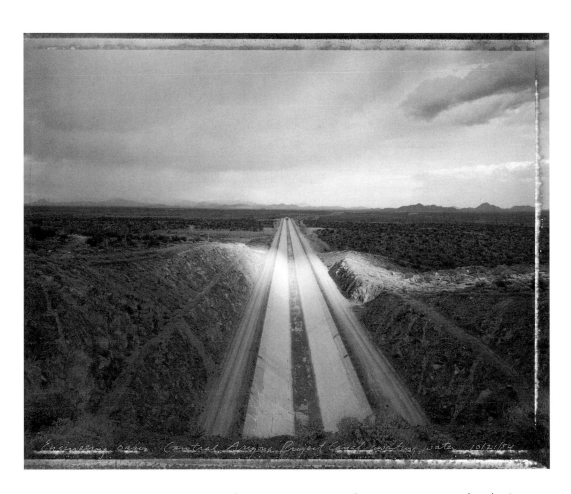

Mark Klett, *Engineering oasis, Central Arizona Project canal awaiting water, 10/21/84.*

the Strip's blinding excess of glitter, which is a deliberate visual distraction designed to make us forget where we are. The flip side of the photograph, of course, is that the dark desert is intimidating and the light of civilized comfort and security is beckoning, just as were the lawn chairs at the campsite on Lake Powell.

Of all the sites in the Southwest, none has been represented more than the Grand Canyon, a subject for painters from Thomas Moran to David Hockney, and for photographers from O'Sullivan to Ansel Adams to Klett. The only color reproduction of the book is quite sensibly devoted to Klett's 1986 five-part panorama, "Around Toroweap Point, just before and after sundown, beginning and ending with views used by J. K. Hillers over one hundred years earlier, Grand Canyon."

The Grand Canyon presents unique challenges to photographers. When John Wesley Powell sent Clarence Dutton to examine the geology of the region, Dutton took with him the foremost topographical illustrator of the century, William H. Holmes. Cameras, although useful to a degree, were unable to penetrate the atmospheric haze to untangle the complexity of multiple strata in the canyon walls. Holmes could clearly portray individual strata from underneath his feet out to eighty-five miles distant; his work was so accurate it remained scientifically valuable throughout most of the twentieth century.

Another problem is the shift of light, shadow, and color; even on a cloudless day the hues can slide radically within a few minutes. Because of the recursively folded and refolded walls, sunlight foregrounds a feature one minute and shades it back the next. Add the presence of clouds, even relatively high ones, and the situation becomes enormously complicated.

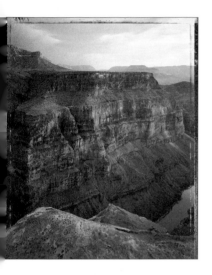 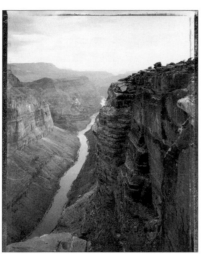

Mark Klett, *Around Toroweap
Point, just before and after
sundown, beginning and ending
with views used by J. K. Hillers
over one hundred years earlier,
Grand Canyon, 8/17/86.*

Many painters and photographers have made numerous and excellent pictures of individual moments within the canyon, but few have been able to compress a continuum of so many changes onto a static page as Klett has in "Around Toroweap. . . ."

John Hillers, a teamster who bumped into Powell in Salt Lake City in 1871 and was hired to work on the major's second Colorado River expedition of that year, taught himself wet-plate photography while boating down the river. He became so accomplished that he supplanted the official photographer hired for the journey. When Powell became head of the USGS, he named Hillers as the agency's chief photographer. But even Hillers, making a set of views up and down the river from Toroweap Point, couldn't capture more than a slightly expanded sense of the canyon's visual complexities.

Klett has some advantages, the most notable being color film and the evolution of the medium's aesthetic. Starting with his leftmost frame, looking east and upstream from the vantage point on the North Rim, the river is a dull pewter in shadow, but the mesa tops defining the reach of our view are slightly bleached out in an afternoon sunlight that is still strong. The next frame shows the cliff tops beginning to glow in a declining sun, the shadow of the formation where the photographer is standing thrown across the river. In the foreground is Klett's hat, formal acknowledgment of both his presence and his invisibility. The hat sits on the rim of the canyon, a slightly comic gesture, yet looking as if the owner had stepped into the immense space and dropped from view. The third and middle frame holds the brightest hues, the last direct light of the day shining onto the sandstone layers. In neither the second nor third frames is the river visible, our gaze extending out level to the horizon and tending

to stay up out of the depths. Panning right, to the west and down river, the water is once again visible and pulls down our vision. The entire scene from canyon top to river bottom is infused with an indirect but evenly saturated light, and the clouds in the background have assumed some color from the setting sun. In the fifth, final, and latest frame of the day after sunset, the river becomes a silver shining presence at the far end of our view as the individual features of the geology begin to fade.

None of the frames precisely adjoins another, sometimes visibly overlapping, the foreground changing as Klett moved from one stance to another. There is a definite lapse in time from frame to frame and none of the color is balanced exactly from view to view. White space between each of the pictures destroys any allusion to seamless panoramas. In short, discontinuity seems the rule, yet the view has a satisfying unity. The permutating angles, colors, and shadows during a perceptible span of time are exactly how we experience the Grand Canyon. The addition of the hat, a nod to Hillers and acknowledgment of Klett's presence, completes the picture by adding to our sense of geological time the passage of human history. It also embodies our imagined vantage point, as viewers, with the presence of the photographer. "Around Toroweap" is arguably and simultaneously one of the most outright gorgeous yet thoughtful photographic representations of a scenic climax ever made, and to date perhaps the most satisfying of the many Grand Canyon pictures taken by Klett.

The book's photographs from the following year include eight that bring signage into the mix. They vary from petroglyphs to intaglios drawn in the dirt by tire tracks, from a graveyard headstone to contemporary initials carved in ancient ruins. The juxtapositions

of hallucinatory Anasazi symbols with graffiti, the declarative simplicities of death and the exuberance of a motorized track inscribed on the ground, require some flipping back and forth among the pages, making the reader a physical participant in the construction of meaning, as if we were reading the landscape like a book, a clever trope. Other photographs taken that year include, as always, those devoted to collecting evidence of violence—for example, the disturbing "Gun found in drifting sand, Kelso, California." Klett admits that it was a toy gun he found resting on the ground, a fact not readily apparent to the viewer. But, the image is no less unsettling for that than the previous one, where Klett has placed his open pocketknife underneath a series of "small dancers" pecked into the rock and holding hands. The gun despoils what we presume to be the pristine innocence of a wild dune. The knife, a play on the nineteenth-century convention of placing a human object in a picture to provide scale, seems to threaten the rock art figures with its open blade. Klett thus manages to conflate three time scales by the introduction of a physical scale.

Two automotive images from 1989 are played off across from each other, arithmetically progressing the compound meanings of each. In the first, "View from the truck: driving below Comb Ridge," we are inside the cab of Klett's pickup looking out the passenger window at a slightly out-of-focus view of a sandstone formation receding into the distance. A view of the other end of the ridge, composed of very similar geological forms, recedes in the outside rearview mirror—perfectly in focus. A hand rests on the windowsill, visible in both the foreground and in the image reflected to us from the mirror. It's one of those Klett shots that looks casual, as if it were just a snapshot taken out of the car, until you notice

that wrap-around frame of Polaroid chemicals and realize he's working with a view camera in a very confined space. And that what is in focus in the mirror must have been harder to achieve than simply the view out of the window. And that hindsight is clearer than what is in front of us. And that the frame of the mirror includes the hand of the artist as well as the window of the picture. Here the artist proves that Szarkowski's "mirrors and windows" can be one and the same in a single instance. The image is not only layered, but folded upon itself.

Facing this complicated composition, which echoes Klett's graduate training as a formalist, is the second image, the small petroglyph of a car carved into the base of a rock in Utah's Canyonlands. The incongruous concatenation of contemporary automobile with ancient rock art, although technically a defacement, is also funny. It reminds us how totemic we have made our cars, and how dependent we are upon them and the entire fossil-fuel industry to experience wilderness.

The last fifteen images in *Revealing Territory* are from the series of saguaro portraits that Klett called *Desert Citizens*, an indexical body of work identifying types of cacti forms from single poles to complicated knots to cacti grown into shapes of the alphabet. Klett is standing self-consciously in the long tradition of using photography to catalog the world around us, from Frith's Egyptian temples and O'Sullivan's geological formations, to the immense astronomical bodies found in Edwin Hubble's *Atlas of the Galaxies,* taken at the Mt. Wilson Observatory during the twentieth century. This series will eventually bring us back to the issue of science in Klett's life.

Looking through *Revealing Territory*, it is clear that Klett often was making strange the landscape by isolating visual elements within it that we usually overlook. Other artists, from Stieglitz to Ansel Adams, had long spoken of the photographer's goal as finding, and sometimes even creating, a unifying order out of the visual chaos we take to be the world. Klett, on the other hand, in culling over three hundred images for the photographs he would include in *Revealing Territory*, was seeking out evidence of the chaos, the patterned randomness of gunshots, discarded toys and appliances, the tire tracks of off-road vehicles. In the Afterword to the collection, he wrote: "I am not much interested in discovering new territories to photograph. Instead, what I wish my pictures could do is lessen the distance one often feels when looking at landscape photographs. . . . The longer I work, the more important it is to me to make photographs that tell my story as a participant, and not just an observer of the land." Standing back and taking a wider look at Klett's total body of work at the end of 1980s, one can discern what the next steps would be.

In addition to working on his own images, Klett continued during that decade to participate in other kinds of projects. His public reputation and identity as a photographer prior to publication of *Revealing Territory* was based primarily on his work as the chief rephotographer in Second View, and he was offered commissions from the cities of Tallahassee and Oklahoma City to rephotograph them in 1989 and 1991, respectively. In addition to the Central Arizona collaboration, he also worked as the principal photographer within a team of writers, researchers, and photographers to produce *Headlands: The Marin Coast at the Golden Gate,* published in 1989 by the University of New Mexico Press, a project that

involved both new and rephotographic shots. In 1990 he also collaborated with Patricia Limerick on the photo essay "Haunted by Rhyolite: Learning from the Landscape of Failure." His photographs taken in and looking down upon the ghost town were a brooding accompaniment to her ruminations over how, once we had colonized the West and run out of places where we could outrun the effects of our history, there was nothing left to make out of our ruins but a "romance of failure," which, in turn, became the economic capital out of which we could create tourism. That same year Klett redid Eadweard Muybridge's 1878 panorama of San Francisco, which later led in 1993 to his accepting a commission from the Smithsonian's National Museum of American Art to make a panorama of Washington, D.C., creating, as it were, not just a circle in space, but a spiral through time.

All of Klett's work is related by theme and methodology, but how we "document" the environment, as in the Central Arizona Project, is the overarching concern throughout. Klett is not a straight documentarian. Instead he uses the documentary process and our idea of picturing singular documentary objects as synecdoches for larger issues, particularly ecological ones, as norms of artistic behavior from which he can move outward. He's more interested in the poetry of the issues than in the arguments surrounding them. And here is where we come back to his colleague Ellen Manchester. The same year that Klett moved to Arizona, 1982, Ellen and Robert Dawson began a relationship that would lead to marriage the next year. Their honeymoon was a photographic tour of "toxic waste sites in the American West," as Dawson puts it. Most of us might consider their itinerary a nightmare, but for artists who were intent on using the science of ecology as a subject matter, it was a dream.

Born in Sacramento in 1950, Dawson originally majored in psychology at the University of California, Santa Cruz, where he studied the nature of creativity, but by 1974 he had decided that he himself wanted to be creative. He had taken photographs since he was a kid, so he naturally started with photography, first taking classes at a community college in Aptos, where he became a lab assistant, and then at San Francisco State University where he earned his MFA in 1980. Dawson had been taking landscape photographs in the style of Ansel Adams, but graduate school kicked him into a new level of aesthetic awareness. At the same time, beginning in 1979 and running through 1982, Dawson photographed extensively around Mono Lake, a prehistoric remnant body of highly saline water in the eastern Sierra that the Los Angeles Department of Water and Power was attempting to siphon off for the growing population down south. The campaign to save Mono Lake was a grassroots effort run by Steve Johnson and was very dependent upon selling images of the lake not only to raise funds, but also, in the tradition of the Sierra Club exhibit books, to obtain favorable public opinion and political leverage. In 1982 the campaign published a book about the lake, which featured many of Dawson's photographs, and the "DWP" water grab was defeated. Like Dawson, Johnson was from the Great Central Valley of California, which Dawson refers to as "one of the largest human-modified places in the world." In addition to wanting to know more about where he had grown up, the psych major in Dawson was also interested in how the environment in which we are raised shapes how we see things. Together with Johnson, Dawson embarked on an ambitious project to photograph the Central Valley, in four years raising $150,000 in order to do the work and

exhibit it. He was finished with his part of the project in 1986, though Johnson worked on the book for another four years with the noted Central Valley writer Gerald Haslam. The book, *The Great Central Valley: America's Heartland*, was finally published to national attention and critical acclaim in 1993.

While documenting the agribusiness of the valley, Dawson realized that water was the most fundamental issue underlying the work he had done in the past, and he began to pursue, during the summers as his personal project, images of waterworks throughout the West. He and Ellen found the topic to be so enormous, however, both in terms of history and the number of physical sites that needed documenting, that in 1989 they turned to two of their colleagues for help, Peter Goin, a photographer originally from the Bay Area who was now teaching at the University of Nevada at Reno, and Mark Klett. They held their first informal Water in the West meeting in Snowmass that year during, appropriately enough, "The Political Landscape" photography conference. In March 1990 the group's first formal gathering was held at the Headlands Center for the Arts. The most notable contemporary photographers who had an affinity for dealing with the subject were invited, including Laurie Brown, Gregory Conniff, Terry Evans, Wanda Hammerback, and Martin Stupich. (Richard Misrach and Meridel Rubinstein had been queried about joining the group, but declined for various reasons).

In her introduction to *Arid Waters,* a book containing some of the project's work that was published by the University of Nevada in 1992, Ellen Manchester acknowledges that the collaborative nature of Water in the West was directly influenced by the experiences she

and Mark had with the Rephotographic Survey. Although some members of the group wanted a more codified working situation—Peter Goin even pushing for a political manifesto—the attitude that they had developed through the RSP prevailed. "Water in the West became the sum of individual projects," is the way Dawson puts it.

Klett's view of the project is that there was never a preconceived agenda, which fit well his nature as "an intuitive photographer who lets meaning arise out of being in a place and working." When pressed further about the differing working methods of his contemporaries, he states how important it was for him not to be "just going out into the landscape and taking 'important trophy pictures' as a heroic gesture." He puts the "trophy" business in quotes with his fingers to emphasize how he wishes to distinguish his working methods from how we perceive, say, those of Ansel Adams. The importance of the project for him, in fact, was that working in collaboration was antithetical to the trend in the field for individual photographers to put career advancement ahead of concern for what they were photographing.

As Manchester quoted Klett in the introduction, his stance was that of the informed observer: "I am interested in making photographs which comment on the experience of a place as well as describe it. My position has not typically been one of advocacy for or against any political position. But I regard photographs as commentary, and that includes, at times, taking a specific political viewpoint on an issue." One of the photographs he contributed to the Water in the West project was also included in *Revealing Territory*, "Boatman's Sandal Print, San Juan River, 9/27/90." The imprint from a high-tech synthetic sole is centered

large in the frame; dried droplets of dirt surround it on the rippled mud. The photograph is finely detailed but politically mute; it contains almost no shades other than the middle grays typical of the Kodabromide paper Klett had been printing on throughout the previous decade, a range equivalent to our judgment of the image's implications. The footprint represents an almost stereotypical picture of healthy outdoor activity, boating on a western river. It is also a visible trace we have left in an environment otherwise unsullied, evidence of the disturbance caused by our passage with all its attendant problems. Further, it again belies the notion that the desert is without rivers and water. The issues raised are as complex as your knowledge of the context and how long you wish to think about them. But there's no judgment here, no advocacy for anything other than paying attention.

Klett had noted his desire to be more than an observer at the end of *Revealing Territory*, to become a participant. The study of the environment would offer him the chance to do so, and to reengage more fully the scientist in him.

Both *Revealing Territory* and *Arid Waters*, the latter the only collective book so far to come out of the Water in the West project, which has since evolved into more of an ongoing archive, appeared in 1992. In another event marking transition in Klett's life, the Photography Collaborative Facility was closing down at ASU and Klett assumed full-time teaching duties, though he would not formally join the faculty until four years later. It was an opportune time for Klett to find a deeper way of engaging both the landscape and his practice, and he found it in a year-long project with the brilliant scientist and writer, Gary Nabhan.

An ethnobiologist by trade, Nabhan was born the same year as Klett but grew up in Gary, Indiana. As a child he played in the dunes and bogs where Henry Cowles earlier had puzzled out the basic principles underlying the still undefined field of ecology. It was a place where one walked in a small wilderness but never out of sight of the enormous steel mills. According to Stephen Trimble in his introduction to the anthology *Words from the Land,* Nabhan credits the experience with why he "grew up thinking about nature as a number of juxtapositions with pervasive civilization," which sounds very much like a description of Klett's photos.

Nabhan earned his doctorate in ethnobotany at the University of Arizona, was for a time a fellow resident of Tempe, where he was the assistant director for research at the Desert Botanical Garden, and now lives in Tucson and is science director for the world-renowned Desert Museum. His primary intellectual characteristic seems to be crossing borders, studying, for instance, both anthropology and botany in order to track down the origins and uses of desert plants. When he writes books about his research, he is more likely to tell stories than slavishly to map out a scientific principle or a historical sequence, yet his conclusions are as precise, accurate, and vivid as if they were equations blazoned on a blackboard. He lists among his intellectual mentors the writers Wendell Berry and Ann Zwinger, and has taken poetry workshops with Gary Snyder and William Stafford. The effectiveness of his crossover learning is displayed in several books about desert ecology, such as *Gathering the Desert* (1985), a pinnacle of nature writing that helped earn him a MacArthur Foundation fellowship, and *Cultures of Habitat,* a copy of which sits on the bookshelves in Klett's living room.

Klett had met Nabhan while they were both serving on a graduate student's thesis committee in the mid-1980s, and it was apparent that they had many views in common, among them that "the positions of many in our respective fields was too reductive: that we've screwed up the land or don't belong there, and other ethnocentric views, and that there was nothing being done about how people can and should exist in the land." Early in the 1990s Nabhan approached Klett with the idea of doing a collaboration, but it took over a year to find a publisher willing to engage in the project. Not until 1993 were they able to begin work on what would be their book, *Desert Legends: Re-storying the Sonoran Borderlands.*

Published by Henry Holt in New York, *Desert Legends* holds fifty-seven images by Klett and eight narratives by Nabhan, plus a preface. It's too simple to call the chapters either stories or essays. Contemporary nature writers—from John Steinbeck in Baja California in the 1940s to Alison Hawthorne Deming in the late 1990s, to take just two examples—derive much of their informational value and narrative power from juxtaposing stories told by locals with their own firsthand experiences with science writing. It's a technique that has been used to represent the land from at least as long ago as the oral epics of the Greeks, who included a catalog of natural wonders while relating various and sundry odysseys. The pattern was followed through the nineteenth century by travelers such as Frith, and Nabhan falls gracefully into it. His writing in *Desert Legends* is more personal than in his earlier books; it's still grounded in the specifics of his discipline, but moves fluidly within the category we have labeled, for lack of a better term, "creative nonfiction."

If Nabhan's hallmark as a scientist is to be hip deep in literature, then one of Klett's as an artist is to be immersed in science. Not only did the two men work well together as they cross-illuminated each other's work, but Klett finds science a useful metaphor in describing photographic practice. When Klett talks about the place of his work in his field, he weaves together a story that leads naturally to Nabhan, and one that he sometimes starts with Ansel Adams.

Ellen was keen on showing the RSP stuff to Ansel, so she made an appointment for us in 1978 and we drove out for cocktails in Carmel. Ansel was there with his wife, Virginia, and we took a tour of the house, then sat down with a half gallon of bourbon and went over the work. Adams said: "It's all very interesting. Of course, it's not art.. . ." Ellen bristled but I nudged her and whispered: "Don't worry." When we were leaving, Virginia told us: "Don't pay any attention to what Ansel says. He's stuck in his ways."

I didn't care if the RSP was art or not, but just whether it was interesting. The two aren't necessarily the same. Ansel's notion was limiting and not very useful— who cares, unless its just for the sake of categorization. I figured he was defending something in his own territory. He had more importance as a figure for me then than now. I never wanted to make pictures like him, but he was a bigger target then against which to react. It was useful at one point to deal with his

legacy. This isn't disrespect for his work, but just how you work with the history. The practice of artmaking is a form of research. If we were doing science, trying to make a contribution to a corner of the field, we'd study previous research and figures, and then challenge or build from them. That's often overlooked in art now, though it's not necessarily a matter of self—it's a matter of the larger field. Look at Frith and Adams. I want a sense of what we created from their pictures—the fictions we create around them—and then work from those. Make a hypothesis, challenge it, plow at it with an intuitive frame of mind. That's the great thing about working with someone like Gary. Someone who works like an artist, but is a scientist. He makes a far better contribution than just by looking at carbon structures and genetic materials. He's effective because he thinks creatively.

When Adams said that—of course, he didn't think O'Sullivan's work was art either—I realized that the definition of art wasn't what interested me. What Limerick and Gary and others do is to make connections out of seemingly unrelated things. When I get depressed about the art world, this is how I get out of it.

For the year that the photographer and the scientist worked with each other, they traveled both together and separately. Sometimes Nabhan would send over a chapter or two for Mark to read, then Mark would go out and photograph by himself—not to illustrate the narratives that Nabhan was compiling, but with the text in his mind, a process that generated many

more works than were ever used in the book. When working together, Nabhan would take Mark to meet people and visit their houses. "Gary was totally unabashed and not shy," Klett recalls. Nabhan took Klett to see a place where a flashflood had undercut the border fence; then Klett went back later to photograph it, an image that has become iconic for people seeking to place the imaginary geopolitical line in the context of the more encompassing natural world.

Klett admires Nabhan for the phenomenal memory of place he maintains. He is able not only to take Klett to a spot and show him how the night-blooming cereus camouflages itself in its nurse plants, such as creosote—but also, in a patch of the desert he hasn't visited for several years, to point to every single example within the entire colony. Nabhan can then relate, as he does in the book, how the gathering of ironwood by rural Mexicans to make wooden folk carvings is driven by the demands of tourists coming across the border from the United States, thus damaging the cereus; and how their pollinators, the sphinx moths, are under attack by the increasing use of agricultural pesticides.

Klett remembers how, when he was a geologist, he fell that deeply into the sense of specific places. "You come to understand certain places so intimately that you internalize them, and are able to recall years later what you were thinking when you were standing there. It's not so much about topographics, but a binding to you in an emotional way. It's an emotional memory."

Klett, in turn, showed Nabhan the vernacular roadside, the abandoned gas stations that the scientist might have otherwise not noticed, and the shot-up remains of a doll underfoot

Mark Klett, *Saguaro with shirt, U.S.-Mexico border, 7/93.*

209

(found, incidentally, when Nabhan was describing the function of nurse plants with their thorns protecting the cereus from being eaten). One of Klett's favorite photos from the project, in fact, is "Saguaro with shirt, U.S.-Mexico border." The single column of a still young cactus stands in a small clearing, its "upper torso" buttoned up in a shirt, a stick thrust through the assemblage to suggest arms. It is a homely crucifixion that, once again, the photograph exposes as an image crossing the borders of nature and culture, and of the vernacular with fine art.

Working together allowed Nabhan, in Klett's opinion, to stretch as a writer, to become "far more personal and risky." For Klett, on the other hand, it meant including more people in his oeuvre, more portraits. It was also a process that got him to reconsider the Rephotographic Survey again, and to rethink our relationship with the landscape. He and Nabhan had gone into *Desert Legends* "hating the idea that there was a split driven between the exploiters and the Sierra Clubbers." The experience confirmed for him that he was inevitably not just an observer of, but a participant in, the world. And he had found a way to distinguish between how some of his colleagues were defining the landscape in environmental or advocacy terms, "where populist sound bites" became the result. He knew the landscape was more complicated than that, and that a reductive stance exemplified by simple visual ironies in the photographs would drive off people. Much photography for Klett was, in his friend Robert Dawson's terms, moving too far away from the audience and, instead of dealing with subject matter, becoming too much like other art forms taught in MFA programs.

Klett voices over and over again what the writer Bill Kittredge and others have been insisting upon for the last two decades: We live our life by stories, and in order to continue to survive in the West, we had better come up with new stories, ones that are less domineering toward the land than the tall tales we inherited from the end of western expansionism during the nineteenth century. What Klett wanted in the carefully named *Desert Legends* was a finely layered work aimed at a larger audience, not just at his colleagues in the art world, and a way of opening up the new stories through images.

In 1994 Klett received one of the rare and highly desirable U.S.-Japan Fellowships from the National Endowment for the Arts. Taking his wife, Emily, and their two young daughters, he once again went to a foreign country, this time immersing himself in the language and culture. He took almost no pictures after arriving in January 1995 for the first three weeks he was there, an attempt just to experience the place. The Kobe earthquake, however, sent him off to document the aftermath, which earned him many friends in the country. He was in Japan for roughly six months, returning in July before turning around five days later and working in Portugal for a brief ten-day visit. In the words of Malin Wilson, an art critic reviewing a show in Santa Fe of the photographs from the trip: "His Portugal photographs . . . deepen the metaphor of the complex passage of a sole or soul through life. He photographs the lonely traveler's approach. . . . It is not just the artist whose hand, shadow, or reflection the viewer may see in his images, but that of Western cultural tradition where each of us is alone."

In 1996 he began talking with a handful of his closest graduate students—Kyle Bajakian, Byron Wolfe, and Toshi Ueshina—about the possibility of starting a Third View project.

Klett has always taught through projects, the way he was educated by his geology professors in college as they were struggling to keep him interested in science by sending him out into the field. Third View could be a large enough project to involve multiple people, diverse enough to investigate his ideas about new relationships with landscape through story, and a way to integrate the computers and digital technology invading both his teaching and his own work. A Third View would bring him full circle around the idea of "documentation."

Klett is fond of quoting the historian William Goetzmann, who said: "History is nothing if not personal." By integrating through multiple-media technology the rephotography with "personal" work conducted by the individual participants at the same time, new stories might arise out of their experiences in specific places, thus "replacing" the generic myths of the West with narratives in which both the photographers and viewers are participants. And, once again working in a team, thus circumventing that American tradition "where each of us is alone," the collaboration would allow him to continue, as he puts it: "to revisualize my own work, enlarge my own limited scope/perspective, be humbled, work past a fixed position formally and conceptually, defy commodification by the field, and push past career pressures."

The first Third View trip was in the summer of 1997 to Colorado to rephotograph Jackson's views at the Garden of the Gods. The team worked the following summer in Green River, Wyoming, to rephotograph Castle Rock and other nineteenth-century landscape icons. Then it was time to follow the path of O'Sullivan across Nevada.

Chapter Nine

THIRD VIEW: JULY 12TH: VIRGINIA CITY TO STEAMBOAT SPRINGS

We drink our coffee this morning to the sharp reports of a 30.06 being fired somewhere just down the canyon from our dusty campsite, and it sounds as if the elaborate target areas we passed on the way in last night are being well used. By ten o'clock the camp is packed up, all of us hoping we'll have more time today to find a better site, and we're on our way to investigate the shooting arrangements.

The first assemblage we stop at builds upwards from a tan leatherette bench seat torn out of a compact pickup truck. On its top sits a large plastic bag filled with sawdust, behind it an empty blue oxygen cylinder mounted on a spring. A whirligig is welded to the top, part of it left free to rotate when hit. Above this contraption is a subassembly of a dozen two-and-a-half-inch pipes suspended from a heavy-duty metal frame set into the hillside, a shooting-range bullet chime. Orange plastic juice jugs, which had looked like pumpkins from the road, preside over the scene. To their left a songbird cut out of painted metal dangles from a chain, an artifact Kyle promptly liberates for the Third View archive. If placed in a gallery, the whole thing would be taken for an interactive folk sculpture. Even though its only purpose is to be destroyed, this association with art makes me feel guilty about taking even this one small element out of its environment, as if it were an arrowhead and under the protection of a federal antiquities act. It doesn't help that the chunks of translucent blue plastic littering the ground, parts of a bowling ball fractured under the impact of high-velocity rounds, oddly resemble lithic tool flakes.

The guys swarm over the site with their cameras, walking back and forth over that thin gray line as they turn a place devoted to the refinement of violence into one used to practice

art. The difference between being a detached documentarian suffering the illusion of objectivity, and an engaged artist falling prey to sentimentality and political correctness, is exactly one of the reasons Klett inserts his shadow into the frame. It's not from a sense of ego to declare himself part of the picture, but to let the viewer acknowledge the presence of the photographer on the scene, then mentally subtract him. It keeps both Klett and the viewer mindful of the fact that there is no such thing as "just a picture," but rather a complex relationship among subject, photographer, viewers, and history. The picture isn't a monologue, but a multilogue.

As we pick our way through the sagebrush down to the next target array, which features an elegantly spray-painted pickup truck roof crosshatched in black and red and a rusted muffler pipe armature holding numerous beer cans, I come at the tangle of associations from another direction. Most of us here this morning own handguns, camping in the American deserts not being as innocent an activity as it used to be in, say, the 1950s. We'd be happy to plunk away here, but would feel uneasy shooting at the doll heads scattered about. But shooting this site, whether by camera or gun, involves us in consideration of such choices, whether we like it or not—just as photographing the equine road-kill yesterday was complicitous with the death of the horse as witnesses, even after the fact. And then there's the issue of whether or not we're making a fetish of the violence, turning it into something precious by tidying up its presence within a frame.

As I attempt unsuccessfully to write myself out of this dead end over the morality of target practice, I almost trip over Byron, who is puzzling together numerous pieces of

Mark Klett, *Doll's head used as target, Six Mile Canyon, Nevada, 7/13/98.*

thick glass from a Zenith television screen. Standing up and surveying the area around us, he notes that circuit boards are becoming a ubiquitous element of shooting sites in the West, a sign of violence against computers which I'm pretty sure isn't yet covered by any statutes.

When we reach the confluence of the two canyons, a prominent rephotographic site, we split up, Mark and Byron walking up a hill for the vantage point, me sitting in the station wagon with the notebook plugged into the cigarette lighter, and everyone else going into town to find a base for computer operations. I type away, occasionally looking up at the butterflies and the white chaff blowing around me from the large cottonwoods overhead, trees that did not exist in the original picture by O'Sullivan. This was the site of the massive Gould and Curry reduction mill, one of the most elaborate follies of the Comstock. Built during the early 1860s in the form of a Greek cross, and featuring an oval pond complete with three water nymphs supporting a shell in which rested a white swan spouting water, construction costs totaled almost $1.5 million. Although it eventually was able to crush and process a hundred tons of ore a day, it was shut down in 1871. Within two years even the foundation stones had been carted away. When Klett first rephotographed it, nineteen years ago to the day, it was the most striking example in the RSP files of a site that had actually gone from intense human usage toward a more natural state, and a comparison that was often included in museum exhibitions and books about the West as an example of how important it is to keep an open mind about the nature of historical process.

Mid-afternoon finds us in town, where Stu has rented a great spot for the operations base, a guest cottage dating from 1870 that sits by a well-watered lawn across from the Chollar Mansion, a three-story brick edifice erected for a mine manager in 1860. The cottage can sleep two or three people, and while some of us unpack all the computer gear, Mark and Byron wander off to find a new campsite in the nearby hills. After we get the monitors and keyboards settled, I go sit outside on the lawn, an act tantamount to putting a cool cloth over my eyes. Virginia City sits in a natural amphitheater at about 6,000 feet, its streets arranged in tiers down the side of Mt. Davidson, almost as if they were stadium rows. Although the piñon-juniper forest is slowly coming back, most of the surrounding hundreds of square miles were denuded of trees used for timbering the mines, to power steam engines, or to make charcoal. Your vision tends to drift out of town and over the hills, clear to the Stillwater Range seventy miles to the east. A green lawn bordered by flowers is an amazing relief from the strain of trying to accommodate visually so much dry space.

At four o'clock Mark and Byron return, having found a spot on a hillside to the east and within view of the cottage at about the same elevation. About this time Ellen Manchester and Robert Dawson arrive with Walker, their eight-year-old son, in tow. They've just driven up from their home in fog-bound San Francisco and are happy to be in bright, arid sunshine. Ellen just two days ago quit her job of five years, working as the development officer for a private school, and is ebullient to be reunited with the rephotographic crew. Bob, a Leica rangefinder hanging from his neck and a few days of stubble on his chin, grins and shakes hands all around. Although Mark had told us he was hoping Ellen and Bob would

be able to join us, it's an unexpected treat to have their company. Mark excitedly tells Ellen about shooting the Gould and Curry mill site, his favorite of all the Second View shots because it was the opposite of what he had then expected, a greening instead of a further degradation.

Not until 7:30 are we able to get everyone over to the campsite, a small ridge that runs out to the north and down into Sevenmile Canyon, several hundred feet almost directly above where we were camped the previous night, but in a different world. Where before we were camped in the slowly eroding detritus of the mines, now we're on top of the lode. We position the tents carefully and use flashlights as evening comes on. Two old mine shafts, one backfilled and fenced, the other simply lurking to one side, are an indication of the pitfalls nearby. Between where we stand and the lights of town coming on, perhaps a quarter mile to the west, are scores of old mining works sitting on top of a honeycomb of shafts, tunnels, and stopes extending downward over 3,000 feet. Despite the extensive use of chain-link fences and warning signs, people still stumble into holes here and are injured, sometimes fatally.

Our campsite is crowned with a small ruin consisting of a handsome stone-and-brick wall with a ledge running along it, and a floor of crumbling concrete. It's an excellent spot for the kitchen, which we dub "the temple." Along with canisters of 35mm film that we place on the shelf are a gas lantern, soy sauce, black pepper, olive oil, a bottle of Cabernet, and the metal cutout of the bird, which swings gently in an evening breeze. We eat at 10:30 and are asleep by 11:15 P.M.

July 13th

I wake at six-fifteen, a three-quarter moon still high above the hills, the sun coming up over the Stillwaters. Mark is outside checking the stick game and our tokens, which we had placed just before going to bed. Satisfied that he's won this morning, he disappears back into his truck. I get dressed and enjoy being able to contemplate the sun without the accompanying heat that we've labored under the last several days. I miss the thunderstorms we had out in the flats, but the weather has dried out and promises to keep getting hotter.

Wandering up the short ridge to the kitchen to make coffee, I watch the sunlight as it works down Mt. Davidson and into town. Mark joins me, and together we gaze out east at the floodwaters backed up behind Lahontan, now a silver sheet reflecting the sun, an act that repeats itself on the hundreds of metal roofs and glass windows of the houses in Silver Springs. So much water sitting in the desert this year continues to amaze, but it reminds me of something about the deepest mine in the Comstock, the legendary Combined Shaft. When it reached 3,250 feet in 1886, it was the largest and deepest manmade hole in the United States—and required three huge hydraulic pumps to empty out over five million gallons of water a day. The pumping was so expensive, however, that the lower levels of the mine were abandoned that same year. Within thirty-six hours the water had risen to the 2,400-foot level, putting the flood at about the elevation of the floodwaters below us this morning, an idea that makes mathematical sense, but is still confounding to the notion of desert.

Bob Dawson had talked last evening about how people are overriding their perceptions of the desert as a harsh place to accommodate their desire for open space, a need that becomes

219

more pressing, literally, as our other environments grow more crowded. The urban grid metastasizing out of Carson City toward Fallon and shining brightly up at us is a result, and one which demonstrates how establishing a space of one's own is only a transitory state of affairs. On the other hand, Virginia City at its height of activity in 1876 held over 23,000 people, half the population of the state. Today only a few hundred people live here, as opposed to the total 1.6-plus million Nevadans, almost 90 percent of whom live in Las Vegas and Reno. Nevada may be almost entirely desert, but it's one of the most highly urbanized states in the country, a counter-intuitive notion. Some places in the state have actually emptied out over time.

The first shoot of the day is the open pit mine in Gold Hill. The Dawsons accompany what has become the regular rephoto crew—Mark, Byron, and myself—to a perch on the curve above the hairpin between Virginia City and Gold Hill. O'Sullivan's photo shows an active collection of mine buildings on a flat shoulder, since consumed by the pit left behind by a now-defunct mining company, victim of the boom-and-bust cycle of the precious metals market in the 1980s. There's still valuable ore to be processed out here, but the price of gold is too low for its extraction to be economical.

Today, cottonwoods partially obscure the view, just as they did nineteen years and two days ago for the Second View. Mark keeps having to back up to frame the picture correctly, the road having been widened since he took that shot. He starts by taking test shots on the outside of the guardrail while Walker forages on the hillside below for artifacts. Then he repositions the tripod so it straddles the railing. Finally he's all the way onto the shoulder of the road. Cars are going by, on average, every fifteen seconds. Walker brings up a smashed

headlight, red taillight fragments, and part of a license plate holder. Ellen notes that our section of guardrail is newer than the rest. I'm not sure which worries me more: the steadily increasing wind, which has me holding down Mark's tripod, or the surprised drivers swerving as they round the curve.

The traffic is more or less evenly split between locals driving pickups and tourists in sedans and minivans with license plates from California, though a few vehicles are from as far away as Ohio. A garbage truck heads down the hill with a guy in a cowboy hat riding on its tail. I wave and he casually lets go with the one hand he was using to hang on in order to wave back, implausibly but perfectly balanced on the bumper even as they descend the hairpin. Mark finishes up and Byron takes over the vantage point to make his panorama; he times each frame to include a passing car, which will appear to the viewer as a steady stream of traffic around much of the 360° view.

After lunch we drive back down Sixmile Canyon to show Ellen the Gould and Curry spot. We've been joined by yet another photographer, Dan Kasser from Stockton, a colleague and former teacher of Byron's who is on the faculty at the University of the Pacific. Ellen and Bob had forayed down Sixmile Canyon years before, when it was still unpaved, but hadn't made it down to the junction with Sevenmile; she's excited to recognize the site from her memories of the original photograph.

The Second View team had investigated another O'Sullivan site only a couple of minutes farther down the road, though they'd not been able to shoot it because of the intervening vegetation that had grown up since O'Sullivan's time. We continue on down the canyon to

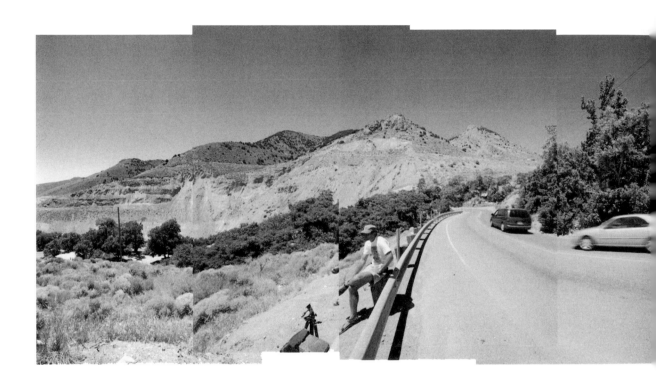

Byron Wolfe, *Hairpin turn and Gold Hill from O'Sullivan's vantage point, 360˚,* July 13, 1998.

check it out. In the first view, the stone arch of a small bridge over the creek sits in the lower center of the scene. Small houses on one side of the road, and what looks like a modest mill on the other, are surrounded by scraps of lumber. The rock formation called Sugarloaf dominates the skyline in the background. No vegetation, just stones and dirt, the buildings and the trash. It's a stern industrial picture. Now, the vantage point is still completely overgrown with cottonwoods and green weeds that tower above Mark's head. At first he doesn't even want to try the shot, but once he's in the weeds and challenging himself to line up the exact line of sight, he warms to the idea. Across the road is a For Sale sign that belongs to a real estate company touting its status as "National Best Sellers."

"So, Ellen," I call out, " who owns the view?" She's been preoccupied for years with this question, and we've talked about the people of Hernandez blocking off the vantage point of the Ansel Adams "Moonrise" picture.

"I don't know," she calls back from where she's taking snapshots down the road. "Maybe we should buy it and make it a home for retired senior photographers!"

As Mark and Byron finish, Bob comes back from around the bend and tells us we should come see the ruins he has found. It's a prime example of Comstock romance, nine terraces of concrete foundations marching up the hillside on the far side of the Sugarloaf. It's all that's left of the Butter's Mill, a tailings processing plant built in 1902 and operated through the late 1920s, employing 300 people at what was once the largest cyanide mill in the U.S. Huge rusted bolts stick up, remnants of early reinforced concrete technology. Walker scrambles up to the top, while swallows dive bomb us from their nests in the walls.

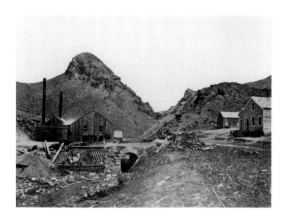

(Left) Timothy O'Sullivan, Untitled [Sugarloaf Rock], ca. 1868. Collection of the United States Geological Survey. (Right) Mark Klett and Byron Wolfe for Third View, *Lot for sale near Sugarloaf Rock, Sixmile Canyon, Nevada,* 1998.

This is, for me, what the Comstock is all about, the construction of enormous industrial efforts in a remote and difficult environment. I find its ruins as tantalizing and exotic as the temples of Karnak, the capitalistic worship of wealth and power here producing edifices on par with those of ancient religions. It's been pointed out by cultural geographers that no other country in the world has so mythologized a single aspect of its physical environment as we have the West. We have erected an enormous reverie over the region built on visual images from O'Sullivan's photographs and Bierstadt's paintings to the television show *Bonanza,* the latter being perhaps the single most important factor in cultivating tourism for Virginia City. And what is a mythical landscape without its ruins? Ancient Egypt . . . or Greece . . . or Mexico? This is as close as we come in the Great Basin to a pyramid, a marble temple, a lost city hidden in the jungle. I wonder how Walker is absorbing all this from his perch several stories above us, if he's imagining himself a young archeologist.

When we troop back into our cottage at the Chollar Mansion later in the afternoon, hot and thirsty and hungry, we take stock of the grocery situation and decide to make runs to various stores. Virginia City is too small for a market, so we split up, Kyle going down to Carson City, Mark and I to Reno. We return an hour and a half later to find Stu sitting on the floor in front of one of the computers, a somewhat ceramified look on his face. He's handled six hundred images today in preparation for posting material to keep us current through yesterday, Sunday, but we're still getting reports via phone that people can't always access the site. It's obvious he needs a beer.

As it turns out, beer is totally insufficient to relax our Webmeister. Kyle, however, has continued to display the foresight of a true gentleman and has brought back a bottle of Absolut Citron vodka on ice, a bottle of vermouth, and a lemon. I mix a round of martinis and by the end of the bottle of vodka, around nine o'clock and with dinner still in preparation, the conversation has loosened up considerably. If O'Sullivan is Mark's hero, then Carleton Watkins is Bob's, and he waxes poetic about his work. Hired by the owners in the mid-1870s to document their mines and mills, Watkins worked in Virginia City almost a decade after O'Sullivan, composing pictures in what was still his industrial heroic mode. The albumen stereographs are dense with detail and taken from angles that emphasize their strong geometries. The panorama he made of the town in 1876, taken from a point close to where we're sitting tonight, is a series of three prints that, partly because of the open amphitheater of the terrain, gives us one of the most complete portraits existing of any western town of the time. Toshi, in the meantime, is comparing the Third View project to a final frontier for photography, as if it were an idea that moved through one person and then into another, a progressive imaging party. Stu, just before lapsing into a mild stupor, declares that the Web is our collective unconscious.

It's definitely getting toward the end of the trip.

July 14th

I'm awake even earlier this morning, watching Dan from my tent at 5:30 A.M. as he shoots a dawn panorama of our campsite from atop the ten-foot ladder that he hangs out the back

of his truck. Byron worked on a rephotographic project with Dan before going to ASU to study with Klett, and it's obvious where he got his hankering for the QuickTimes. Halfway through Dan's sequence in the warm early light, the batteries die in his camera and he has to climb down to replace them. I go back to sleep.

The next time I wake up its seven o'clock and a desert-camo painted Jeep, complete with a rack of spotlights and multiple antennae, is cruising slowly by on the dirt road outside our camp. Ten minutes later it rolls silently back the other way. I give up and roll out of bed for coffee. Everyone else starts getting up, and pretty soon Mark and Byron are making blueberry pancakes, which disappear almost a fast as they can flip them. While we're eating, a series of faint but dense pulses on the ear announces a bombing run out by Fallon. Ellen stands to let Byron sit so he can mop up the last batch of the pancakes, and she joins Mark in washing the dishes, reminiscing about the Second View project twenty years ago. No homemade blueberry pancakes then, much less lemon-infused martinis! They lived on trail mix, ramen noodles, canned food. Motels and showers were too expensive; at one point they had been reimbursed for so much mileage at eighteen cents a mile that Mark could afford to rebuild his engine. Third View is still running out of pocket with a minimum of institutional funding, but everyone's pockets are a little deeper now, and there's a taste for gourmet coffee and fresh fruit.

Again, the middle of the day is devoted to a rephotograph, this time one of Virginia City looking south from a shoulder slightly outside and above the elevation of the main street in town. The city is greatly reduced in scope from the original photo, and what was once

a barren industrial complex is now softened by trees. The shoot is done by two-thirty, but Dan has to walk back up the hill to look for his watch, a Timex "Explorer" model with a compass on the band. He finally declares it a sacrifice to the gods of photography; maybe a Fourth View team will find it in another twenty years, along with the little plastic bag we left on Karnak Ridge.

Mark, Byron, Dan, and I cruise downtown looking for lunch among the sixty or so attractions that line the boardwalks on C Street. Saloons, museums, and candy shops dominate, in roughly that order. The Bucket of Blood and the Delta are the two bars I remember from being a teenager, when driving up from Reno to see if I could find the ghosts of my ancestors who had raised a family here. Separate museums cover everything from the red light district, Mark Twain, and gambling, to the local firemen. We end up in a new coffeehouse featuring a snazzily deconstructed western mural and halogen track lighting instead of fake brass antiques; the rock band Morphine in the background replaces the customary honky-tonk music. After sandwiches Mark herds us over to Silver Sadie's Old Time Saloon Photos, where he and Gordy Bushaw had their pictures taken in gunfighter drag nineteen years ago, when they furnished their own Polaroid film and posed with their own 4x5 cameras for five bucks. The price today is $19.95. We're running low on cash, and despite the appeal of rephotographing the rephotographers, Mark decides to pass.

Back at the cottage a major trauma is in progress. The G3 laptop has frozen up, capturing a CD-ROM in the process. Stu pulls out his trusty Leatherman, straightens out part of his key ring with it, and extracts the disc, as impressive a bit of mechanical surgery as I've

seen on the trip. Further investigation reveals that there is a "master directory block," which Byron describes to me as the computer having a serious case of Alzheimer's.

"How big a problem?" I inquire. Byron spreads out his not inconsequential arms as far as they will go. "Oh," I reply. I have a vision of the interior architecture of the computer looking like the mining headframes around town that are rusted into immobility.

Mark is stony, Stu ready to prop up the G3 on one of the target armatures and let fly. We all hope that no files from yesterday have been lost permanently, and that all that's been compromised is our ability to post on the Web those images and text that have been prepared since Fallon. Mark, Byron, and Toshi leave for a short tourist train ride featuring a restored Virginia & Truckee steam locomotive, hoping to lose some frustration along the way. The sound of its whistle as it makes nine daily runs has been a cheerful backdrop to our work, and the Dawsons have recommended it as a tonic. Stu stays behind, using one of the desktops to send frantic e-mails around the country asking for advice, there being no phones in the cottage, just a line and a jack.

It is possible to put material up onto a Web site while on the road; we've been succeeding in fits and spurts the entire time we've been out, and scientists have been doing it for several years. But it still seems like there's always one more cable we need, one more program or external drive. It's the curse of technology, whether in the mines or with Third View. If we could dig just a little deeper, a bit longer, surely we'd strike pay dirt.

Mark has a deeper motive driving his frustration, though. While it's a bonus for him and Third View that I'm writing about his work and the project, the reality is that his photographic

books are out of print, including *Revealing Territory*. This is a real concern for photographers, because books are the primary medium through which people know their work. And it's doubly troubling that it's a university press that let it go out of print. Trade houses, the commercial publishers based primarily in New York, are better served to pulp existing stock, if it's not moving fast enough, than to warehouse it, where the books are taxed as an asset after one year. The nonprofit university presses are exempt from the tax and keep books around longer. Considered by many writers and artists to be the last bastion of serious publishing, they are nonetheless falling prey to manufacturing costs and marketplace pressures, too, and are starting to let titles lapse, even ones that sell through their print runs in what used to be considered a relatively short two or three years. The Internet and CD-ROMS are a potential way around this. Anyone can have a Web site, and CDs are relatively cheap to produce. Mark and Byron and other artists are capable of producing them on their own. So Mark is not only testing out a new way of working, but how the future might look in terms of publishing photography and keeping it available to its audience.

8:25 P.M. The curve of the earth projects its shadow several miles high out into the atmosphere, a dark blue band above the eastern horizon topped with a red line that fades upwards into a transparent gray where the stars will come out momentarily. Despite the computer problems everyone is more mellow than usual. Stu has heard back from a computer store in Reno, and he's been reassured that the new G3 microprocessors are having this problem, that all is not lost. Plus, there's only one more site with two rephotos remaining in the trip, and everyone will start to scatter soon thereafter. The kitchen is cleaned up and we're actually

ready for bed before eleven. I take a binocular scan of the night sky before crawling into the tent, enjoying my last clear night before heading back to Los Angeles tomorrow evening. Two shooting stars cross the lens, the first time that's ever happened to me, but I have no idea how to make an omen of them.

July 15th: Steamboat Springs

"Smell that?" Mark is sniffing the air in the truck as we drive out from the campsite.

"Yeah . . . burning sagebrush."

He stops in the middle of the dirt road and hops out to take a look at the undercarriage. Nothing. Often when driving across the desert the muffler will pick up loose brush, which can ignite, one of the reasons why geologists and others carry a fire extinguisher. Now smoke is trickling out from the front left front wheel well and he pops the hood. There's a full-blown packrat nest built on top of and down into the exhaust manifold. Before I can get out of the cab Mark starts yanking at the sticks.

Flames start licking the air cleaner and he jumps back into the cab for a water bottle.

The water appears to work, steam boiling out from under the hood as the liquid hits the engine. We keep our fingers crossed that the radical temperature change doesn't crack anything. As the air clears, we try to locate the remaining sticks and twigs, using a tent pole to knock out the pieces we can't reach with our hands. Mark and Kyle had both heard noises in their trucks last night, and Kyle had jumped out, expecting to find a bobcat tearing at the garbage he had bagged and tied up on his roof. Neither Mark nor I have ever heard of

a rodent building a nest on an engine while someone was sleeping in the vehicle, and we're amazed at the amount of material the industrious packrat managed to accumulate during the night.

We double check the engine once more when we get to the cottage, but it looks as if we've gotten it all. Kyle, when he hears the story, goes to check his own engine compartment, which turns out to be clear. Stu is still working on the computer, reentering data, but soon everything is packed up and we're ready to head down the west side of the hills for the last round of shots at a geothermal area south of Reno. Stu will split to check out the computer at the store, and I start the first of my good-byes for the day, as I won't see him again.

As we drive down Geiger Grade, Mark is a little concerned about getting to the site; since he and Gordy did the Second View photos in 1979, it has been taken over by a private power company. We can see the workings of the plant, in fact, as we drive down the steep road. Klett had called Peter Goin before starting the trip, who told him that he had recently tried to take some his students there and couldn't get in. We hit the highway intersection with US 395, turn left and drive for about a minute to reach the turnoff for the dirt road leading up into the steam vents. To our left up a small rise, and even with the ground temperature approaching a hundred, steam is issuing visibly from the fissures that O'Sullivan photographed. Sure enough, though, our way is blocked by a four-strand barbedwire fence that's posted: "No Trespassing: Endangered Species Habitat—Steamboat Development Corp." A phone number is listed and Ellen encourages Mark to try it, which he does. Byron sits in the truck with him to tape his end of the conversation; Toshi sticks his head in the

passenger window and videotapes the proceedings. The receptionist at the other end is friendly and calls up Bob Filut, the operations supervisor of the geothermal plant. When we drive up half an hour later to the office on the other side of the springs, he's there to meet us. At first a little unsure of what we're up to, once he sees our copy of *Second View* with its sets of photos, he gives us permission to wander at will—but not before taking us outside and pointing out specimens of the endangered buckwheat grass, apparently a variety growing here and nowhere else in the world. We promise to watch where we put our feet.

Mark, Byron, and I carry in the camera gear, followed by the Dawsons and Kyle, all of us slipping through the barbed wire and being careful to avoid the small bunches of buckwheat, which are surprisingly numerous. We hike up to Steamboat Ditch, a branch of which miles away to the north in Reno runs only a block away from the house where I grew up. We step gingerly on rocks to cross the foot-deep stream siphoning off Truckee River water for irrigation, then continue uphill to the vantage point. Below us stretch the bleached earth and fissures that I've wanted to visit since I was nine years old. It was January 1958, a cold clear morning when I drove by with my mother, and the hot springs were venting dense billows of steam that rolled down the hill and enveloped the highway. There was snow on the ground and the air reeked of sulfur. I'd never seen a geothermal area before, and I thought it was like being in a science fiction novel by Jules Verne. The majority of the activity is capped now by the long racks of pipes at the plant, but the machinery is behind us and almost completely out of sight. The long jagged cracks in the earth in front of us are still letting off steam, and that's good enough for me.

Bob and Walker, followed more slowly by Ellen and Kyle, pass through a split-rail fence, originally the only barrier here between hikers and the vents. "Danger: Thermal Area—Keep Out" say the signs at regular intervals along the wooden rails.

Two hundred yards away the heavy commuter traffic between Reno and Carson City streams past. Across the highway sits the Steamboat Springs subdivision, which is "creeping" not so slowly into the foothills toward Virginia City, just one ridge east of us. This is by far the most congested site in which we've worked.

Byron and Mark line up telephone poles with distant mountains, taking test shots and working up the proportional measurements on a calculator to refine their stance. Once again they're working from the Second View shots, as the foreground topography has changed so much, and what they're documenting isn't really an original scenic location, but a focal point through which to examine the change. I sit uphill and behind them, writing for the first time directly into the smaller and still functioning laptop. I've been taking field notes by hand on paper, then condensing and rewriting them again, still on paper, before typing them into the computer. Slowly I've been getting comfortable enough to work directly on the computer, and find the idea of composing in the field under a midday sun, which means I can't easily see what I'm doing on the screen, much truer to the spirit of what Mark has envisioned for the author of the field notes.

Mark finishes and Byron does a QuickTime during which I get up and move around, thus appearing in more than one frame of the panorama, a document of both time and space. Then it's our turn to recross the stream and head under the split-rail fence, walking

across a flat of what might be travertine. Everyone else has left, headed up to Lake Tahoe for a dip in the cold water. We waved good-bye from a distance to Ellen, Bob, Walker, Kyle. A strange way to part, and we envy them the trip up over Mt. Rose Pass and into the Tahoe Basin this afternoon. We don't have a thermometer with us, but the light and heat reflecting up off the thermal crust now beneath our feet is blinding and almost suffocating. But . . . but . . . we're happy to be walking out among the fissures and fumaroles, despite the heat.

The guys work fast, locating the stance and shooting more quickly than anywhere else on the trip. It's just too hot to move slowly and the film holders are actually cooking the film and washing out the test prints. Mark compensates by stopping down the lens. While we're working, a Nevada highway patrolman stops at our vehicles, which are in plain sight from where we're standing. He looks up at us, walks around the vehicles, looks up at us again and, perhaps judging from the large camera that is the traditional sign of the innocent landscape photographer, departs. We finish at 3:30, making the two shots in as many hours, a record. An hour later we're in Reno, where Mark drops me off so I can catch a ride with a friend to the airport. I'm sunburned and dehydrated, anxious to see my wife, to take a shower, to wear clean clothes, and sleep in a bed instead of a sleeping bag. I'm also not sure how it's going to feel waking up tomorrow morning without the prospect of moving on to a new site and feeling as if walking with O'Sullivan. Mark can tell how I feel.

"Listen . . . next summer. Maybe we'll do Yellowstone. You'll have to come—you're part of the team now."

Chapter Ten

TEMPE: REVISIONING LANDSCAPE PHOTOGRAPHY

Arizona State University has some of the most stunning examples of contemporary campus architecture in America, including an excellent regional art museum designed by Antoine Predock, its descending concrete galleries leading the viewer underground and out of the heat, a practical as well as a handsome application of ancient kiva construction. But the art department is housed in what is externally one of ugliest examples of bland modernism I've ever seen—and the insides are worse, poorly signed doorways in claustrophobic hallways lit with unbalanced fluorescent lights. In short, a typical university building from the 1960s. Klett's office and work space, the old Collaborative Printing Facility, are in the basement. We're in the middle of an interview, Klett leaning back from his computer in a battered swivel chair.

" . . . and I need to branch out in my photographic practice from landscapes. I'm beginning to photograph the kids and things around the house. Some of it's still tied into nature—their toys, how they learn about nature and abstract it through play—but to be better at landscapes, I need to do other things.

"Landscape photography's gone as far as it can go until we begin to integrate it with other things—like the kids and portraits." He pauses for a moment to let my notes catch up. "Third View does it by bringing in stories. This year, when we go into the field, we need to spend less time on direct rephotography and more on personal work pushing our ideas of place. Byron says we shouldn't even do the rephotos until we do the other stuff—that we should reverse the flow of energy. We started out with Second View as an experiment and then moved into production because we found we could do it. Third View was going

the same way, but we need to change to remain experimental. Logistics trap you there, in product, but landscape is a practice. Third View should move beyond the roots of conventional landscape photography.

"We've seen the photographer as an observer, as a witness, but not as a participant. What we have to do is put the process first and judge the quality of that—so we don't lose sight of what it is we enjoy, which is exactly that process. I mean, it's still a product, the photographs, but we can turn the tables a little. We can avoid a simplistic, reductive analysis of the work and lay out the complexity of the process.

"What we've lost is the art of science, the wonder, which is why we read the old expedition reports. It is what attracted me to Frith. I never took a photo history course—I read Newhall's book, of course—and I can't remember when I first came across his work, probably in graduate school. I wasn't much interested in his skills or ideas, the reproductions were so bad, but I was attracted to the subject matter, the 'Ozymandias' thing of time and grandeur, the romance of the age of discovery. Frith's photographs were the hallmark of an era and a certain world view. I'm not nostalgic for it, but it's a baseline from which to move forward.

"There was a poetry to early science, like the dusty bins of minerals and the hardwood mineral models we had at St. Lawrence of crystal structures that had been made in Germany in the 1930s. The old survey reports, those guys had the luxury of describing the beauty of a place. Now the writing's proscribed: tell the facts as economically as possible. The survey guys were involved with time in a place, experiencing it from all angles. Science and art

were together. That's what I learned from Gary Nabhan, the value of stories, and of crossing from one story to another."

Klett pauses again, shakes his head, and grins. "I've got this room at the house that you'll see. It's becoming that kind of a place for me. You'll laugh. It has the feeling of a reading room for the science I remember as a kid.

"What we have now are artists who hire designers for their exhibitions and publicists to promote them. You know who I really admire?—Linda Connor. She's one of the best straight photographers in the country right now. It's a kind of work that's not very popular, but she's not a strategic career builder; she just does her work and that's her life. We were talking about this in San Francisco a couple of days ago, that photography is a living practice. Sometimes you don't even take a picture, you're just looking. That's part of the process. And you know, sometimes I'm just as happy finding an artifact as taking a picture. The most prevalent working method in photography right now is project oriented: you go after an idea. I like the old way, the intuitive approach. You follow your nose and take pictures and see what emerges. It happens after the fact."

He falls silent for a moment, having woven together several strands of questions I've been asking him about his early career. I remember driving up from Tonopah to Austin last summer and how he insisted that we not camp in an organized campground, but find our own place. "Following his nose" is also how he likes to walk, avoiding trails, the paths that have already been picked over by everyone else.

"I don't think we should go back to Yellowstone," Klett suddenly announces. "That's too

much about rephotography. Byron and I have been talking about Utah and Wyoming, maybe the Flaming Gorge, where there's rephotography to do, but it's not so dominant. We'd all do more of our own work there."

With that it's time to pack it in and think about dinner. I grab the handle of my wheeled carry-on, having just arrived by plane earlier in the day, and we go upstairs to retrieve his bicycle. The infamous two-wheeler over which he took the dramatic header this last July—I'd imagined a high-tech fiber-composite ten-speed road model, given Klett's affinity for expensive cameras—turns out to be an ancient three-speed Sears bike that no one would give a second glance, much less bother stealing. Klett lives only a few blocks from campus, and we walk across the large boulevard bordering the campus and enter a relatively quiet residential neighborhood. The Klett house is a modest single-story adobe dwelling built originally in 1942 and is being slowly reworked to accommodate the needs of a growing family. Emily is home with their two daughters, Natalie and Lena, when we arrive and Mark busies himself for a few minutes with greetings and news of the day, then shows me to my quarters, the girls' "art room." Filled with pads, crayons, markers, and dozens of their pictures, a large Roy DeForest drawing shares the space, its dense and slightly comical picture of Tempe no doubt an inspiration for the younger generation.

While Mark is sorting out dinner plans, I take myself on a tour of the house. A Frith photo of Karnak is propped up on a table in his cluttered office, and I carry it out into the living room so I can more thoroughly examine it. Rows of broken columns and toppled masonry lead the eye to an obelisk in the distance, not only a view chosen by the photographer, but

presumably a frame also designed by the architects. As always, the amount of detail in the albumen print, as contrasted to that of contemporary black-and-white prints, startles me, especially in the shadowed areas.

I put it back, then return to browse among a cluster of both historical and contemporary photographs hung in the large living area. I recognize one of the images, a rare Woodburytype of the moon entitled "Overlapping craters." Actually, the photograph is an elaborate fiction from the nineteenth century. Although at close range it absolutely looks like an exposure made through a telescope, no one in that century had the technical ability to make photos this clear of a foreign body. The image is from a book published by James Carpenter and James Nasmyth in 1874, *The Moon: Considered as a Planet, a World, and a Satellite.* Nasmyth made careful observations of the moon for over thirty years, recording them meticulously in drawings, then constructing minutely detailed models. These simulacra were placed outside in the sun in order to duplicate the shadows on the moon, then photographed by Carpenter. The book pairs these pictures with photographs of a wrinkled apple, the back of a man's hand, and a "Glass globe cracked by internal pressure," an effort to provide visual analogies for the geological processes presumed to have caused the formation of the craters.

Even without knowing its background, the photo of the moon is a romantic print, an exotic landscape we can almost imagine ourselves walking upon. As evidence of how science was conducted 120-some years ago, it's a breathtaking artifact. Some photographs automatically elicit covetousness, and this is one, as is the Frith, and for much the same reasons.

Old photographs that illuminate how we have developed our view of the world are cultural touchstones. We worship these things and put them in museums, both to celebrate our accomplishments, and to remind ourselves that we are never at the end of knowledge. To excerpt the photographs in a museum away from their contexts means we deprive them of their intended function as informational items, however, and while we might admire them as art objects, there's a larger story to which they belong. Science remains a highly romanticized part of our social endeavors; combined with art, it makes for irresistible artifacts, which is also part of the reason we so love maps.

After he's decided with Emily that he and I will go out to dinner in order to continue the conversation, Mark takes me around his "reading room," where he's in the process of framing a fireplace with smooth river stones. Glass cabinets contain treasures that he and the family have found over the years: rare mineral samples, tiny skeletons, the shells of expended military munitions, bits and pieces of worked wood and metal, the sunrise sticks created during previous trips (including the one from Nevada last summer). Large-format photography books sit piled on a coffee table surrounded by comfortable chairs and a sofa. He's right, the room feels a little like a cabinet of curiosities from an earlier era and is a place in which I intend to spend some time reading through his books.

December 18th

Klett's office files are relatively well organized and complete. Mark is off at a mid-year graduation ceremony, leaving me to work at my own pace through stacks of newspaper and

magazine reviews of his exhibitions. I'm about halfway through when Byron shows up, and I'm as delighted to see him as I was with Toshi earlier in the day, who brought by a photograph of me that he'd taken in Austin. Byron plunks down his bag and we talk a little about how his job search is going. Slowly, as it turns out. He's had a semester of work to do for the Third View project, but now it's almost over and he's seeking a teaching gig somewhere, preferably in the West. Being one of Klett's graduate students is a help, but the market remains very, very tight for the three thousand-plus MFA grads produced every year. Somewhat less than 3 percent of them will stick with art, most drifting into other fields in order to support families.

"So, have you seen the panorama we've made from the Green River trip we did two summers ago?" he asks, changing the subject. He shuffles through the CD-ROM files on Mark's desk and slips one into the computer. The Green River buttes in Wyoming are steep multilayered cakes of sedimentary materials that are uniquely positioned among other scenic climaxes of the West. Flaming Gorge and, farther downstream, the canyons of the Colorado River are to the south. Yellowstone is due north, the Great Salt Lake to the west. Green River is famous as the site of early mountain men rendezvous, and for having been painted by Thomas Moran shortly after he accompanied W. H. Jackson on Hayden's first scientific surveys of the Yellowstone region.

Castle Rock, one of the buttes, has been photographed many times, and when you visit the Third View Web site, the first images you see are those taken by Timothy O'Sullivan in 1872, Klett and Bushaw in 1979, and the Third View team in 1997, all lined up next

to each other as a banner for the project. In the first photo the buttes stand isolated atop the skyline of arid hills. In the second a suburb has sprung up in front of the view, six overhead utility wires slicing diagonally across the sky, and the rear of a school bus blocking the lower right-hand corner of the frame. The last view shows the two houses still in place, their trees and shrubs now mature, the view still masked. The juxtaposition of the images is a vivid example of how nineteenth-century artists monumentalized the landscape by seeking out the most prominent features and presenting them as above and aloof from human affairs. The rephotographs tend to demythologize the view because the physical context of the monuments has changed, the Green River buttes now in the backyard of a small town.

Byron's panorama, made from a point high above the town between two other formations nearby, is utterly different. As Byron shows me how to position the mouse and coordinate my clicking, I pan 360° through his eight color shots, which he has painstakingly scanned into and then stitched seamlessly together in the computer to form a single continuous view. I'm standing in place of his tripod and rotating through space, the houses far below and the view once again asserting its primacy. Amazingly, I can stop and zoom in on any portion of the panorama I care to visit more intimately, doing so to investigate what turns out to be a pile of photographic gear left nearby. I take another complete turn around the view, then stop, virtually dizzied and oddly dislocated. Byron retrieves the disk.

"Pretty amazing, huh?" My response is to say that I've never seen anything like it. Byron smiles broadly, pleased by my momentary lack of words, then takes off back to work, leaving me alone once again. I return to the newspaper clippings, but muse on and off throughout

the rest of the day about what I've seen. The photographic panorama stems from two painting traditions. The first is the view of the city, Barbari painting his *Birds-eye View of Venice* in 1500, and Robert Barker making his *Novel View* panorama of Edinburgh in 1788, to give just two examples that led Daguerre to start his artistic career as the inventor of the painted diorama in 1822, presenting panoramic views of Paris to the public. Watkins and Muybridge were following in this tradition when they did their 360° views of San Francisco in the 1860s and 1870s, which are the direct forebears to Klett's work both there and in Washington, D.C. But Daguerre also presented to the public dioramas of the Alps, a subject that acknowledged the more recent genre of landscape painting.

Most scholars agree that the Dutch invented landscape painting in the early 1600s. If you walk through a collection of European painting you might find that the predominant gaze from 1400 to around 1600 is one of looking upwards—often up to the heavens, to Christ on a cross, to the vaults of a cathedral—all overt or implied narratives reinforcing worship of a higher power. But by the mid-seventeenth century you find yourself looking downwards in the paintings, often from a real or imagined point in a landscape. You're witnessing part of a huge cultural shift, as human rationalism slowly supplants unquestioning faith in the powers from above. It's just one swing of the seesaw; by the time we get to landscape painters like Bierstadt, or photographers like Ansel Adams, we're looking up again, this time at sublime nature as the ascendant object in our beliefs. Panoramas developed in the belief that we could visually encompass the world in a spherical gaze, and wherever it is in which we historically put our overarching priorities in the world—in the city of God,

in the secular city-state, in the church of nature—the panoramic view seems to follow. It's no accident that, with the invention of the Cirkut camera in 1902, a device that produced a long continuous image, panoramas of the industrial sublime became common, among them pictures of open pit mines, the largest-scale evidence of our ability to move at least earth, if not heaven. Panoramas represent the pinnacle of ambition for a culture that believed in the power of the lens to describe the world faithfully.

One of the publications on Klett's table in the reading room, which I browsed this morning before walking back to campus, is a book of selected essays by A. D. Coleman entitled *Depth of Field,* recently published by the University of New Mexico Press. In it is reprinted his now-classic essay "Lentil Soup," in which he defined what he calls our "lens culture." Coleman notes that more than 2,000 years ago a spherical bottle filled with water was used as a device to start fires, that by the tenth century A.D. we had single-lens magnifiers, and that eyeglasses were invented in Italy circa 1285. Rereading Coleman, I was reminded that Guilamo Cardona mounted a lens in the camera obscura in 1550 in order to focus the image it cast inside its box. Three years later an Italian professor held up a glass lens as an analog for the eye, and a British mathematician was soon to invent the compound lens. That invention, making possible both telescopes and microscopes, was the first optical device not just to gather, but actually to generate information, allowing Galileo to facilitate our long separation from the egocentric world view.

After immersing myself in the Castle Rock panorama, I'm wondering about an idea with which many other computer users and critics are wrestling: are we now entering a new phase

of visuality, perhaps a "screen culture." Looking through the lens is no longer the primary way we parse the world; perhaps it's now by projecting digitized information onto a flat screen in front of us. We aren't capturing images directly through the lens and into our own eyes, but mediating the information by first translating it into binary code and then reconstituting it. This changes what we see. Byron, for instance, deliberately lowered the image quality of his panorama in order to blend the edges of his eight frames into a seamless unit. He did that by degrading the information, by reducing the amount of it, and he plans in the future not to seek such perfect seams in order to preserve more information, hence more sharpness.

On the other hand, transforming light gathered by the lens into code, then rebuilding it, allowed me to forget that the eight images were separate entities. It created a flow more akin to how I actually see when I look around me. It also made me a participant in the panorama, encouraging me to drive my eyes around it with movements of my hand and fingers, a process of hand-eye coordination that, by more physically involving me in the process of viewing, produced actual dizziness and a sense that I was no longer in the basement of the art department. A trade-off, in short.

Coleman points out in his essay that the French word for lens is *objectif,* and that leads us to interrogate, yet again, the constant struggle we have had with the concept of objectivity ever since Niépce took the first picture outside his window. Some critics fret about the ability of the computer to change images at will, as if there were a standard of purely straight photography that is being violated. But every artist subjectively chooses a vantage

point and the limits of the frame. The pictorialists were modifying at first prints and then the negatives themselves soon after the invention of the medium, and every time Klett maneuvers his shadow into the frame he's alluding to a history of subjectivity. Panoramas, in a way, encapsulate the problem. They show us an uninterrupted view of everything in sight, thus providing a more complete context for a view than a single frame of film; but, they're still made from a single vantage point chosen by the artist, a very specifically egocentric stance.

Perhaps the increasing monetary value of historical photographs isn't simply arithmetically related to the distance in time from which they were taken, but partly derives from the fact that they represent the height of the lens culture, when science was a matter less of quantum statistical calculations than of peering through multiple lenses mounted in elegant brass tubes. They represent what we take to have been a time of simpler faith.

I once built a telescope, grinding a ten-inch glass blank with ruby dust into a parabolic mirror, producing an instrument of only reasonable quality but nearly infinite satisfaction. I spent my evenings watching the planets and sketching the progress of the Red Spot around Jupiter, the angle of Saturn's rings, the faint structure of gas clouds elsewhere in the galaxy. Eventually I sold the telescope to the local planetarium in Reno, where one summer I worked running the projector and hosting star-gazing parties after the evening shows. But I still visit observatories, entranced by the elegant Victorianisms of big refractors and the proto-modernity of reflectors such as those on Mt. Wilson and at Palomar. Each time, though, there's a momentary lapse in satisfaction when I see the boxy electronics connected to the

telescopes, the cables sneaking off to an office somewhere else in the building. The observer doesn't sit high above the observatory floor anymore, now replaced by computers collating photons. No, the astronomer sits in a room much like Mark Klett's office and monitors a computer screen, reading either digital code or graphs or charts, or at best computer-generated images constructed out of code. The degree of mediation between the stars and the starwatchers has become enormous, and that's changed the nature of the romance.

The romantic devaluation is another reason to question this of issue of value. Photographs are deemed to be of less value by our society than paintings, in general for three reasons. The first has to do with how they're made. We presume that paintings take more time to make than do photographs, and that chance plays a larger part in the photographic process of capturing a moment than in applying oil to canvas, a more deliberative act. Photographs can be made only of things that exist; paintings can display scenes and situations assembled entirely from imagination. Thus, we take photographs to focus our attention and narrow our vision. Paintings, however, can open up the view and enlarge our vision.

The second reason has to do with scarcity. We can, thanks to Fox Talbot's invention of the negative, make as many virtually identical copies of a photograph as we wish. The same cannot be said for a painting. If you own an original oil-on-canvas object, chances are no one will even attempt to duplicate it. If they do, they will fail by degrees large or small, but always detectable.

Third, we associate value inversely with utility. The more we can use an image, the less value we assign it as art. Paintings are not of much utility, though we consider them

necessary. They don't fuel the car, you can't eat them, or build a house out of them, but we believe they help us understand the world. That's a much more intangible purpose, so we use only surplus discretionary funds to buy them. Photographs, on the other hand, we still tend to take as the literal truth. We use them to sell both cars and houses, and the photographers are paid by advertising agencies for the use of their images. The result? A painting by a living American artist can sell for millions of dollars, far beyond the range at which photographs currently sell.

This isn't just theoretical. Some people value Klett's rephotographic prints less than his other work because they are perceived to be of more utility. You can use them to measure change in the physical world. His "own" work is viewed as being more idiosyncratic, of less practical application, and monetarily more valuable. Like everyone else, he has trouble deciphering how people value artworks, a process most gallery owners will admit has more to do with magic than science. This makes the pricing of his photographs a matter of tortured guesswork for Klett. He's also left to grapple with some awkward pragmatics. If the artifacts of the lens era are romantic and somewhat valued also for their age, as well as for their scarcity, how do we value an infinitely reproducible digital image on a CD-ROM, or a well-done and somewhat stabilized photocopy, such as an Iris print? If, as some people argue, photography is now debased in value because it is no longer assumed to be truthful, but prey to hidden manipulation, others argue that tweaking images in the computer, by infusing the images with more imagination and subjectivity, defines them more firmly as art. But aren't both useful for what they reveal about our reading of the world?

A more subtle shift is occurring with the way photographs are handled by photography galleries, more and more of which are shifting their identities toward being simply "art" galleries, including Paul Kopeikin, Klett's dealer in Los Angeles. The harsh economics of a gallery are so perilous as to induce, literally, suicide, and dealers, most of whom lose money consistently, can't be blamed for trying to find a profit somehow. If a photographer makes only a few prints, scarcity drives up the price. The larger the size of the print, the more it looks like a painting in terms of its presence on the wall, which further drives up the price and increases the probability of a profit. Prints such as Klett's, which aren't enormously enlarged nor limited to tiny editions, might sell for $1,000. Larger and more exclusive images by his contemporaries go for as high as $50,000. For Klett, who considers photography to be a democratic medium, this split in the gallery world is yet another art-market-driven commodification forcing galleries that wish to survive away from the history of the medium itself.

If books by Klett are out of print, presumably becoming more valuable as time goes on because of scarcity, and he circumvents print publications and overcommodification by going online and making CDs—how valuable are they? No one knows the answers yet, but obviously Klett and Byron are going to find out firsthand.

December 19th

It's getting late in the afternoon and Mark will soon drop me off at Phoenix's Sky Harbor, the airport almost due west from here, and from which jet airliners climb over his house

roughly every ten minutes. Between that and the freight trains rumbling behind a screen of bushes at the far end of his backyard, it's sometimes necessary to time our questions and answers carefully between the interruptions.

We made one last visit to his office today, this time to prowl through the flat files, pulling out prints dating from graduate school through the very latest ones made of Emily and the kids. As we talk in between the takeoffs and trains, he's jumping up and down on a large trampoline with Natalie. He holds her hand with one of his own, keeping free the other to snap shots while in midair with a digital camera.

Showing me a few of the pictures made during his Japan visit in 1995, Klett said: "I was interested in getting at landscape as more than a single self-contained image. I wanted to see if I could create meaning through combinations of images." And it's true, the single pictures didn't do much for me, but once connected they began to resonate together. "The idea is that you make them fast, using the Mamiya for snapshots, but I was thinking that they should read as a scroll."

Speaking about his work with Gary Nabhan the year before, Klett commented that working with him "solidified an idea, how to make a statement in photography, to make a narrative and to influence how people think about landscape. It's no use alienating them, you have to make them participants in recreating a story. I'm trying to show that we belong in the land, and *how* we belong in it."

Watching Klett jump, camera in hand, flash going off in the deep shadow of the towering date palms behind them, I speculate on what kind of sequence could be stitched together

out of these digital images, and how they would differ as a static object from a motion picture. And I can't help but think that Klett is entering into a different kind of rephotography that has to do with the passing time and his family. I'd asked him a few minutes ago if it was all right that I write about Emily, the house, the children, which with some artists is off limits. Klett had shrugged.

"Patricia Limerick talks about 'responsible anecdotalism,' and I think there's a hinge point there, where you can move from the personal to the public. Rick Dingus and I were talking once about documentary work and the New Topographers. His point was that there was no viewpoint in that work, so you couldn't evaluate it, the viewer couldn't gauge what was behind the camera. And some photographers protect themselves by not allowing the viewpoint to be known." He shrugged. "I don't mind if people know my viewpoint."

I'm also trying to digest the last images Klett had shown me, work that was startling because of how much more sharply defined the tonal ranges and colors were becoming. The prints were larger than the earlier work, 20 x 24 inches versus the 16 x 20 prints from, say, Nepal. A photo taken in late 1997 is of Natalie in Aravaipa Canyon, a place special to Klett because through it runs one of the last free-flowing rivers in the state, and therefore a place he considers important to take the children.

In the picture she is a figure glowing in sunlight, her back to us, arm raised as she throws a stone overhand into the river, which is an almost inky black. It's a portrait not just of his daughter, but of an *ur*-child facing nature, the great unknown, and casting a message into it to see what might echo back. The blacks and whites of the print are much farther apart

Mark Klett, *Natalie throwing rocks, Aravaipa Canyon, 11/96.*

than we've come to expect in a Klett print. One of the reasons why is that the Kodabromide paper he'd been printing on since Idaho days was phased out in 1991 and he's been slowly running through his stock. The new paper doesn't flatten tones as much. But the other reason is that, where he was once interested more in the middle grays than in the deep blacks and bright highlights associated with Ansel Adams and conventional landscape photography, he now wants a greater tonal range. It's less important to him now than it was when he was younger to avoid the deep tonal contrasts as a reaction against the other work. (No story is without its complications, however. Ansel Adams had a close relationship with the Polaroid Corporation, working to promote their products and telling his friend Edwin Land that Polaroid film not only was useful to professional photographers in spot-checking their work in the field, but that he was sure someday its use would be raised by someone to the level of art. It's ironic that one of those "someones" turned out to be Klett, who was deliberately working so hard against the grain of the photography elder.)

Then there are the color prints that Klett is tweaking in the computer before having them printed at an outside lab, seeking a color palette through "digital darkroom" work. One is of Emily sitting in the truck, all purply night on the outside and eerily green inside the cab. Another is of sandstone cliffs in the far, far background blazing orange in the late afternoon sun, all the near visual space taken up by dark bluish asphalt and traces of broken glass. The colors are preternaturally magnified, as if a layer of film had been stripped away. He's not sure he's satisfied yet with the results, but feels that he is on to something, a new way of both forming and processing the images. The use of the computer for Klett isn't a rupture

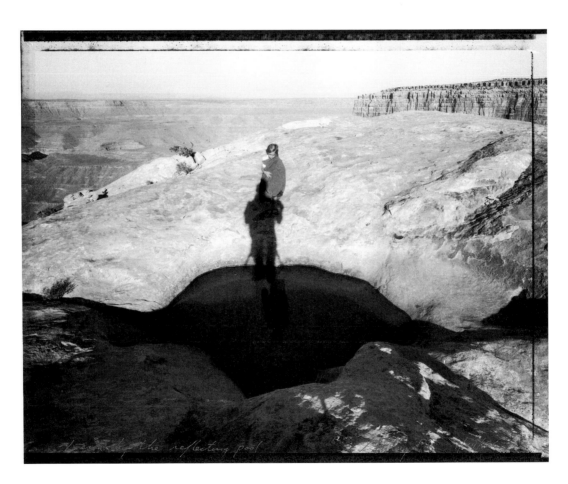

Mark Klett, *Lena by the reflecting pool, Muley Point, 7/14/96.*

with the past, but a continuation of how O'Sullivan practiced photography. He's using the latest technology available to picture the world, not for the sake of artistic style, but better to connect images to the stories we construct about where we live. Photography for Klett is best exercised as ongoing experimentation. The camera and the computer—like the camera obscura in the eighteenth century—are not just devices for making images, but tools through which to investigate the natures of reality, of perception, of knowledge.

He's practicing, I think to myself as I finish up my notes. He's living his practice in order to practice, and letting us watch, about as exposed a position in which a photographer could put himself. He's letting us know that he has no idea how it will all turn out, and whether it is of any literal or metaphorical value. He knows that's not the point.

Mark Klett, *Reading Powell's book at the source: Horseshoe Curve, Utah, 7/12/99.*

Epilogue

MULEY POINT

The sun hasn't yet hit camp when I wake, but Mark and Toshi are already standing on the edge of the cliff with their cameras pointed south. Mike Marshall, an ASU grad student and new member of the Third View team this year, ambles out to join them. The air is heavy and placid after the thunderstorms of last evening, humidity fading the view east and west, but it's to the south that everyone is looking. We'd driven into camp late last night, a spot that Ed Abbey had shown Mark years earlier. Walking to the cliff, we had shined flashlights over the edge, their beams failing to reach the ground. This morning, pulling on my shoes, I see why.

Our sandstone ledge drops vertically to the Colorado Plateau, which then itself plunges into the San Juan River thousands of feet below, a major tributary of the Colorado River. Before us in the breaking light is all of Monument Valley. Parts of Utah, Colorado, New Mexico, Arizona. Much of the Navajo Nation. Silence.

I try to focus on so much detail over such distances without blinking that my eyes start to water. Toshi takes a picture every few minutes from his tripod-mounted Mamiya, compressing the changing light during an hour into seconds. Mark wanders about on his own agenda, camera in hand. Mike and I just sit and watch.

This is the storied book of the West, the stone pages one atop the other that explorer-scientists like John Wesley Powell read during the nineteenth century. It's where John Ford set stagecoaches running to underscore the drama between his actors and the landscape, itself a character, as he filmed the myth of the West. And it's an encyclopedia of recursion. The runnels carved in the dirt next to me from the hard rains yesterday are miniature ver-

sions of the washes that resemble exactly their larger cousins, the canyons, which are branches off the mainstem gorge. The geography is thus self-similar at all levels, what we call fractal, a visual analog for complexity theory, a mathematical story we tell ourselves that explains the universe as well as any other.

Every journey has its theme, and last summer, as the team convoyed across Nevada, the running motif had been the accelerated nature of change in the landscape. Now we were prepared to take the next step, and the "nature" of the trip this summer has been mediated experience. Here, at Muley Point on the last morning of trip this year, science and art and popular expectation climax into a scenic exclamation point that ends Third View expedition work in the twentieth century.

Entering Big Cottonwood Canyon outside Salt Lake City on the Fourth of July weekend, our work had begun inauspiciously, an electronic reader board and printed signs warning us that picnic areas closed at 10 P.M., that no dogs and horses were allowed, and that camping was in designated spots only. The canyon we were driving up was so narrow that it held only a few places wide enough for campgrounds; furthermore, its creek supplies water to the city. To preserve the quality of the visual experience and the drinking water from being overrun by the millions of people living at the mouth of the canyon, usage was regulated with spatial, temporal, and economic boundaries: camp here, leave by curfew, and pay the fee.

After spending the night in a pleasant but full campground organized around loops of asphalt, we began the rephotography with the Storm Mountain Amphitheater, a circling of quartzite cliffs, part of which now forms a reservoir, the remainder made into one of those

picnic areas subject to evacuation each evening. A toll booth greeted us with a sign proclaiming a $5-per-vehicle fee, and a $2-per-person walk-in tariff. Mark grumbled and set to figuring out which combination of vehicles and people would be most economical, while I pondered the cutbacks in government funding that make such user fees necessary in order to maintain the facilities.

Mark had pointed out over breakfast the irony created by contrasting the needs of the nineteenth-century explorers with ours. The former were trying to piece together any security they could manage in the landscape—safe water, good forage for pack animals, game for the table, and passable routes through the mountains. Now we're more concerned with getting away from amenities secured for us by public servants.

Irony is too easy, though. Klett's contention is that people should be able to act responsibly in the land and manage themselves, instead of remaining ignorant and having to be herded together in order to protect the land. During breakfast we had watched a teenager stripping green vegetation from a live bush in the center of the camping loop, an act of unconscious vandalism for a vanity fire this morning—not one to be used for cooking, but just for atmosphere—and I wondered how the public school system could take on that burden.

The morning stayed quiet until a fish hatchery truck drove into the parking lot and backed up to the water's edge beneath the nearby spillway. An older man hopped out, eyeballed the location, then gestured for the other to scoop some fish out of the tank on the truck. The younger guy tossed a long-handled net in the air as if flipping pancakes, and the first of three loads of ten-inch rainbow trout smacked into the water, darting away so quickly

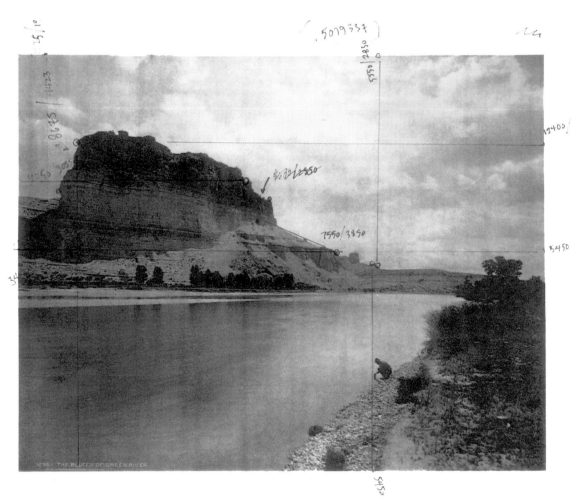

William Henry Jackson, *The Bluffs of Green River, Wyoming,* c. 1885.

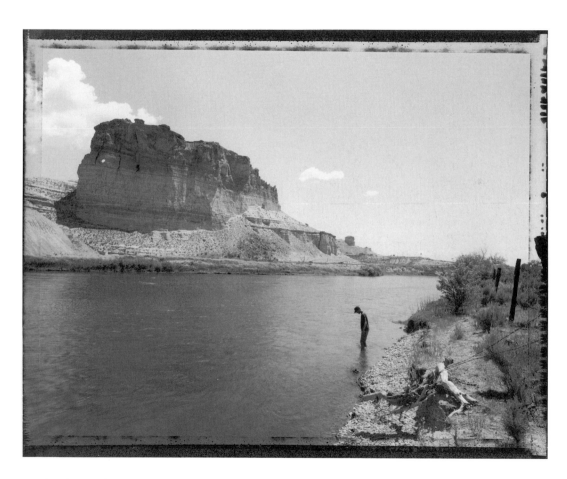

Mark Klett and Byron Wolfe for Third View, *Mike at Tollgate Rock, Green River, Wyoming,* 1999.

that I thought I imagined them. The Forest Service was deliberately stocking put-and-take trout for the holiday weekend. Families from the city would drive up into the canyon with the expectation of getting a campsite, catching some fish, and grilling them over a fire. The government was not about to disappoint them, but there was no mistaking this for anything but a manufactured version of nature.

Driving down into the city for lunch, Mark commented on how the rephotographs had gone. "The first one is an overview of where O'Sullivan was camped, and you get a real sense of vista down the canyon. The second shot is truncated by trees, so it's closer in, and there's a sense of enclosure. In the third one there's that chainlink fence at the reservoir right in front of you, and it's topped with barbed wire. It's not a benign barrier."

Mulling over the fact that our space has suffered an increasing load of control, he returned to the issue of access versus quality.

"The crux for me is the mediation of experience, the controls the government uses to funnel our experiences. By setting up campgrounds and fire pits, regulating the hours and putting in fish, they're telling you how you have to interpret the place. In order to have your own experience, you have to override those controls.

"If all you have is an experience designed by someone else, how do you develop an attachment to a place, or develop a sense of it? Thank god they haven't fenced Toroweap Point on the North Rim of the Grand Canyon. It's still your choice for how close you get to the edge; it's up to you whether or not you fall. If someone else has kept you away from that edge, you don't have the choice to experience any fear there, hence respect for it.

Timothy O'Sullivan, Untitled [Big Cottonwood Canyon], 1869. Collection of the United States Geological Survey.

Rick Dingus for the Rephotographic Survey Project, *Edge of Storm Mountain Reservoir, Big Cottonwood Canyon,* 1978.

Mark Klett for Third View, *Reservoir fence at Storm Mountain, Big Cottonwood Canyon, 7/2/99.*

"I don't mean you have to have fear, but you have to have choice, the freedom to screw up. That's how you develop responsibility. It's like with your kids, you can just order them around, or you can help them find out what's going on so they develop their own responsibility."

He paused for a second, and I jumped in. "That's a basic need, that existential choice, I agree. But Mark, not every parent knows how to take their kids out camping without hurting the environment. It's like that kid this morning stripping the bushes at his campsite. He wasn't being bad, he just didn't know any better, and neither did his parents. And given that there's a population that keeps on growing. . . ."

Mark replied quickly. "Yeah, but, look. What we need to do is to teach our kids and students and each other new stories that aren't about domination of the land, that nineteenth-century way of doing things. I don't mean to pick on the National Park Service, but funneling people into one kind of experience is same old story of control over nature, and we need new stories.

"I have to teach my kids that, my students . . . it's what I'm trying to do as a photographer, and you as a writer. Maybe things will change that way; they sure won't change if we just keep doing what we're doing now."

After lunch we stopped in at a sporting goods store, a place selling everything from golf balls to rock climbing shoes. The woman behind the counter asked if we were from out of town, and Byron, who was purchasing a pair of sunglasses, answered that we were a photography team.

"Oh," she said. "An advertising shoot? Pretty girls for Penthouse?" Byron patiently explained what rephotography is, but the question was relevant. More often than not, landscape photography is just a background against which sport utility vehicles are sold. Even "pure" landscape work sometimes smacks of pornography, cameras intruding into the private corners of the land and exposing them for all to see, a kind of scenic exploitation that is interested only in the seductive image of a private wilderness without cultivating any responsibility.

We piled back into the vehicles and after a side trip to buy groceries started the drive back uphill, headed this time toward Little Cottonwood Canyon. I'd tried to find out from the U.S. Forest Service national campground reservation service, an 877 number located in an anonymous city, whether or not any sites were available in the smaller canyon, but the operator couldn't help. Computerized reservation system notwithstanding, we would just have to drive up and see.

On the morning of the Fourth we decided to do something uncharacteristic for the team: visit a place not documented as part of the government surveys that the Second and Third View usually retrace. Nonetheless, the site where the final spike was driven to complete the transcontinental railroad is a historical locus from the same period. We convinced ourselves that it was fair territory in this game we've created, and as we turned off west toward the Promontory peninsula, we found that we were also on the route to the rocket display at Thiokol. The conjunction of Victorian railroading with the company that manufactures engines for the Space Shuttle was almost too good to be true. And it got better.

As we pulled into the parking lot of the Golden Spike National Historical Site, the rangers were announcing that a reenactment of the spike driving would be held in five minutes. We raced through the visitor's center and out back to where two exquisite steam engines sat head to head, puffing gently before an audience of about thirty people. Eight men, mostly older, wore black frock coats and formal trousers, volunteer actors playing the part of dignitaries. For half an hour they wafted abbreviated versions of the speeches given on May 10, 1869, through the air. The master of ceremonies, not one to miss a trick, gestured at the Third View crew and proclaimed to the audience that "world-famous photographers" had gathered to document the event. Mark grinned and waved, enjoying our participation in the ongoing maintenance of a cultural myth.

When a spike finally was pounded into place by the resident locomotive engineer, great blasts from the trains' steam whistles threw children into tears, the long mournful hoots too loud in the silence that otherwise reigned on the high plateau. Afterwards we visited the trains and the engineer, and listened to the ranger explain how the engines were recreated from scratch down to the last detail for an estimated million dollars apiece. I found myself softly humming the theme song from the old television show, *Wild Wild West*. A feature film spun off the series had opened that weekend in several thousand theaters nationwide, a movie with two Victorian secret agents traveling the West in a train pulled by a locomotive much like the ones in front of us. Byron and I had argued strenuously on behalf of seeing it sometime during the trip as an official Third View activity, and this reenactment whetted our appetites.

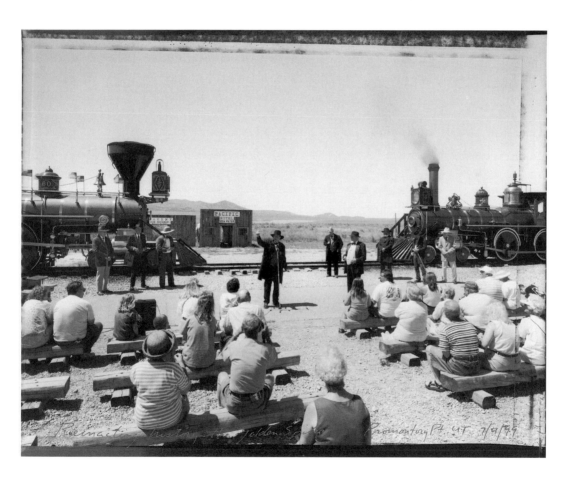

Mark Klett, *Reenacting history: the Golden Spike, Promontory Point, Utah, 7/4/99.*

As we left, I asked one of the rangers to stamp the official national park passport emblem on a small piece of paper. It wasn't until Byron pointed it out that we saw it read "Promotory Point" instead of Promontory, perhaps more than a typo, but a telling Freudian slip.

Caravaning out of the park, we stopped at a crossing for one of the locomotives to realign itself for the next reenactment, and waved at the engineer, a railroad enthusiast from West Virginia who considered himself fortunate to be running an engine up and down the same mile and a half of track twice a day for six weeks. The original tracks were pulled up and the final spike undriven in 1942, the steel recycled into the "war effort." Now we were on our way to observe some artifacts from what came next in the development of the military-industrial complex. Thiokol is the company that has built rocket engines for missiles from the Minuteman intercontinental ballistic mammoths of the Cold War to the shoulder-held Stingers used by rebels in Afghanistan, but it's a name mostly known to the public as the corporation responsible for the Space Shuttle booster that blew its crew to smithereens in front of millions of television viewers. Some Thiokol engineers had, in fact, argued against the launch that particular day, predicting that a critical o-ring could fail—but launch windows are narrow, time is money, and the countdown proceeded.

Located only a few minutes from the Golden Spike park, Thiokol is spread out judiciously over hundreds of desert hillside acres, the terrain providing natural blast buffers in addition to the constructed berms. Large corrugated steel buildings had escape chutes descending from each floor to the ground, which looked as if playground equipment had collided with a chemical plant. The rocket display was a square half-acre of gravel framed with incon-

272

gruously lush lawn just south of the administration building. Several dozen minimalist cylinders, some fat, some slender, all painted with a glossy white enamel, stood along the self-guided walking tour.

The first object we encountered was a "Standard Missile #2." The sleek tube looked like a larger version of the amateur rockets we used to launch from backyards when we were kids. The next two assemblages were stubby rocket engine casings inside which solid propellants used to burn furiously; now they were filled with birds' nests. As we walked deeper into the display the familiar names of the late-twentieth-century American armory popped up on placards before us: Patriot, Polaris, Titan. It all seemed pretty innocent, an illusion fostered by the careful separation of the manufacturing process. You can work at Thiokol and argue that all you do is build rocket engines. You don't make the explosives, or the triggers, or the guidance systems, all of which are made by other corporations scattered around the country. As a passive audience even further removed from the reality, and walking around on a pleasant summer day, we had to concentrate to remember these were the most destructive delivery vehicles on the planet.

Raised at an angle, a booster rocket from the Space Shuttle ran the entire length of the display and dwarfed the ICBM nearby, which was otherwise the largest object in the exhibit. We stood on tiptoe to wrap our hands around the rim of its flared nozzle, an aperture large enough to stand up in. It made the hair stand up on the back of my neck to touch the legendary vehicle, though the ICBM was a reminder that science, commerce, and the military are as inseparably linked today as when the transcontinental railroad was built.

Mark Klett. *Inspecting the Space Shuttle booster rocket at Thiokol, 7/4/99.*

From Thiokol we headed north into Idaho to the City of Rocks, once a junction for wagon trains emigrating west, but now a rock-climbing mecca so well known worldwide that it's been declared a national reserve with camping limited to just seventy-four spots. When Mark and I had last been there, more than twenty years ago, it was unrestricted territory; the change infused everything the team turned up over two days, but most notably our interviews with locals.

Venna Ward, who with her husband is the largest landowner out of the dozen or so in the reserve, is part of an early ranching family that slowly bought out other homesteaders in the area, often just by paying the back taxes on abandoned property. It took some politicking for the Wards to get permission to build in City of Rocks, their two-story house tucked away in a rocky nook and facing the reserve out the front window, but they managed to get the county to agree to it, provided it was constructed of logs.

Venna, a retired middle-school librarian, agreed with most of the other locals that organizing the reserve was a good thing. Although she was a bit confused about the National Park Service belonging to the Department of Agriculture and not Interior, and thought grass only grows wild in the West if cattle are there to crop it annually, she was happy with the coexistence of climbers, day users, and ranchers that had been negotiated. The interview uncovered a deeply individualized landscape, not just property held for the public good.

The same thing happened to us at our next stop in Twin Falls, the site where O'Sullivan took more pictures than anywhere else. The falls, when we got to their overlook, were a complete surprise. I'd been expecting something around the order of forty or fifty feet high,

and had been denigrating the signs proclaiming them to be the "Niagara of the West." But the water drops 212 feet, which is fifty-two feet more than Niagara Falls, although the volume of water was less, at least in the middle of summer when almost three million acre feet were being diverted upstream to corporate potato farms.

When we sought permission to approach the water in order to reach the nineteenth-century vantage points, City Hall directed us to the office of Dennis Bowyer, the superintendent of Twin Falls' Department of Parks and Recreation, a man who so admires the falls that he'll sometimes drive out to the overlook just to watch them for a half hour or so. Mike and I arranged an interview, and he filled an hour of tape with stories of teenage high jinks in the gorge, of industrial dumping into tributaries, and of plans to link the town with foot and bike paths to the gorge. He pulled out a tattered 1910 blueprint by Florence Yoch, a local landscape architect, part of a proposal to make the falls a national park. Dennis was proud of the town's growing self-awareness of its scenic tourism, and that Twin Falls had what could be declared a national scenic treasure as a city park. But driver's education instructors take their students down to the lake behind the dam to teach them how to back up the rear wheels to the water, a necessary skill in a town where boats and water skiing are primary recreations. Once again, what we took to be a scenic climax was held by locals to be their backyard.

By this time the sequence of pictures we were taking, which we could monitor in our daily Polaroid shots, was assuming a narrative shape. A reporter from Phoenix, who had joined us in Twin Falls, asked over dinner one night whether or not we were conscious of

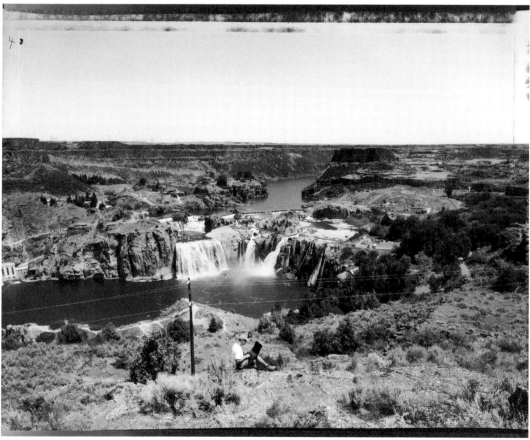

(Top) From the web site of the National Archives, Washington, D.C., 1999. What Byron saw on the laptop above Shoshone Falls: Timothy O'Sullivan, *Shoshone Falls, Idaho,* 1874. (Bottom) Mark Klett and Byron Wolfe for Third View, *Byron with the laptop above Shoshone Falls,* 1999.

"making history." Mark framed it more as participating in a lineage, that we weren't separate from history, but part of its ongoing process—which I compared to culture likewise being embedded in nature. Mark brought up the idea of "re-storying" the West, which then spun into "re-historying." That lead Mark to contrast the more dominating style that other nineteenth-century survey photographer, William Henry Jackson, who tended to assume a singular viewpoint from above his subject, to O'Sullivan, who often occupied multiple vantage points lower down in the landscape. Jackson was following the pictorial tradition of his time; O'Sullivan, at least from our perspective, seemed to be inventing a new one more appropriate to the land.

Later that night, seduced by the advertising around town, we took in *Wild Wild West,* which turned out to be more relevant than we thought. Despite a plethora of puns, much of the movie relied on forced humor between the protagonists and sometimes mediocre special effects to carry it over an extraordinarily thin plot, a total lack of character development, and no dramatic tension. In short, we had a great time, due to the geography and storyline of the film overlapping the Third View work.

The denouement of the film occurs at Promontory Point during the driving of the Golden Spike. Although the movie had President Grant attempting himself to drive the big nail home, a fictitious appearance interrupted only by the arrival of the villain's eighty-foot-tall steam-driven metal tarantula, the conflation of place and event with our witnessing the reenactment was striking. In fact, the movie had the scene looking more like the current play-acted version than what the photographs show to have been the actual appearance, a visual

loopiness worthy of a French deconstructionist essay (or a classic Roadrunner episode, which amounts to the same level of cultural criticism).

Then there was the slip-sliding from scenes of the heroes' train flying over the open prairie directly to Monument Valley, neither of which are within three hundred miles of each other or Promontory Point. Some of the scenes actually were filmed in Idaho, which partially explained the signs and promotional gimmicks in town. This was considered a local production, the Idaho prairie several hundred miles to the north providing location shots. "Promotory" on the official park stamp looked less and less like a typo all the time.

Finally, the overlapped technologies appealed to us. Steam-powered machines, such as the infinitely articulated tarantula that clambered up steep mountainsides and blew away an entire town with what look like Thiokol-inspired effects, were so obviously an invention of twentieth-century hindsight that they could be accepted only with an utter suspension of disbelief. On the other hand, pulling up O'Sullivan images on the laptop in our hotel room from the National Archives also would have seemed like science fiction a few years ago. After the credits, when asked how he liked the movie, Mike made the point that *Star Wars* was the western movie gone to space, and it was only fitting that science fiction should come back to the westerns.

There's a reason why so many science fiction and postapocalyptic movies are set in the deserts—just as they're cheap places to bury waste, so they're inexpensive locations in which to film large-scale warfare, explosions, and monsters. The deserts are also places where, because our imaginations are less constrained by familiar geographies, we can suspend reality more

easily. We can accept the mechanically implausible mega-tarantula of *Wild Wild West,* the forced innocence of rockets at Thiokol, and the supposed safety of trains bearing radioactive waste so hot we have no way to constrain it for more than a few years before it burns its way free into the environment. All of them are loosed in the West as experiments in entertainment, science, and industry.

It wasn't so much that we linked these things with irony, but more that they were connected in our history through the stories that we construct over and over again. *Wild Wild West* was, at one level, another retelling of who would run the train of Manifest Destiny. It was a fitting bit of unconscious symbolism in the movie that the two trains meeting in Utah were blown up during the struggle; after all, progress has been something of a train wreck in the West. Individually and as a team, we revel in that sense of swimming in a deep and live current of time, where almost everything we stumble across links to what we're doing. As I said, we had a great time.

On Saturday, July 10, we trooped into Green River, Wyoming, each butte above town evoking a painting by Thomas Moran, a photograph by Jackson, a Second or Third View photo. The Green, largest and longest tributary of the Colorado River, flowed to our right. A red steel bridge crossed over it to Expedition Island, where Powell launched the first boat voyage down the Colorado in May 1869, just a few months before the Golden Spike was driven. Like Promontory, this was a nexus in the transportation of goods and money, of power and curiosity. In addition to the freeway and the river, dozens of trains crowded the large switching yard, hundreds of freight cars awaiting engines. Power lines, bifurcating highways,

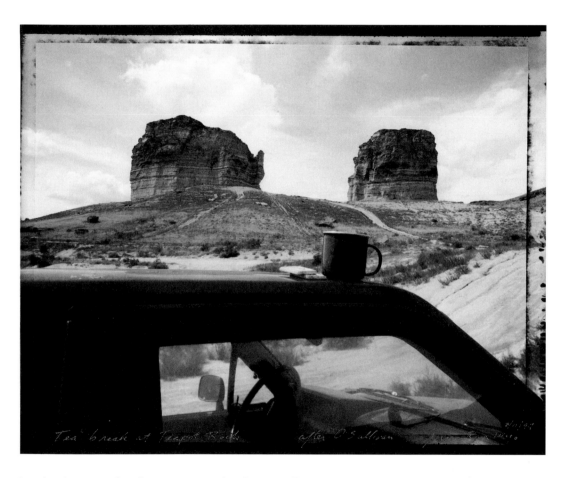

Mark Klett, *Tea break at Teapot Rock, after O'Sullivan, Green River, Wyoming, 8/11/97.*

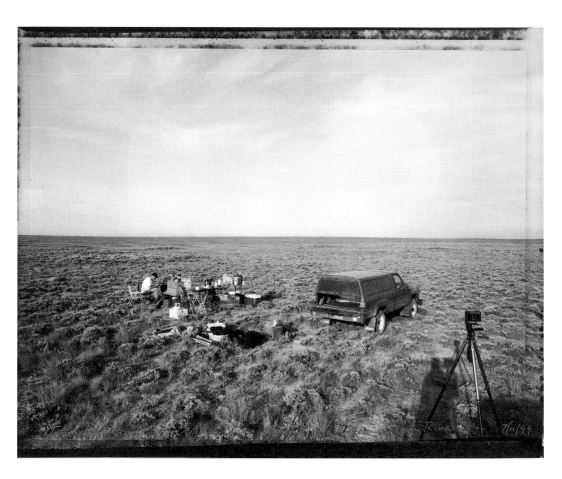

Mark Klett, *The kitchen at Wildhorse Camp, near Green River, Wyoming, 7/11/99.*

microwave towers—every grid that crisscrosses America was there in force, dominating the tree-lined residential avenues.

Other kinds of intersections were present, too. On the dirt road up to Castle Rock, we discovered the still decomposing remains of four pronghorns along with dozens of exhausted fireworks launchers. On the local radio stations fundamentalist preachers and talk show hosts blasted vitriol over the state and society. The ground was charged with violence and weirdness. "Welcome to the real West," intoned Mark.

The road led us up and over the twin tunnels of the interstate to the back side of Castle Rock, where we spent an hour photographing a small rock incised with the words "Kim I love you forever." Our shadows were necessary to screen the sun from the lettering so it was legible, but it gave our presence an unpleasant looming quality over the message, perhaps appropriate to the violence portrayed around us by spent fireworks and munitions, the little sisters of Thiokol. I let my eyes wander while Mark finessed the view camera around the declaration of love. An enormous waste-water treatment facility far out of scale to the apparent population of the town sat on the edge of the river. As the Colorado supplies drinking water to twenty million people in the Southwest, including to the populations of Tempe and Los Angeles, I found that reassuring.

The next morning while leaving camp, which we had pitched off a jeep track, Byron drove up and handed through the passenger window a photo album he had spotted in the sagebrush. Its first page was the sonogram of a fetus *in utero* dated October 1998. The next pages included a baby picture, casual portraits of a young couple, the program from a funeral,

Mark Klett, *Making dinner at Flaming Gorge Camp, Rephotographic Survey Project, 8/79.*

a picture of a tombstone, and a half-dozen snapshots of what might have been a family reunion in a double-wide. The remaining seven leaves were blank.

It was almost too painful to contemplate, but we tried, independently coming to roughly the same conclusion about something having gone bad for these people. Too heavy to have been blown off the road, had someone simply dropped it, it seemed likely that the album had been hurled away in an effort to get rid of the pain. Maybe the baby died, maybe the young couple split up. Mark is always urging us to find artifacts that are less generic and more personal. Now we'd gotten it, and wished we hadn't. We put the album away for closer inspection later, wrestling with thoughts about voyeurism.

After dinner that night by the edge of Flaming Gorge Reservoir, we turned down the lantern to watch the satellites traverse the sky. Thiokol engines put them up there in the name of science, commerce, and mutually assured destruction, outer space in our minds not all that different from Green River. We like to think of the West as being so vast that we can sacrifice part of it for the national goal of circulating capital around the world in an ever-increasing spiral of wealth. We treat the "final frontier" the same way. You can't help but compare the space junk that will rain down increasingly upon us in the next century, as satellite orbits decay, to the unintended consequences we're created for ourselves in the West. There is no such thing as an area that can be safely sacrificed to produce nuclear power or weapons. The larger the reach of our technology, the more its consequences are entwined with nature, a calculus of inevitability. All the more reason why Klett is right in insisting that we teach ourselves and our children how to act responsibly outdoors. It's

better to learn risk and consequence at a personal level first, before attempting it on a planetary scale.

Rephotography high above the gorge the next day entailed scrambling along the rim for hours, which left us dehydrated and tired. After dinner we sprawled in our folding chairs and began to dissect out loud what we'd seen this trip. We decided that Green River epitomized our tussles with the issue of access to, versus preservation of, the landscape. The buttes are prominent in time as well as space, landmarks in the cultural history of the last century as well as handsome geological specimens. You could argue that they should be classified as a national historical site, protected from casual beer-fueled assignations, and interpreted with signs. On the other hand, there's the invaluable freedom of discovering and reading for yourself the significance of a neglected site. Wyoming is one of only two or three states remaining with few enough people where that's possible. If you doubled the population of Green River to the size of Twin Falls, the town would start to formalize its relationship to buttes, as it had to Powell's Expedition Island, now a city park.

Then there was the issue of the photo album. Because it was such a recent and singular item from a personal life, versus an anonymous piece of emblematic junk, which is what we usually collect, it troubled us to classify it as an artifact. We went round and round over what our responsibilities were toward its owner, trying to balance preserving the privacy of the people involved, who might wish fervently to never see it again, versus a simple way to let someone who may wish to retrieve it know where it can be found. We finally settled on taking out a newspaper ad in the local paper.

Byron Wolfe, *After cocktail hour at "Mosquito Camp" with an empty chair for Kyle, Flaming Gorge, Utah,* July 11, 1999.

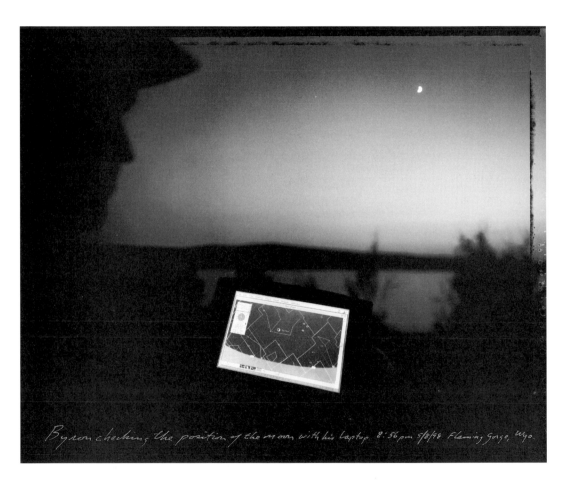

Mark Klett, *Byron checking the position of the moon on his laptop, Flaming Gorge, Wyoming,* 8:56 P.M., 8/8/97.

We felt that rephotography, while still the core activity of the group, was less the goal of the journey now, and more of a starting point. We had the site work down pat, which allowed us to take excursions into relevant side issues, whether they're a place like Promontory Point, a parallel medium like a movie, or, in the future, a picture by someone other than a survey photographer in the nineteenth century. We also wanted to continue to find new people each year to bring into the journey so that we could constantly refresh our viewpoints: A historian, a scientist, an eco-critic, someone who would keep the dialogue opening outward.

This year, Mark had decided that we'd forego all the computers save the laptop for my writing and miscellaneous necessities, such as Byron's research at the National Archives. Last year, our wrestling with the computers to post daily materials on the Third View Web site had become a distraction from what we were experiencing in the field. It was a good choice, allowing us to travel a deeper story.

Two days later and back in Utah, we visited Dinosaur National Monument. The drive in was littered with rock-and-fossil shops, and numerous Jurassic reptile models ranging from miniaturized ones the size of a collie to life-scaled ones with saddles for a photo-op. At the park we boarded a shuttle tram, its taped message commanding us take our seats on the "time machine" and "enjoy your visit to 145 million years in the past." We looked at each other, strains of *Wild Wild West* in our heads. If it's not one theme park, it's another, the script for the near past of Promontory Point being supplanted by that for *Jurassic Park*. The conflation of national parks and historical sites with movies represented a homogenization of narrative that threatens our intellectual diversity as much as the monolithic

corporate agriculture of Simplot in Idaho curtails biodiversity in crops, a trend we pondered over lunch.

Coming out of the restaurant we encountered the first raindrops from the thunderstorms that would dog us down to Muley Point. We said good-bye to Byron, who took off west to California, while Mark, Mike, Toshi, and I continued south. We'd done seventeen sites, the majority of the work for the summer, and it was time to head back to Arizona. And here I was, sitting on the rim of the world.

The nineteenth-century explorers of the Colorado Plateau were interested in reading downward the layers of geology, tracing back a linear progression of events leading to the formation of the earth itself. This morning, however, we're more interested in the horizontal aspects before us, the topographical surface produced by the erosion. Western science, literature, art, philosophy all tend to be linear. We think in terms of the increasing complexity in all fields, an upward trend of evolutionary achievement, of insight, of order. Yesterday in the truck, Mark had described how Third View is, among other things, a passage for him toward new work. Taking pictures for himself during the journey, he's not getting the same kind of images he did twenty years ago, the supreme synecdoches that juxtaposed culture to nature in a singular photograph. Now his images are less singular and tend toward the cumulative—a seriality that is less straight-forwardly progressive, instead rounder, more allusional. They're more akin to scrolls that are rolled out, he thinks, their stories to be divined by the viewer. That's a very Eastern way of looking at life, one that implies cycles, of indeterminate events that nonetheless tend toward pattern.

Mark Klett, *Toshi studying an interpretive plaque, Dinosaur National Monument, 7/14/99.*

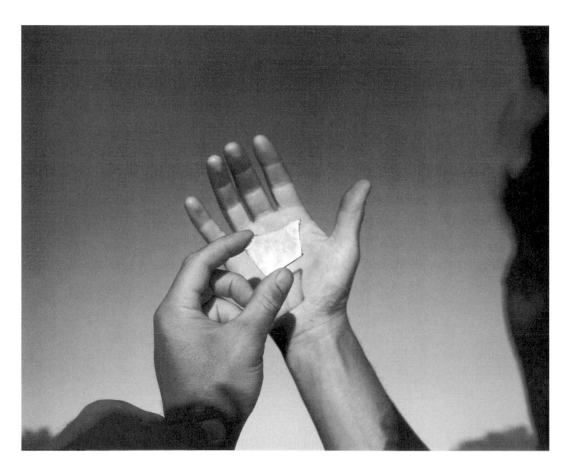

Mark Klett, *Plate sherd found at O'Sullivan's vantage point, Flaming Gorge, 7/97.*

"I've been putting this off for years," he told me yesterday, referring to this idea of serial photography that he's been thinking about since visiting Japan. It's related to how O'Sullivan would take multiple views to investigate a site instead of a singular domineering view attempting to define it. And it's part of finding more than just a new story for the West, but developing a viable narrative technique.

We pack up the cameras and continue southward. Mark's refrain for the day becomes: "This is where I made the picture of. . . ." He's taking a journey of rediscovery, of personal rephotography done in the mind, as well as sharing with us. He's mining the historical past not only for images, ideas, and inspiration, but for his own memories, the deepest mediation of experience we have.

We enter Monument Valley, and in the distance are the buildings where John Ford's movie crews used to stay. Ford first came to the valley in 1938 to direct the thirty-one-year-old John Wayne in *Stagecoach.* Its success guaranteed that he would return here to film other movies, and he did, setting all nine movies in among the red buttes, including *She Wore a Yellow Ribbon* (his first to present Monument Valley in color), *My Darling Clementine,* and *The Searchers.* The popularity of Ford's westerns also made it impossible for the director of *Wild Wild West* to use any other landscape as immediately emblematic of the West.

We bear west through the sandstone towers and back to Flagstaff, completing the loop we started sixteen days ago. I'm looking back through my notes as we drive into a strip mall where Mark knows a decent Chinese place for lunch. Getting out of the truck, I find myself wanting to count the countings, to measure my compulsiveness, to compare the recursive-

Mark Klett, *The sunrise stick game at the edge of Cedar Mesa, 7/15/99.*

ness of the landscape to the cycles of a scroll. It's an impulse short-circuited only when we see the headline of the newspaper. "Wild Wild West Revived," it reads, a story about a theme park planned for the edge of town. Perfect, I think, just perfect.

Ozymandias

I met a traveller from an antique land
Who said: Two vast and trunkless legs of stone
Stand in the desert . . .
Near them, on the sand,
Half sunk, a shattered visage lies, whose frown,
And wrinkled lip, and sneer of cold command,
Tell that its sculptor well those passions read
Which yet survive, stamped on these lifeless things,
The hand that mocked them, and the heart that fed:
And on the pedestal these words appear:
"My name is Ozymandias, king of kings
Look on my works, ye Mighty, and despair!"
Nothing beside remains.
Round the decay
Of that colossal wreck, boundless and bare
The lone and level sands stretch far away.
—*Percy Bysshe Shelley 1792–1822*

Sources

The literature of landscape photography is extensive, and the sources listed here are only the ones I consulted while writing about Mark Klett. In no way should their authors be held responsible for my errors or omissions. Readers interested in pursuing the intertwined histories of the West and photography may wish to consult some of the titles listed below. The original field notes from the Nevada trip of July 1998 first appeared on an Internet site hosted by the Institute for Studies in the Arts at Arizona State University in Tempe (now at www.thirdview.org). The site included photographs and other materials by various members of the Third View team.

Western History

Ansari, Mary B. *Mines and Mills of the Comstock Region Western Nevada.* Reno: Camp Nevada (Monograph No. 8), 1989. Alvin McLane, when he's not out exploring the Great Basin on foot, runs a small press devoted to its natural and cultural history. This is one of the invaluable bibliographic resources he has sponsored.

Goetzmann, William H. *Exploration and Empire: The Explorer and the Scientist in the Winning of the American West.* New York: W. W. Norton, 1966. The author won the Pulitzer Prize for this excellent book, which gives pleasurable and insightful context for the work of the photographers in our exploration of the West.

Hague, Arnold, and S. F. Emmons. *Descriptive Geology* (United States Geographical Exploration of the Fortieth Parallel, vol. 2.). Washington, D.C.: Engineering Department, U.S. Army, 1877. The reports from King's survey run to several volumes; this is a companion work to King's own *Systematic Geology.*

King, Clarence. *Mountaineering in the Sierra Nevada.* Lincoln: University of Nebraska Press, 1970. Introduction by James M. Shebl. A classic of both climbing and exploration literature, King recounts with relish the experiences that led him to support a mixture of uniformitarianism and catastrophism (glacial and volcanic forces, for instance) as a theory of geology.

———. *Systematic Geology* (United State Geographical Exploration of the Fortieth Parallel, vol. 2). Washington, D.C.: Engineering Department, U.S. Army, 1878. Many of O'Sullivan's photographs are reproduced as lithographs in this and in *Descriptive Geology.*

Limerick, Patricia Nelson. *The Legacy of Conquest: The Unbroken Past of the American West.* New York: W. W. Norton, 1987. Perhaps the single most influential revisionist history of the West, it has since become the standard against which other views of the region are judged. Limerick traces the history in terms of national and regional economics. She is also the author of a fine essay about Klett's photography in the collection of his work *Revealing Territory.*

Wilkins, Thurman. *Clarence King.* New York: Macmillan Company, 1958. A pedestrian biography, but valuable. The material regarding King's near-marriage to a woman in Virginia City is poignant.

On Photography

Armstrong, Carol. *Scenes in a Library: Reading the Photograph in the Book, 1843–1875.* Cambridge: MIT Press, 1998. Taking her cue from Roland Barthes's *Camera Lucida,*

Armstrong meticulously deconstructs the relationships between science and art in nine-teenth-century England as exemplified in books using photographs to explore the "natural philosophy" of the time. The chapters on Fox Talbot and Francis Frith were particularly helpful.

Barthes, Roland. *Camera Lucida.* New York: Farrar, Straus and Giroux, 1981. An important, short, even exquisite meditation on the subject, the controversial and sometimes infuriating last book by a key philosopher of the late twentieth century.

Clarke, Graham. *The Photograph.* Oxford: Oxford University Press, 1997.

Coleman, A. D. *Depth of Field: Essays on Photography, Mass Media, and Lens Culture.* Albuquerque: University of New Mexico Press, 1988. Coleman's classic essay "Lentil Soup: A Meditation on Lens Culture" is an unusual variation on the standard story of photographic history.

Davis, Keith. *An American Century of Photography: From Dry-Point to Digital: The Hallmark Collection.* New York: Abrams, 1999. This revised edition of a serious and comprehensive study is an important history.

Green, Jonathan. *American Photography: A Critical History 1945 to the Present.* New York: Abrams, 1984.

Jenkins, William. *New Topographics: Photographs of a Man-Altered Landscape.* Rochester: International Museum of Photography at the George Eastman House, 1975.

Newhall, Beaumont. *The History of Photography.* New York: The Museum of Modern Art, 1964. A compact source for information on the complicated and competing paths that

led to the invention of photography and how it came to America, as well as modernist trends.

Sontag, Susan. *On Photography.* New York: Farrar, Straus and Giroux, 1977. It remains difficult to bring up any issue concerning the field without Sontag having already at least touched upon it in what remains one of the most important books about the subject.

Szarkowski, John. *Mirrors and Windows.* New York: The Museum of Modern Art, 1978. His discussion of how the concerns of photography shifted from those of Stieglitz and Weston to photographers such as Robert Adams and Joel Meyerwitz lays out an axis within a plastic medium that accommodates both public representation and private exploration. He takes photojournalism, and by extension documentary photography, to task for its "hubris," pointing out that the personal visions of individual photographers can shed more light on events and trends in the world than can sweeping magazine assignments. I take this as also saying that, for contemporary times, the Sierra Club might sometimes be better served by the rigorously centered windows of Robert Adams and Lewis Baltz, for instance, than by the grand mirror of Ansel Adams.

Wells, Liz, ed. *Photography: A Critical Introduction.* New York: Routledge, 1997. A handy textbook on the history and practice of critical theory and photography, especially useful in addition to and contrast with the Newhall book.

White, Jon E. Manchip. *Egypt and the Holy Land in Historic Photographs: 77 Views by Francis Frith.* New York: Dover, 1980. This extensively captioned, large-format paperback is a handsome and inexpensive collection of Frith's photographs.

Of related interest are books about the scientific, social, and artistic constructs that we use to decode vision as our most common method of apprehending reality. *Vision and Visuality* (edited by Hal Foster, and published by Bay Press in Seattle for the Dia Art Foundation in New York, 1988) is a much-admired collection of essays about these issues. The discussion by Jonathan Crary in "Modernizing Vision" about the shifting away in the nineteenth century from the model of the camera obscura as an objective instrument is an instructive example. For a detailed examination of the intersections of mathematics, optics, and the visual arts, *The Science of Art* by Martin Kemp (New Haven: Yale University Press, 1990) is a compendiously illustrated treatise. On the role of the artist in society and the utility of artwork, Donald Kuspit offers some provocative thoughts in his essay "The Good Enough Artist," in *Signs of Psyche in Modern and Postmodern Art* (Cambridge: Cambridge University Press, 1993). The relationships among art, the art world, and money are taken up by Dave Hickey in a number of essays, some of which can be found in *Air Guitar* (Los Angeles: Art Issues Press, 1997), possibly the single most useful book of art writing anyone could hope to read. Barbara Novak's *Nature and Culture: American Landscape Painting, 1825–1875* (New York: Oxford University Press, 1995) is a requisite analysis of how nineteenth-century scientific, political, and economic views are represented in art.

Landscape Photography / Photography and the West

Adams, Ansel. *Ansel Adams: Classic Images.* Boston: Little, Brown and Company, 1985.

The introduction by John Szarkowski, and the essay and chronology by James Alinder,

former director of the Friends of Photography and husband of Adams's biographer, Mary Alinder, are a good primer on the photographer.

Adams, Robert. *Why People Photograph.* New York: Aperture, 1994.

————. *Beauty in Photography.* New York: Aperture, 1996. An articulate writer and photographer, Robert Adams successfully bridges the landscape traditions of the nineteenth and twentieth centuries. Unlike critics, curators, and theorists discussing O'Sullivan's work, or that of others working in the West, Adams has the advantage of being a practitioner—he knows what matters to the photographer. While cognizant of how people have negatively impacted the western land, he also is able to find hope in the landscape.

Castleberry, May, Martha Sandweiss, et al. *Perpetual Mirage: Photographic Narratives of the Desert West.* New York: Whitney Museum of American Art, 1996. Exhibitions about the West, the West and art, western Art (which is a different matter almost entirely), and photography and the West are among the most enduringly popular shows mounted by museums in America. Some of them are useful, some are excellent, some extraordinary, and this is the catalog from one of the lattermost. Because it carefully and fully traces both the history and our perceptions of the history of the region through a set of specific and material manifestations of our visual culture, as well as essays by notables such as William Kittredge, Patricia Limerick, Marc Reisner, Kevin Starr, and Terry Tempest Williams, it is one of the most valuable books on the West anyone can own. Thomas Southall, currently curator of photography at Atlanta's High Museum, contributed an excellent essay on Mark Klett.

Enyeart, James L. *Land, Sky, and All That Is Within: Visionary Photographers in the Southwest.* Santa Fe: Museum of New Mexico Press, 1998. Enyeart provides a useful summary of the philosophical issues underpinning veracity in photography, and beautifully reproduces photographs not always presented in the discussion of landscape work in the West.

Flattau, John, Ralph Gibson, and Arne Lewis. *Landscape: Theory.* New York: Lustrum Press, 1980. This features interviews with and statements by ten landscape photographers who arc from the classicism of Edward Weston's son, Brett, to the postmodern gaze of Robert Adams and Lewis Baltz, to the performance documents of Hamish Fulton.

Foresta, Merry A., Stephen Jay Gould, and Karal Ann Marling. *Between Home and Heaven: Contemporary American Landscape Photography.* Albuquerque: University of New Mexico Press, 1992. A comprehensive overview of its topic, this catalog from a Smithsonian exhibition demonstrates how the development of landscape photography in America is intimately related to the West, but also how such photography within the West resides within a larger national tradition. The book includes a double-truck reproduction of Klett's "Around Toroweap Point . . . ," a photograph about which Foresta, the curator, writes with great intelligence in the lead essay. Her views on the "promise of the earliest camera obscura," wherein she believes "the mix of scientific precision and poetic ideas integral to landscape photography" have reconciled the inside and the outside are in direct contrast to Crary's essay cited above. Foresta is also the curator responsible for commissioning Klett to execute the Washington, D.C., panoramas.

Naef, Weston, Margaret Stuffmann, and Martin Christstadler. *Pioneers of Landscape*

Photography: Gustave Le Gray, Carleton Watkins. Malibu, California: J. Paul Getty Museum, 1993. Linking American and European landscape traditions, this unusual exhibition catalog sheds insight into how technical limitations helped form the aesthetics of nineteenth-century landscapes.

Palmquist, Peter E., and David Featherstone. *Carleton Watkins.* Los Angeles: J. Paul Getty Museum, 1997. This concise overview of the artist reproduces photographs of Watkins not often seen, and provides thorough notes on each, making the case that Watkins was, at least in Weston Naef's opinion, the most significant American photographer prior to Alfred Stieglitz.

Phillips, Sandra S., and Richard Rodriguez. *Crossing the Frontier: Photographs of the Developing West, 1849 to the Present.* San Francisco: Chronicle Books, 1996. The exhibition for this catalog opened at the San Francisco Museum of Modern Art in 1997 and was an excellent, comprehensive, and often startling show with numerous historical documentary photographs juxtaposed against modern and contemporary works. As such, it presented much more than the usual suspects, as does the catalog.

Read, Michael, ed. *Ansel Adams—New Light: Essays on His Legacy and Legend.* San Francisco: Friends of Photography, 1993.

Spaulding, Jonathan. *Ansel Adams and the American Landscape.* Berkeley: University of California Press, 1995. Not only is this an interesting biography of a photographer whose work was much more complicated than generally acknowledged, but it provides excellent context for the artist's work within the larger evolution of landscape photography

and the environmental movement. While discrete, the book is more revealing than the photographer's own autobiography in that Spaulding is able to uncover the contradictions in the life of Adams, such as his selling images to Kodak and the Curry Company for promoting film and tourism, yet working to preserve the wilderness from the impact of people who bought Kodak film from Curry stores in national parks.

Although not directly about photography, Joni Louise Kiney's book, *Thomas Moran and the Surveying of the American West* (Washington, D.C.: Smithsonian Institution, 1992), is an accessible and intelligent introduction to how the American West was imaged in the nineteenth century.

Timothy O' Sullivan

Dingus, Rick. *The Photographic Artifacts of Timothy O'Sullivan.* Albuquerque: University of New Mexico Press, 1982. A sensitive reading of O'Sullivan's work by a member of the Rephotographic Survey Project.

Horan, James D. *Timothy O'Sullivan: America's Forgotten Photographer.* Garden City, N.Y.: Doubleday, 1966. Out of print, but somewhat useful for its numerous reproductions, it presents the chronology of O'Sullivan's life in less than clear terms and makes some errors of fact. They include the misidentification of Logan as "Hogan" and placement of what some people regard as O'Sullivan's most famous desert photograph, that of his wagon on Nevada's Sand Mountain, which Horan labels as being "in the California Desert."

Newhall, Beaumont. *Timothy O'Sullivan.* Rochester: George Eastman House, 1966. A small exhibition catalog.

Snyder, Joel. *American Frontiers: The Photographs of Timothy O'Sullivan, 1867–1874.* New York: Aperture, 1981. Concentrating on just O'Sullivan's seven years as an expedition photographer, this is perhaps the most complete and accurate biography, as well as an intelligent analysis of his place within, and contrast to, the romantic tradition of western representation.

———. "Aesthetics and Documentation: Remarks Concerning Critical Approaches to the Photographs of Timothy O'Sullivan" in *Perspectives on Photography,* edited by Peter Walch and Thomas Barrow (Albuquerque: University of New Mexico Press, 1986). Snyder argues stylishly against O'Sullivan's work being considered merely as naive documentary photography.

There is no proof that O'Sullivan actually authored "Photographs from the High Rockies" in the September 1869 issue of *Harper's New Monthly Magazine* (39: 465–75), which recounts various adventures of the King survey party, but many historians assume he may have penned it, given that it does not follow Clarence King's style. In any case, this is the source of the quote attributed to O'Sullivan regarding the Humboldt Sink being "a pretty location to work in."

By and About Mark Klett

During a visit to Klett's office in December 1998, I found 137 reviews of and/or articles about his work dating from 1984 onward. His résumé, which had just been updated in November by a graduate student, listed his appearance in 156 group shows in at least six countries, 69 one-person exhibitions, 11 fellowships and awards, and 10 books or published projects. The following are only the principal sources by or about the photographer that I consulted.

Klett, Mark, Ellen Manchester, JoAnn Verburg, Gordon Bushaw, and Rick Dingus. *Second View: The Rephotographic Survey Project.* Essay by Paul Berger. Albuquerque: University of New Mexico Press, 1984.

Klett, Mark. *Traces of Eden: Travels in the Desert Southwest.* Essays by Denis Johnson and Peter Galassi. Boston: David Godine, 1986. A very hard-to-find collection of his early Southwest photographs.

———, with Miles De Coster, Mike Mandel, Paul Metcalf, Larry Sultan. *Headlands: The Marin Coast at the Golden Gate.* Albuquerque: University of New Mexico Press, 1989. Commissioned as a text and photo document by the Headlands Center for the Arts, it traces the history of the area, in particular from the military in World War II through its current status as a recreation area.

———. "A View of the Grand Canyon in Homage to William Bell." In *Myth of the West.* New York: Rizzoli, 1990. Klett is himself an articulate writer with both a solid profes-

sional and deeply personal understanding of the history of the West. This essay combines both and appears in the catalog for a wide-ranging exhibition at the Henry Art Gallery (University of Washington, Seattle) that examined the myth-making of the West.

———. "The Legacy of Ansel Adams: Debts and Burdens." In *Beyond Wilderness* (Aperture 120). New York: Aperture Foundation, 1990.

———. *Revealing Territory.* Essays by Patricia Nelson Limerick and Thomas W. Southall. Albuquerque: University of New Mexico Press, 1992. The largest book of Klett's photographs, it thankfully includes many of the photographs from *Traces of Eden.*

———. "Haunted by Rhyolite: Learning from the Landscape of Failure." *American Art* 6, no. 4 (Fall 1992). A photo essay done in collaboration with Patricia Limerick.

———. *Capital View: A New Panorama of Washington, D.C.* Washington, D.C.: National Museum of American Art, 1994. This panorama publication includes essays by Klett and Merry Foresta.

Muybridge, Eadweard, and Mark Klett. *One City/Two Views: San Francisco Panoramas, 1878 and 1990.* San Francisco: Bedford Arts, 1990. A nine-foot-long accordion book that prints the two panoramas back to back, this rare publication illustrates clearly and explains the liberties taken by both photographers in presenting what most people would assume to be objective documents.

Bergin, Phillip. "New Romantics." *Artweek* 22, no. 43 (December 19, 1991). A notable review only in that it is one of the few negative ones that I could find, and one which mistakenly accuses Klett of supplanting the romanticism of the Old West with that of the New Age.

Campbell, Neil. "Signs of my own presence: the redefinition of western landscape in the writing and photographic projects of Mark Klett." A paper given at the Association for the Study of Literature and the Environment (ASLE) annual conference in July 1997, at the University of Montana, Missoula.

Gauss, Kathleen M. "Mark Klett: Searching for Artifacts—Photographs of the Southwest." In *New American Photography.* Los Angeles: Los Angeles County Museum of Art, 1985. Essay in catalog from the exhibition of the same name.

The information on Gary Nabhan and his work is taken from Stephen Trimble's *Words from the Land* (Reno: University of Nevada, 1995, expanded edition), which is an excellent introduction to the primary nature writers of the country, particularly those living in and writing about the West. The article by Malin Wilson quoted in chapter eight was "An Individual Perspective," which appeared in the Journal North section of the *Albuquerque Journal* (Thursday, July 2, 1998).

All quotes by Mark Klett, Ellen Manchester, and Robert Dawson are from interviews with the author, or letters and e-mail to the author, unless otherwise noted.